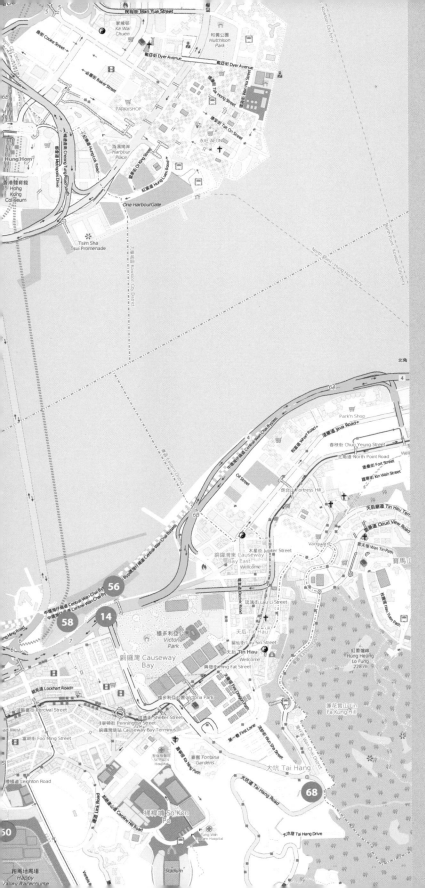

HONG KONG THEN AND NOW

You can find most of the sites featured in the book on this outline map*

Numbers in red circles refer to the pages where sites appear
in the book.

* The map is intended to give readers a broad view of
where the sites are located. Please consult a tourist map
for greater detail.

T0312358

HONG KONG

THEN AND NOW®

First published in the United Kingdom in 2016 by
Pavilion
An imprint of HarperCollins*Publishers*
1 London Bridge Street
London SE1 9GF

www.harpercollins.co.uk

HarperCollins*Publishers*
Macken House
39/40 Mayor Street Upper
Dublin 1
D01 C9W8
Ireland

ISBN-13: 978-1-91090-408-4

Repro by Mission Productions, Hong Kong
Printed in Malaysia

Reprinted 2018 (Twice), 2019, 2021, 2024

PICTURE CREDITS

Then photographs

All 'Then' photographs are courtesy of the author's collection, except for the following:

Getty Images: 10, 12, 14, 16, 18, 20, 22, 24, 28, 30 left, 32, 36, 38, 40 left, 42, 52 left, 56, 60 top, 62, 66 left, 74, 76, 78, 80, 82, 84, 86, 90, 92, 94, 95 left, 98, 100, 102, 104, 106, 108, 112, 118, 120, 132.

Library of Congress: 44 bottom, 46 bottom.

Roy Passingham: 54 left.

Corbis: 122, 124.

Now photographs

All 'Now' photographs were taken by Vaughan Grylls, except for the following:

Getty Images: 23, 55, 89, 97 top, 121, 123.

Isaac Chu/Simon Lam: 101 top.

Alamy: 107.

Endpaper map is courtesy of OpenStreetMap contributors (www.openstreetmap.org)

HONG KONG
THEN AND NOW®

VAUGHAN GRYLLS

PAVILION

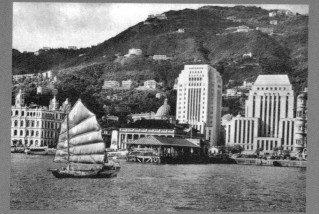

Hong Kong Central, c. 1952 p. 10

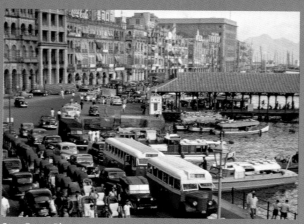

Star Ferry Pier, 1954 p. 18

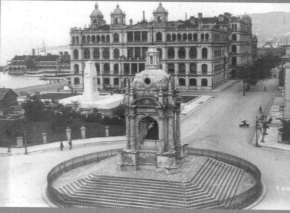

Ladder Street, 1945 p. 30

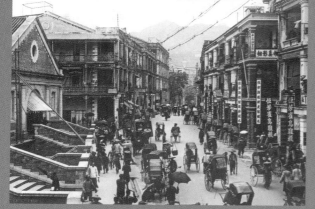

Central Market, Queen's Road, 1895 p. 36

Queen's Road East, 1945 p. 42

The Hong Kong Club, c. 1925 p. 44

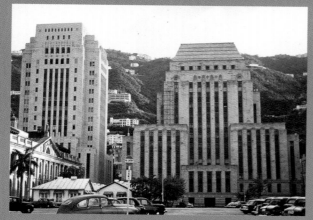

HSBC Building, 1954 p. 54

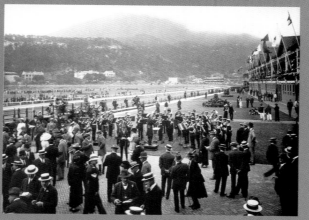

Happy Valley Racecourse, c. 1910 p. 60

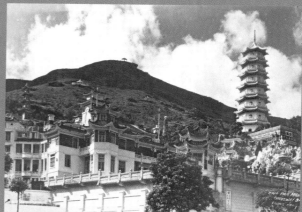

Tiger Balm Garden, c. 1950 p. 68

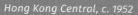

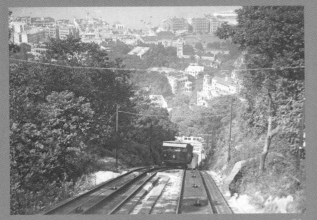

The Peak Tram, c. 1930 p. 70

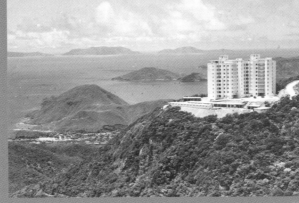

La Hacienda, 1986 p. 72

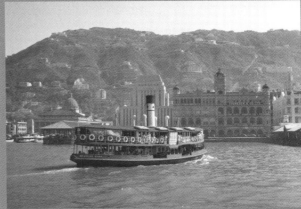

The Star Ferry, 1949 p. 76

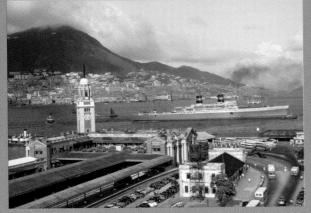

Kowloon–Canton Railway Terminus, 1954 p. 82

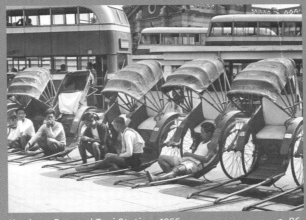

Kowloon Bus and Taxi Station, 1955 p. 86

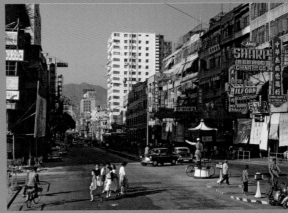

Nathan Road, 1961 p. 90

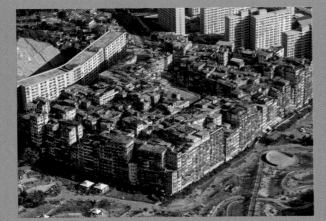

Kowloon Walled City, 1989 p. 100

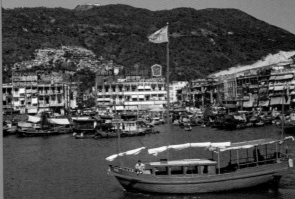

Aberdeen Harbour, 1961 p. 108

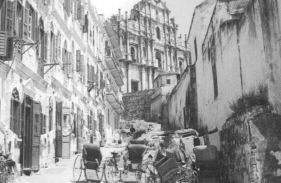

Travessa da Paixão, Macau, c. 1950 p. 132

A SHORT HISTORY OF HONG KONG

In 1832, in Canton, two British merchants, William Jardine and Thomas Matheson, set up a company: Jardine Matheson. There was a lucrative trade to be had shipping Chinese tea and porcelain to Europe, but instead of paying for the goods in silver they saw an opportunity to pay in opium. Macau, opposite Hong Kong on the Pearl River Delta, had been smuggling it into China for years.

Cantonese officials were bribed to turn a blind eye to the import of large quantities of opium from India, but ultimately the Chinese authorities discovered the illegal trade. Twenty thousand chests of opium were confiscated from the British trade superintendent in Canton, Charles Elliott, and burnt. The British response was to send Royal Navy ships to Canton and up the Yangtze River, firing on ports and cities. China's rivers were key to its economy, and with the overwhelming power of the Royal Navy stifling the economy, the Chinese Emperor had to negotiate.

The British were granted a base and chose an island in the Pearl River Delta, which was easy to defend, given their naval power. Charles Elliot, humiliated in Canton, planted the Union Jack at what is now Possession Street on 26 January 1841. British sailors had asked locals what this island was called and were told 'Heung Kong', meaning 'Fragrant Harbour' in Cantonese. The sailors thought they had meant the whole island.

In 1842 China transferred Hong Kong Island in perpetuity to Britain and gave them trading rights in Canton, Shanghai and other Chinese coastal cities. In 1860 they added the Kowloon peninsula, following another diplomatic spat. With a safe harbour and mainland access in Kowloon secured, investment started to flow into the fledgling colony. Jardine Matheson were joined by many others, including the Hongkong and Shanghai Banking Corporation in 1864.

Yet Hong Kong was too mountainous to build a large port city with only Victorian building techniques. The answer lay in extending the foreshore by claiming land from the sea. From this time onwards the shoreline crept relentlessly nearer and nearer Kowloon. In 1898, Hong Kong received more land in Kowloon – the New Territories – on a 99-year lease. Unwittingly, the British had set 1997 as their exit date.

Trade with China in the late 19th century was booming, with opium accounting for half the colony's income until 1890. By 1907 Chinese warlords controlled the business and opium poppies were cultivated within its borders, yet an expanded Hong Kong had become a trading force no longer reliant on the demand from opium dens. Thanks to its free trade status guaranteed by the British it had become a major entrepôt for the Chinese hinterland.

The late Victorian success contrasted with the decline of the Hong Kong economy between the two world wars. Shanghai now took the lead as the trading centre of choice for the Chinese Empire. Hong Kong appeared sidelined and some

thought it would share the fate of the nearby Portuguese colony of Macau; a historical curiosity.

World War II brought fundamental change to the region. The second Sino-Japanese war had begun in 1937, after Beijing and then Shanghai had been attacked and captured. In 1941, Japanese forces assaulted Hong Kong eight hours after the attack on Pearl Harbor. After a short and bloody fight with British, Canadian, Indian and Hong Kong troops, the British governor surrendered on 25 December 1941. A Japanese governor was installed and the currency replaced with the Japanese Military Yen. The colony endured atrocities, hyper-inflation, deportation and starvation rations until liberation by British and Chinese forces in 1945.

The political vacuum created by the defeat of the Japanese led to China's own internal struggle for power. In 1949 Hong Kong reeled under mass migration from mainland China as Mao Tse-tung's Communists defeated the Nationalists. Fearing the strictures of Communist governance, Western businesses hurriedly relocated from Shanghai, removing at a stroke its competitive threat to Hong Kong. Despite the Communist government's regular public rhetoric denouncing Hong Kong, business boomed; for it was now the only place where it could receive essential hard currency for its goods. Hong Kong became a manufacturing centre as well as a trading port. But the population boom had resulted in squatter settlements, and the authorities ordered apartment blocks, built quickly and often shoddily.

In the 1970s, Hong Kong underwent many changes that would shape its future. China started investing in Hong Kong through Chinese-owned businesses; 65,000 Vietnamese boat people arrived following the Vietnam War; and the arrival of martial arts movies, led by Bruce Lee in films such as *Enter the Dragon* and *Fist of Fury*, gave the Hong Kong film industry an international audience.

By the 1980s, the end of Britain's 99-year lease on the New Territories was in sight. In London, Prime Minister Margaret Thatcher was shown that despite its long-term tenure of the island, the colony was not viable without the New Territories. In 1984 the Sino-British Joint Declaration was signed. China agreed that Hong Kong could keep its legal and capitalist system as a Special Administrative Region (SAR) for at least 50 years after 1997. The Chinese leader Deng Xiaoping called it 'one country, two systems'.

Hong Kong had become an economic jewel. In the 1990s, half of China's exports passed through the colony and half of all foreign investment in China came from Hong Kong. The Stock Exchange was now the third most important in the world after New York and London.

Chris Patten arrived in 1992 as the last Governor of Hong Kong and lowered the voting age from 21 to 18, enfranchising 2.7 million citizens. A new airport was built at vast expense, replacing what had seemed like a major air accident waiting to happen at Kai Tak Airport, whose approach path skimmed the roofs of the densely populated suburbs in Kowloon.

Macau, far older than Hong Kong, also became a Special Administrative Region for 50 years, with Portugal handing back China's first and last European colony in 1999. It would become a gambling capital; the Las Vegas of the South China Sea.

Since 2001 Hong Kong has branded itself Asia's World City. LIfe expectancy in Hong Kong is among the highest in the world; and as China's most important Special Administrative Region, Hong Kong enjoys low taxation, free trade and some of the most laissez-faire economic policies anywhere. Before handover in the mid-1990s, Hong Kong's fear was that the private enterprise and dynamism that had driven the colony's extraordinary growth and prosperity would be squashed into the communist model. Yet the world's emerging superpower has decided quite the opposite. China's major cities are to become like Hong Kong, and that is now its greatest challenge.

HONG KONG

THEN AND NOW INTRODUCTION

The Cathay Pacific 747 dips sharply to the right, a little too close for comfort to blocks of flats rising on either side. Then the huge aeroplane is surrounded by water as it touches down, engines screaming as the brakes are applied hard. Passengers catch a glimpse of boats buzzing about as the most astonishing cityscape comes into view – a Manhattan with mountains.

Kai Tak Airport, projecting into the harbour, was for pilots one of the most challenging airports in the world. They had to undergo arduous training to use it. But in 1998 Kai Tak accepted its last landing, replaced by the massive Chek Lap Kok (officially known as Hong Kong International Airport) off the north coast of Lantau Island.

Both airports were built on reclaimed land and as this book will show, the story of mountainous Hong Kong is a story of reclaiming land from its beginnings. Chek Lap Kok is now the busiest airport in the world for cargo, which is not surprising as Hong Kong stands alongside London and New York as one of the world's three leading business and financial centres.

It has been a pleasure to research, photograph and write this book, but it has also been a challenge, as Hong Kong is an ever-changing city. As some of these photographs show, it is not always a question of a Then and Now but a Then, Then, and Now, with little if any visual carry-over between the images. Sometimes the carry-over lies entirely in the topography; other times in an insignificant part of a building

or a garden that has somehow escaped the relentless bulldozing, rebuilding and reclaiming. Yet ultimately it is Hong Kongers who make the place, as it is a city that buzzes with people. This can be seen in many of the Then images and I have tried to capture that energy in my Now photographs.

It would have been wrong to have left out the former Portuguese colony of Macau, as it is just across the Pearl River and was also once a European colony; the first in China, founded in 1557. A sizeable part of Macau's traditional city centre has been restored in recent years, maybe over-restored, but it is still recognisable. The same cannot always be said elsewhere. The advent of the super-casino occasionally made it difficult to believe I was in the same place where sampans were moored less than 20 years earlier – now replaced by Dutch-style houses with a replica of the Roman Colosseum rising incongruously behind them.

My grateful thanks go to Andrew Lam in Hong Kong for helping point my camera in the right direction; to Ferdy Carabott in London for massaging many of my images into an acceptable form; to my editors, Frank Hopkinson and David Salmo in London, and to C.K. Lau in Hong Kong, for reading my text and advising me. Any mistakes are entirely my own. I do trust you enjoy this book. I have certainly enjoyed taking the photographs and writing it.

Vaughan Grylls

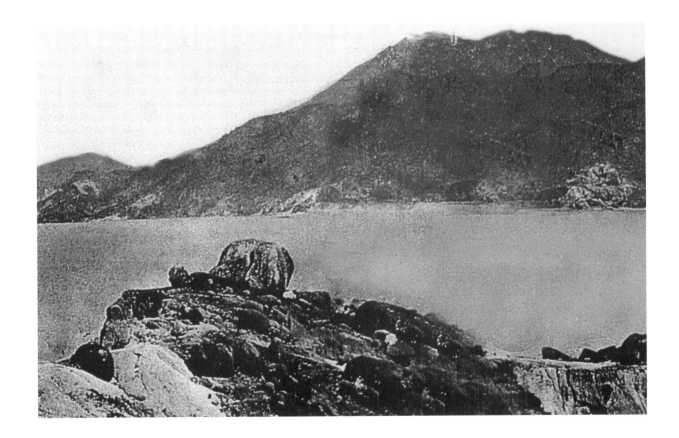

ABOVE: The earliest known photograph of Hong Kong Island, taken circa 1841 from a rocky outcrop in Kowloon.

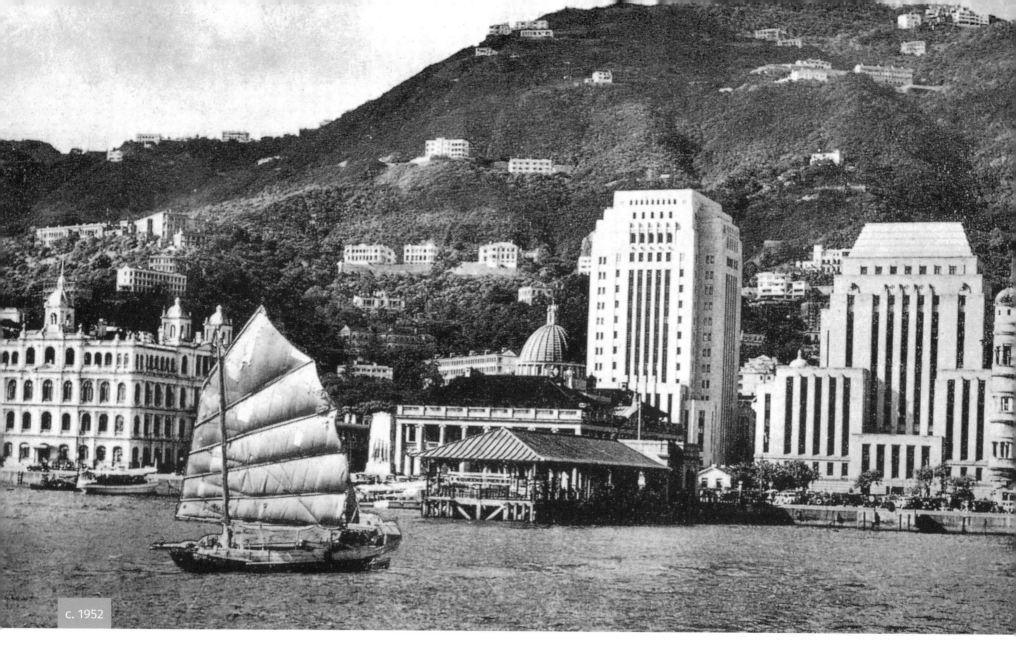

c. 1952

HONG KONG CENTRAL

The old Bank of China, once the tallest building in Hong Kong, is now dwarfed by skyscrapers

ABOVE: Taken in the early 1950s, this image of Central Hong Kong, or the City of Victoria, as it was then known, shows a traditional Chinese junk with the ferry terminal of Victoria Harbour behind. On the shore is, from left to right, the Hong Kong Club (1897), the Cenotaph (1923), the Supreme Court (1912), the Bank of China (1951), the Hongkong and Shanghai Banking Corporation (HSBC) headquarters (1935) and the corner of the first Prince's Building (1904). Rising up Victoria Peak behind can be seen the mansions of Hong Kong's elite. These well-appointed properties were set aside for taipans – the western heads of Hong Kong's major businesses and banks. At this time, the Hong Kong Chinese were barred from the Peak, unless they could demonstrate that they were employed as servants of the taipans.

10

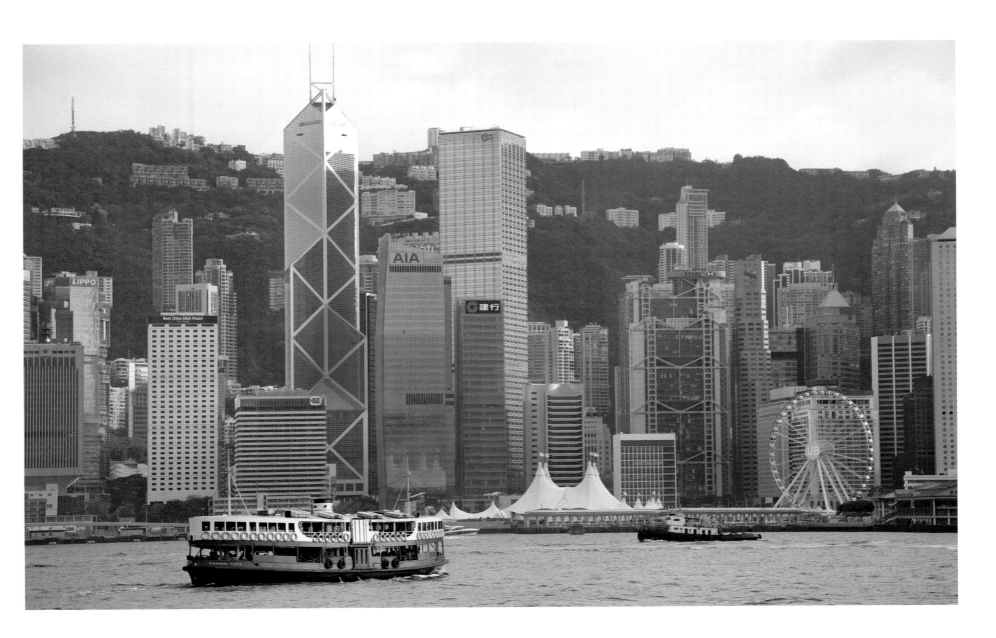

ABOVE: A Star Ferry makes its way to the ferry terminal, which is now to the extreme right. Only one building from the previous photograph can still be seen – the old Bank of China, behind the right-hand pinnacles of the marquee on the foreshore. Immediately to the left is the replacement building for the Hong Kong Club (completed in 1984) and to the right is the new HSBC building, designed by Foster & Partners and completed in 1986. The tallest building in this view is the new Bank of China (1989), designed by the Chinese-born American architect I.M. Pei. Behind the spindle of the Ferris wheel (the Hong Kong Observation Wheel) is the Mandarin Oriental Hotel, with the new Prince's Building immediately behind it. The Mandarin Oriental is consistently voted the best hotel in the world. On the Peak, the taipans' mansions have been replaced by upmarket apartment buildings.

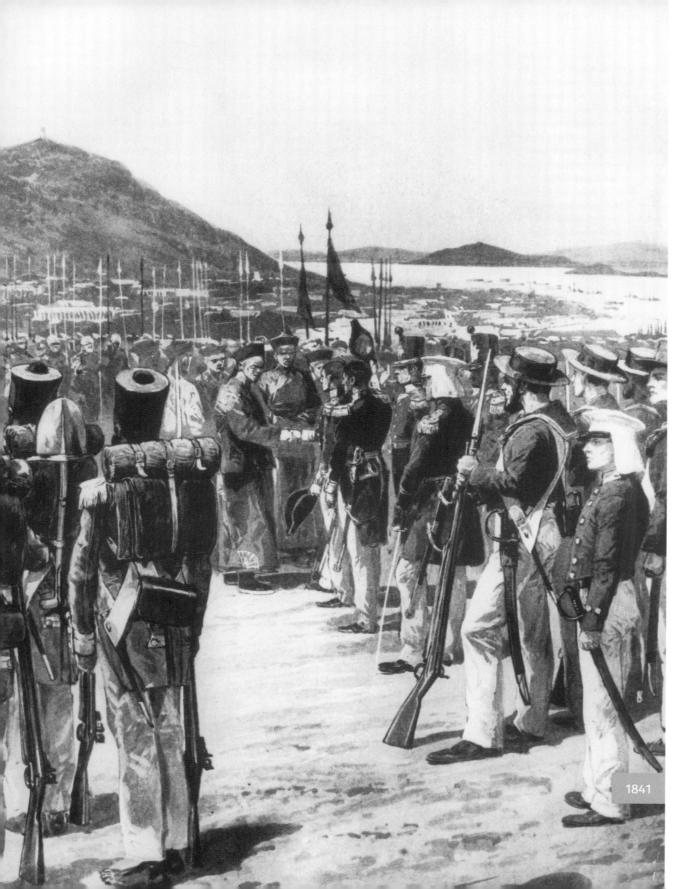

1841

POSSESSION STREET
Where the Chinese agreed to cede
Hong Kong to Great Britain

LEFT: It is January 26 1841 and this picture, published
in the *Illustrated London News*, shows a group of Royal
Navy Officers led by Commodore Sir James John Gordon
Bremer shaking hands with Imperial Chinese officials
on the shore of Hong Kong Island. They are agreeing in
principle the transfer of the island's ownership from
China to Great Britain. Imperial Chinese guards cluster
in the background while in the foreground a contingent
of Royal Marines stand by. Out in the harbour, Royal
Navy battleships ride at anchor. Inland, British military
tents have been erected. In April 1841 the Royal Navy
had its first victualing yard here. The following year, the
Qing Chinese Emperor ceded Hong Kong 'in perpetuity'
to Queen Victoria as part of the Treaty of Nanking, which
officially concluded the First Opium War between the
two countries. This unequal treaty gave Britain access to
'treaty ports' and from that moment unhindered trade
into China.

RIGHT: Where the 1841 signing took place is now Possession Street – known in Chinese as the 'Mouth of the Ditch Street' for the storm-water course that once ran next to it. In the foreground, at the foot of Possession Street, is Queen Street Central, the oldest street in Hong Kong. It is at this junction that the transfer is believed to have taken place. Until quite recently, this area of Hong Kong, with its old narrow streets, was not well regarded. Indeed, the whole street was once lined with brothels. Today, the oldest area of Hong Kong is a favourite haunt of the young and hip, especially on Friday and Saturday nights, who come here for its bars, clubs, restaurants and boutique hotels. The black spot on the map below marks Possession Street, while the red lines mark the approximate positions of the shoreline as more and more land was claimed from the harbour over the next 175 years.

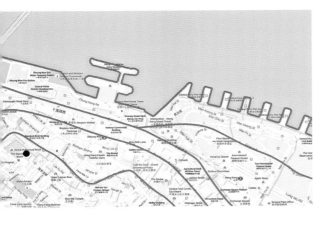

VIEW OF VICTORIA HARBOUR

Land reclamation schemes have completely transformed the waterfront

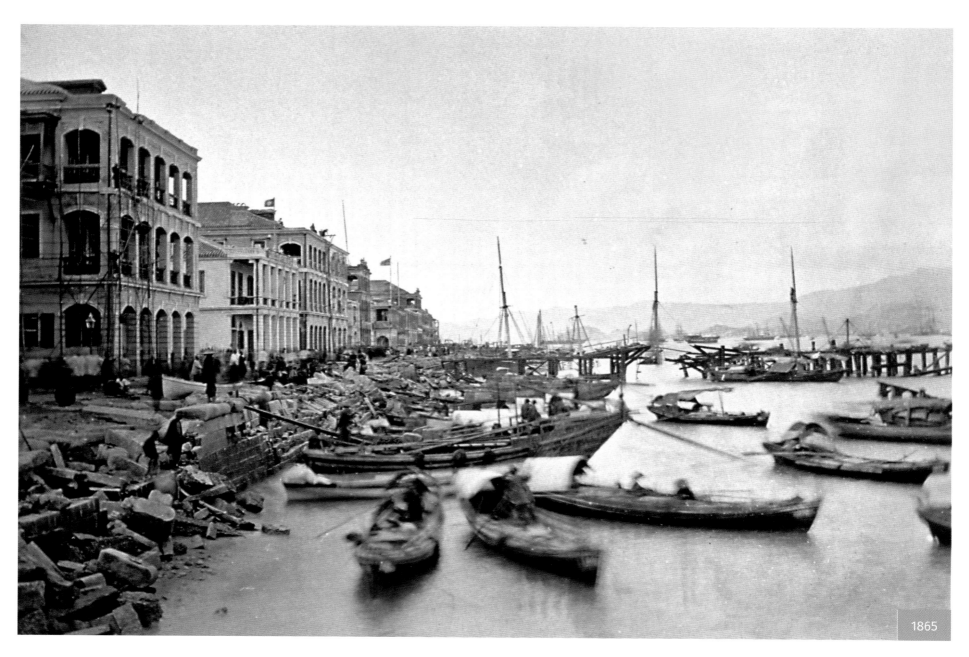

1865

LEFT: This photograph of Victoria Harbour from 1865 shows the effects of a South China Sea typhoon. The wharf's granite blocks have been ripped out and the pier is smashed. In the background, the Union Jack flies in the face of all this devastation. Lining the wharf are the city's offices and warehouses, which would then have been called godowns. The big trading houses such as Jardine Matheson built them. The building nearest to the camera is scaffolded. Perhaps it is being repaired following typhoon damage, although it is more likely that it is still being constructed, as British Hong Kong was only 24 years old when this photograph was taken. Riding at anchor is an assortment of craft; derivations of the dragon boat, traditional to the Pearl River Delta.

BELOW: The Central–Wan Chai Bypass, carrying the ubiquitous red Hong Kong taxicabs, sweeps over Victoria Park. To the left is the original Gloucester Road, following the line of the previous waterfront. Straight ahead lies the Hong Kong Convention and Exhibition Centre, designed by Skidmore, Owings and Merrill in association with Wong and Ouyang. The building, which was designed to resemble a seabird in flight, was opened in 1997 and served as the venue for the handover of Hong Kong from Britain to China the same year. Nearly all the land seen in this photograph has been reclaimed from the harbour.

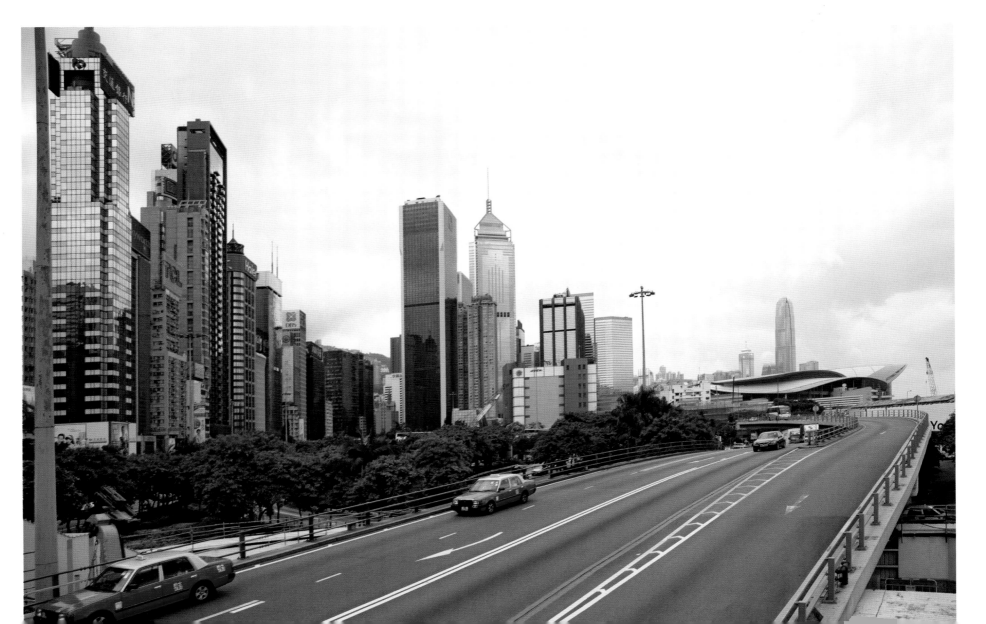

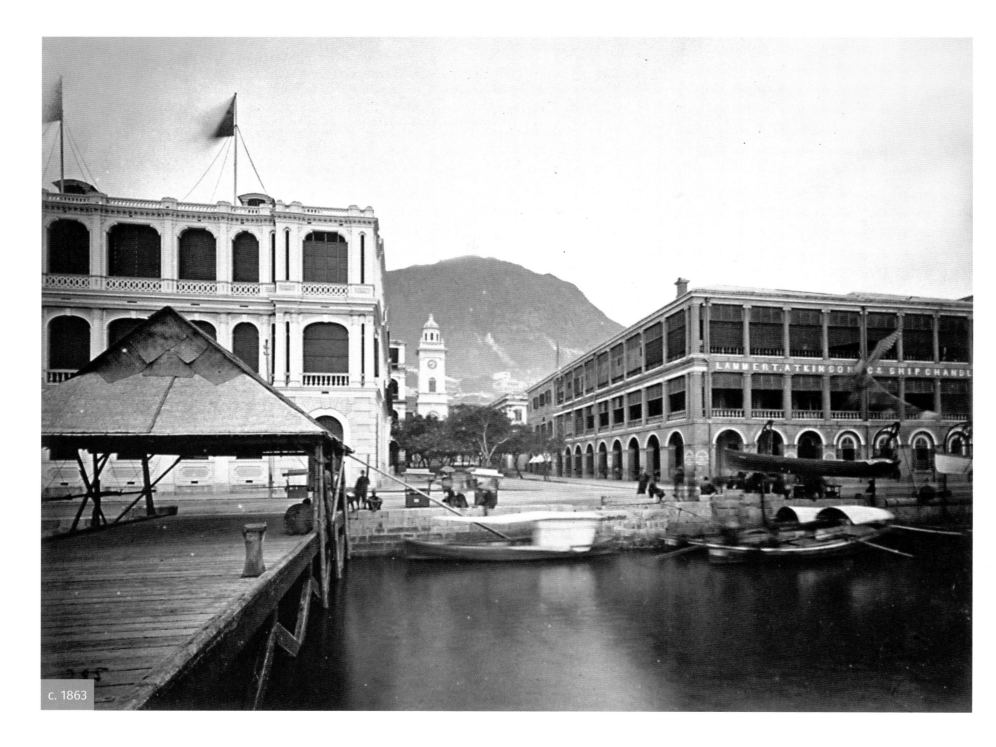

c. 1863

PEDDER STREET

Though it no longer reaches the waterfront, Pedder Street is still at the commercial centre of Hong Kong

LEFT: At the junction of Pedder Street and Queen's Road stood Hong Kong's Clock Tower, completed in 1862. Douglas Lapraik, the taipan of a successful shipping company, gave it to the city. In the early 1860s, when this photograph was taken, Pedder Street, which takes its name from Hong Kong's first harbourmaster, Lieutenant William Pedder, was flanked by warehouses and offices and led down to the waterfront and the harbour. From the Clock Tower to the harbour was the commercial fulcrum of Hong Kong, the place where ships' suppliers set up shop and where the 'Hongs', British-owned companies each with a reach extending well into Mainland China, established themselves. The building on the left is the headquarters of Dent and Co, a leading British merchant firm. Further down Pedder Street on the opposite side are the offices of Jardine Matheson.

ABOVE: Pedder Street is still at the heart of the city, although its Clock Tower landmark was demolished in 1913 as a 'traffic hazard'. The clock itself was saved and in 1915 it was incorporated into the clock tower at the former Kowloon–Canton Railway terminus. It is now known as Tsim Sha Tsui Clock Tower. In the foreground is the junction of Chater Road (left) with Des Voeux Road Central (right). These roads follow the line of the wharf in the 1860s photograph. They are named aptly. Sir Paul Chater was a successful British entrepreneur of Armenian descent who took secret soundings at night in a sampan to determine seabed levels in Victoria Harbour, which led to the Praya Reclamation Scheme. Through his company, Hongkong Land, he introduced the first major reclamation scheme in Hong Kong between 1868 and 1873. Sir William Des Voeux introduced an even larger reclamation scheme during his time as Governor from 1887 to 1891. Although the Clock Tower was not preserved, happily Hong Kong's trams were, albeit in smaller numbers, and they continue to ply this key route.

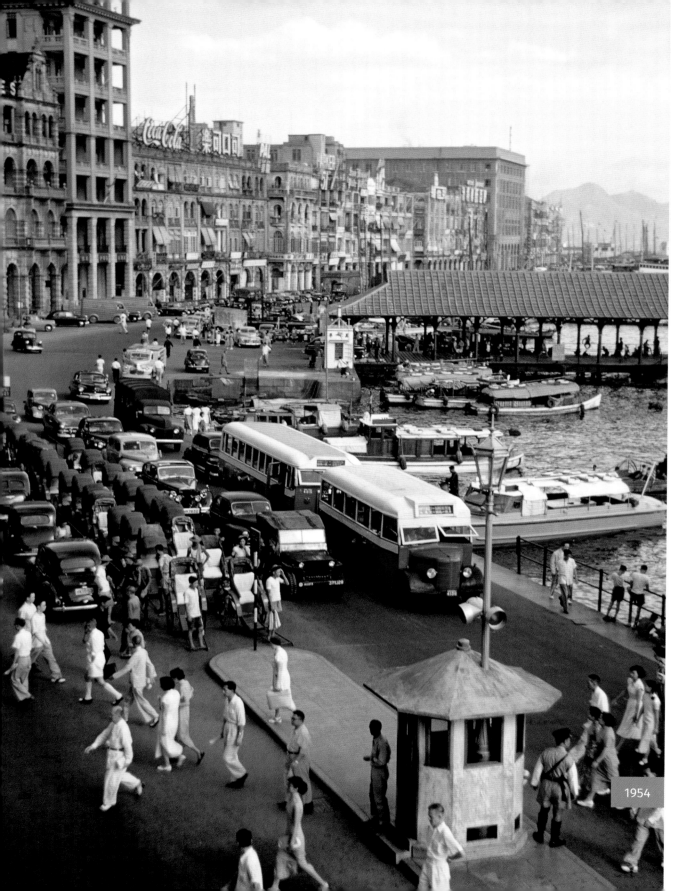

1954

STAR FERRY PIER
Where the Star Ferry Company has been linking Central to Kowloon since 1898

LEFT: By the time of this 1954 photograph – showing commuters leaving the Star Ferry, linking Central with Kowloon – many who had escaped the fall of China to communism in 1949 had established themselves successfully in Hong Kong, which had replaced Shanghai as the principal commercial city on the east Asian mainland. Many Westerners, as well as Chinese, had come from Shanghai, often transferring their businesses. The waterfront had moved yet again, from Des Voeux Road to Connaught Road. Skyscrapers were yet to come, although here we see the beginnings of tall, block-like structures, which were starting to replace the Victorian buildings with their characteristically ornate facades. Dressing in white was the expected Empire way in the tropical summer months. Spotless white clothes were an indication of status, giving the impression of an unpressured life, complete with servants.

RIGHT: This photograph was taken from a restaurant above the present Star Ferry Pier. This area has seen huge land reclamation over the years, allowing the construction of an International Finance Centre with malls and walkways, a bus station, extensive taxi ranks at ground and subterranean levels, and a broad promenade. There are eight ferry piers, each dedicated to a destination such as Lantau Island or the Tsim Sha Tsui Ferry Pier in Kowloon. Pier 6 can be seen on the right. The former waterfront at Connaught Road is now a dual carriageway and runs where the smaller fawn-coloured buildings can be seen. Abundant servants still exist for Hong Kong's elite. Today most are not Chinese but Filipino and Indonesian. The main walkway in the development (shown below) is a favourite place for servants to socialise on Sundays off. Temporary homes are created from cardboard boxes, each carefully furnished and stocked with food. 'Neighbours' are invited for a meal with shoes left outside.

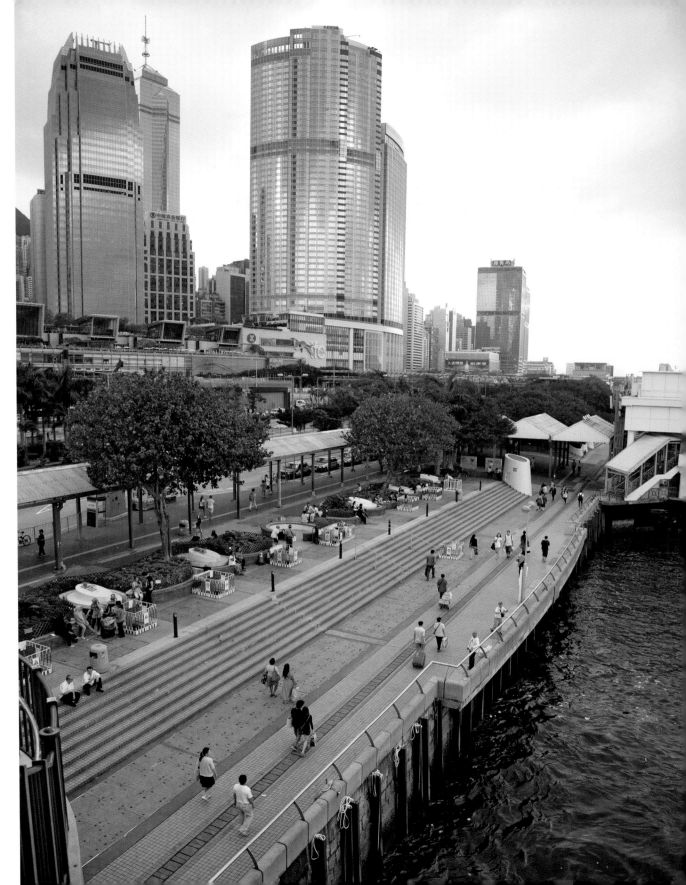

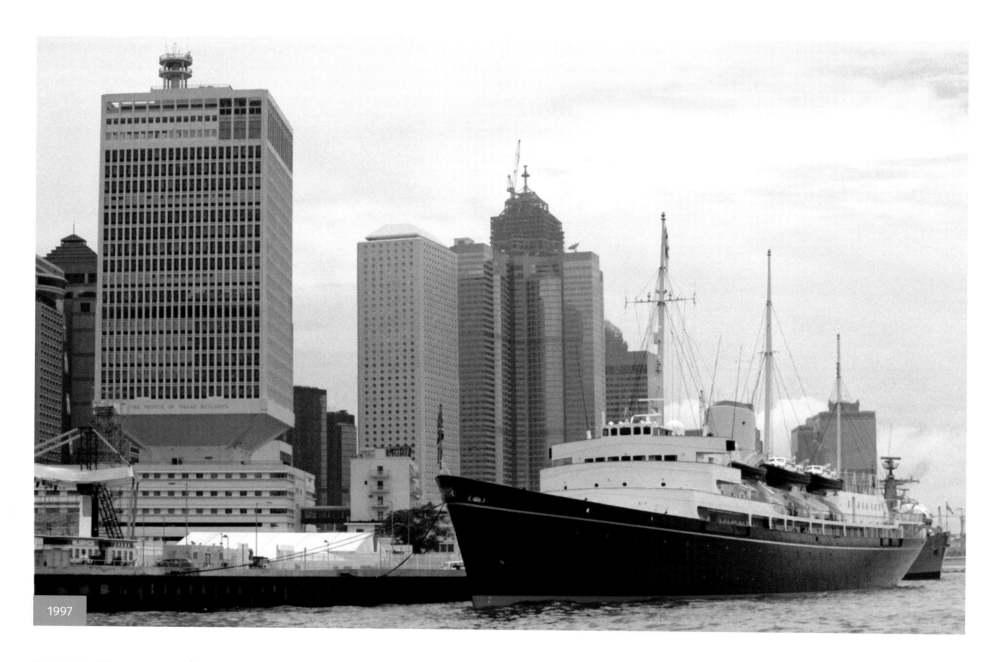

1997

HMS *TAMAR* / CENTRAL GOVERNMENT COMPLEX
Site of the British Royal Navy base from 1897 to 1997

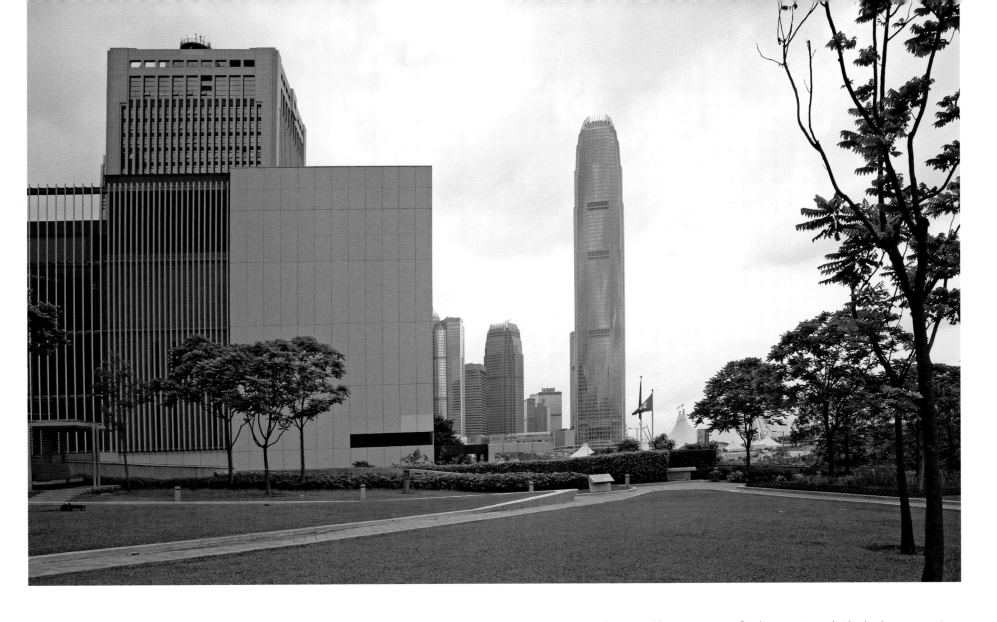

LEFT: On the eve of the handover of Hong Kong to China in 1997, the Royal Yacht *Britannia*, with Charles, Prince of Wales, aboard, docks in Hong Kong. A British warship is moored aft. The British Royal Navy base, named after the HMS *Tamar*, is on the left with the Prince of Wales Building (completed in 1979) rising above it. Known to the British military as the upside down gin bottle, its architects said it was designed to foil attack from below. *Britannia* sailed for England on 1 July 1997 after the handover, carrying the Prince of Wales, Prime Minister Tony Blair and (by now) former Governor of Hong Kong, Chris Patten. Not only was Hong Kong the last substantial colony of what had been the British Empire, the sailing was the last overseas commission for *Britannia* herself. At that year's end the royal yacht was decommissioned and the Queen, uncharacteristically, wept at the ceremony. The yacht is now moored at Leith, Edinburgh, and is a popular tourist attraction.

ABOVE: Tamar Park, opened in 2011, sweeps further out towards the harbour as part of 'Central Reclamation Phase III', which has reclaimed land all the way to the ferry piers. The site of the former HMS *Tamar* shore station has become part of the Central Government Complex and the Prince of Wales Building is now the Chinese People's Liberation Army Forces Building. In front is the Legislative Council Complex. In 2013 a large communist red star was placed on the former Prince of Wales Building, which was then scaled by protestors, despite its architects' intention to make it resistant to attack from below. On the horizon is Two International Finance Centre, popularly known as 2 IFC, which was completed in 2003 and stands 1,362 feet (415 metres) tall. The Hong Kong Monetary Authority is on the 55th floor, safely above two inauspicious non-existent floors below. Although 2 IFC officially has 88 storeys and 22 high-ceiling trading floors, the 14th and the 24th floors do not exist, as 14 sounds like 'will certainly die' and 24 sounds like 'easy to die' in Cantonese.

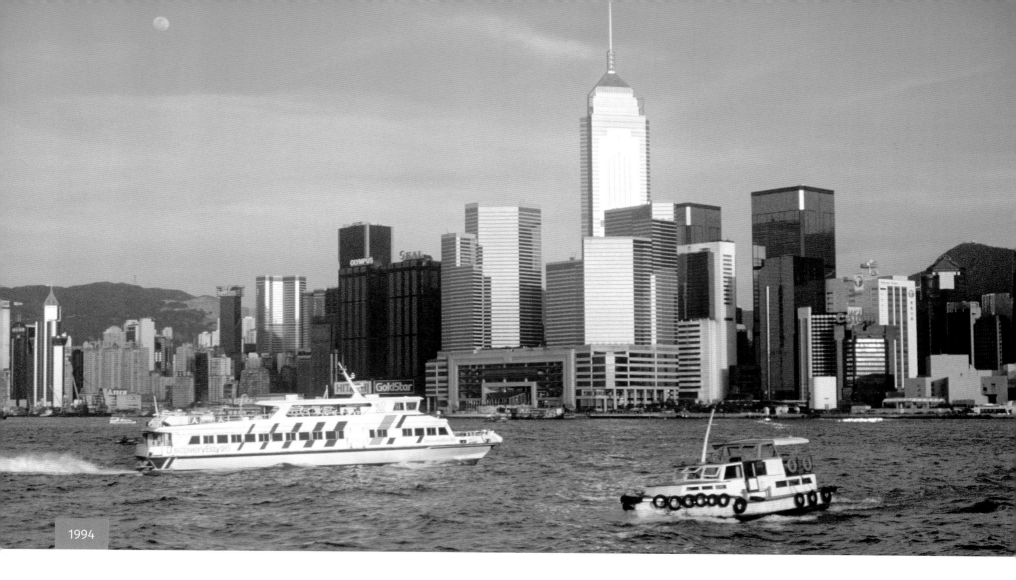

1994

VICTORIA HARBOUR FROM KOWLOON

The 'King of Kung Fu Fighting' has been immortalised on Kowloon's Avenue of Stars

ABOVE: In 1860, the British wrested the freehold of Kowloon from China, securing what is now Victoria Harbour. Investment started to flow into Hong Kong, for this deep water harbour would prove key to its economic success. By 1994, when this photograph was taken, the colony had only three years to go before handover to China, but it had achieved pre-eminence as the financial capital of Southeast Asia. Alongside London and New York, it became one of the three great financial centres of the world. Central Plaza, the huge

pinnacled office building shown here, was completed in 1992. Reaching 374 metres (1,227 feet), it was the tallest building in Asia until 1996. Although it may be a symbol of Mammon for Hong Kong, the apex of the tower houses the Sky City Church, the world's highest church inside a skyscraper. Today the tallest building in Hong Kong is the International Commerce Centre, which was completed in 2010 and reaches 484 metres (1,588 feet).

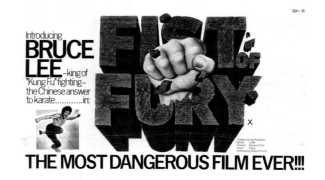

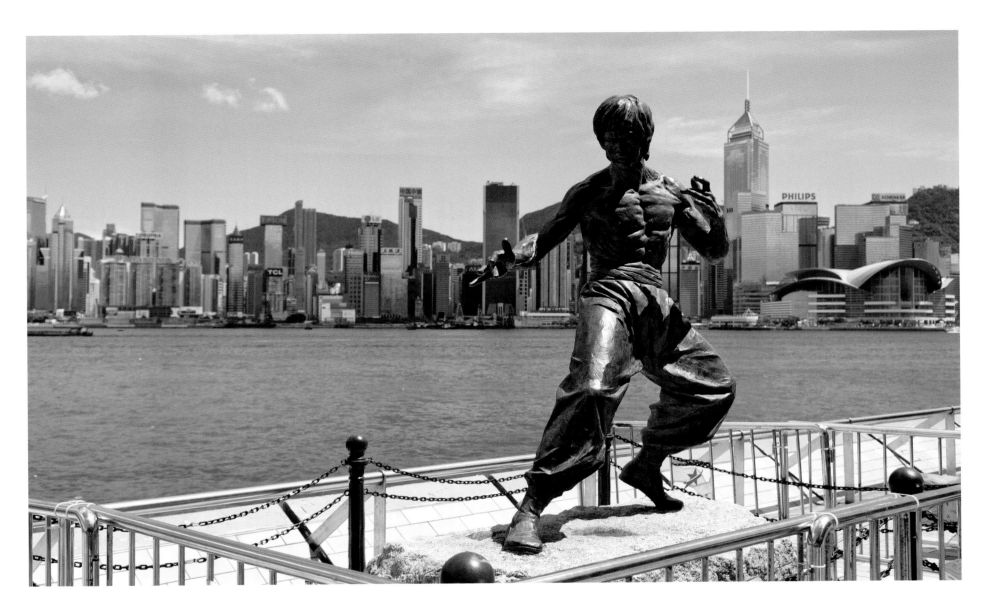

ABOVE: The Central District of Hong Kong has many skyscrapers, although in this view Central Plaza still stands out, especially at night when its inbuilt light installation switches on. To the right is the Hong Kong Convention and Exhibition Centre, which opened in 1997 and served as the venue for the handover of Hong Kong from Britain to China. On the Kowloon side there is now a bronze statue of the Kung Fu movie star Bruce Lee – a Kowloon-raised actor, martial arts expert and son of a former Canton opera star. Lee's second film, *Fist of Fury* (see poster opposite), won him the awards of Best Mandarin Film as well as the Special Jury Award at the 1972 Golden Horse Film Festival in Taiwan. He died in 1973. The statue, which was unveiled in 2005, reminds visitors to Hong Kong of the city's thrill-a-minute cinematic heyday which brought Hong Kong movie-making to a worldwide audience. Martial arts movies have long since been displaced for Hong Kongers by modern Chinese cinema, alongside the products of Hollywood, Europe and Australia.

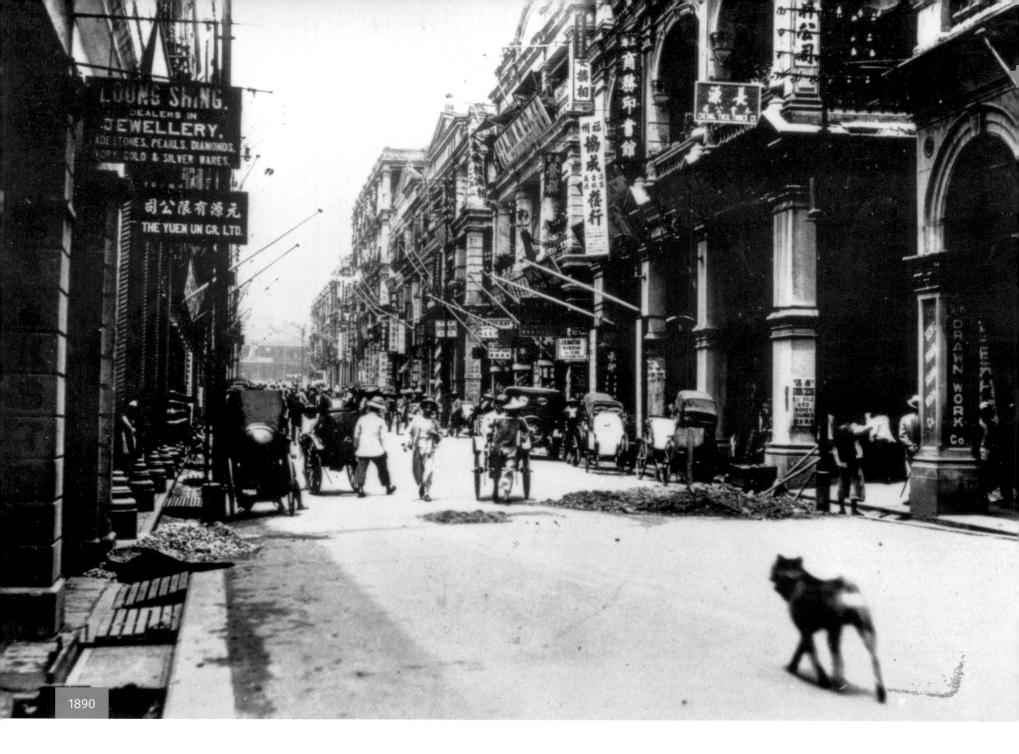

1890

HOLLYWOOD ROAD

The second street to be constructed in colonial Hong Kong

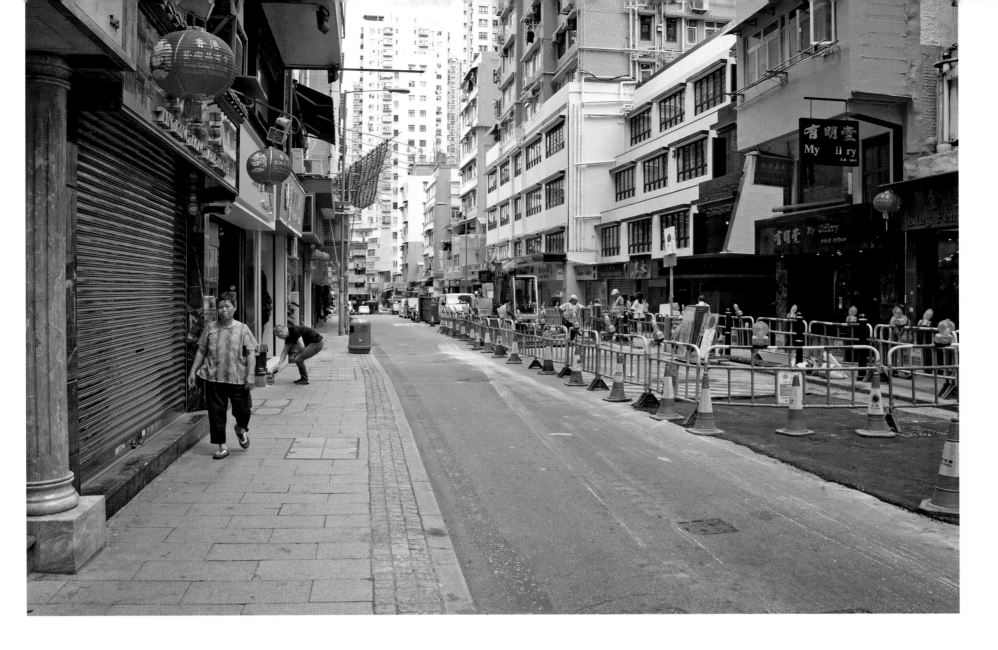

LEFT: Built in 1844 by the Royal Engineers, and named many years before its famous Los Angeles counterpart, Hollywood Road was the second street to be constructed in Hong Kong. In 1890, when this photograph was taken, Hollywood Road was known for its jewellery, antiques and curios, many of which had been 'discovered' in mainland China by British soldiers and sailors, as well as by foreign merchants enjoying their protection. Hollywood Road housed Hong Kong's first police station, constructed in 1864, as well as its first jail, Victoria Prison. The first Union Church was built here in 1845, soon after the road's construction. Open gutters run along the roadside over which are placed wooden ramps for access to shops and other buildings. The blurred dog in the foreground indicates the long shutter speeds necessary at the time the photo was taken.

ABOVE: Hollywood Road twists and turns as it follows the foot of Victoria Peak, but there is just one section that is straight. Every building appears to have changed over the past century, making it almost impossible to replicate the exact view shown in the 1890 photo. However, some of the same types of businesses and activities continue today, such as trinket shops, coffin sellers and roadworks, but they have now been joined by contemporary art galleries and trendy clubs and bars. You may not guess it from this early morning photograph, but here, especially on weekend evenings, is the centre of hipster Hong Kong.

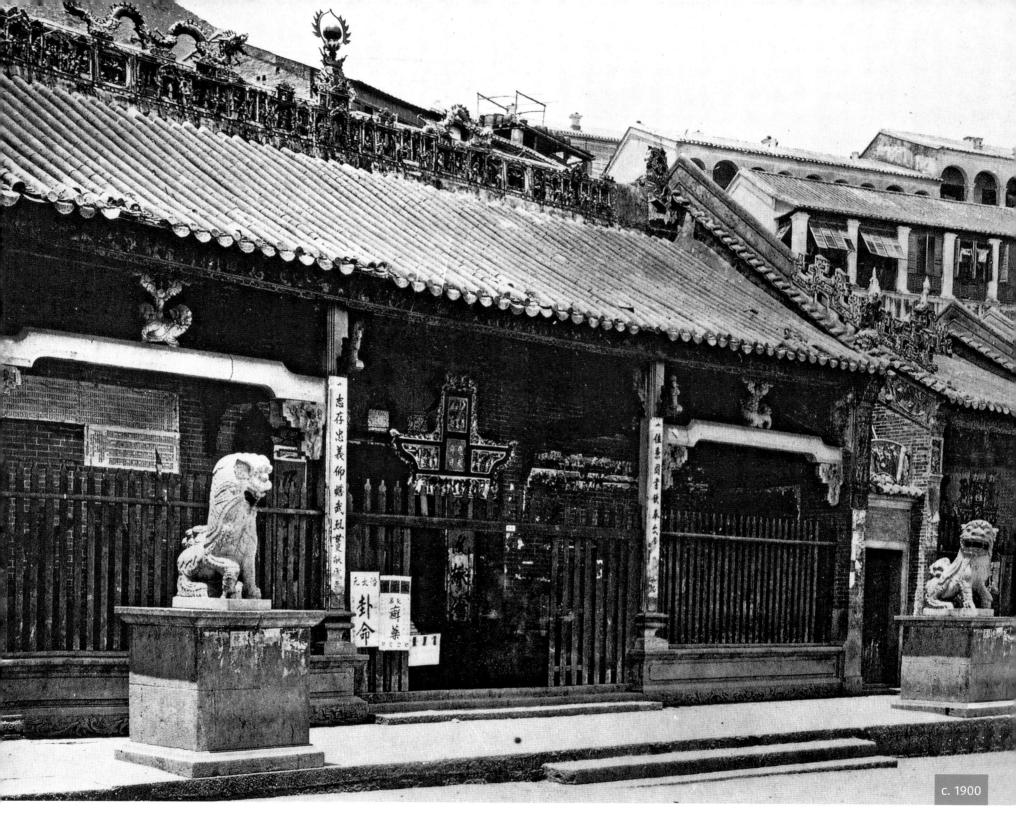

c. 1900

MAN MO TEMPLE

Patronised by those seeking advancement in the civil service

LEFT: The Man Mo Temple was built in 1847 on Hollywood Road and dedicated to two gods; a martial god (Mo Tai) and a god for civil servants (Man Tai). The civil service was the elite profession in China and a god to help one mount the hierarchy to mandarin, or top bureaucrat, was essential. In the 18th century, the first British envoys seeking trade met the Chinese Emperor. They were treated with disdain, for merchants were of low status, below that of farmer, as their only purpose was seen as self-enrichment. For the British, the highly regimented ranks of Chinese civil servants was an eye-opener. Clearly a gold-standard civil service was essential to run an empire; thus did that most elevated of British civil servants come to be named a mandarin, although their own temple was the gentleman's club, a particular feature of Hong Kong. Inside the Man Mo Temple is a statue of the civil god brandishing a writing brush. Stone lions deter the ill-intentioned.

RIGHT: Although lions no longer guard this Grade I listed historic building, Man Mo Temple has been extended, and a new frontage has been built. Inside, the impressive decorations brought from mainland China remain, as do the statues. Scented coils burn, adding to the sacred atmosphere. This is the oldest Chinese temple in Hong Kong. Tung Shing Terrace, the 34-storey residential tower block behind, dwarfs Man Mo. It is favoured by young ex-pats and stands between the Mid-Levels – an area between Central and Victoria Peak where ex-pats traditionally lived – and the now trendy Hollywood Road area. Tung Shing Terrace is named for the 'All-Knowing Book' (the *Tung Shing*), which is supposed to date back to the Yellow Emperor, nearly five thousand years ago. The *Tung Shing* advises on the best days for doing almost anything important, from marriage to moving house.

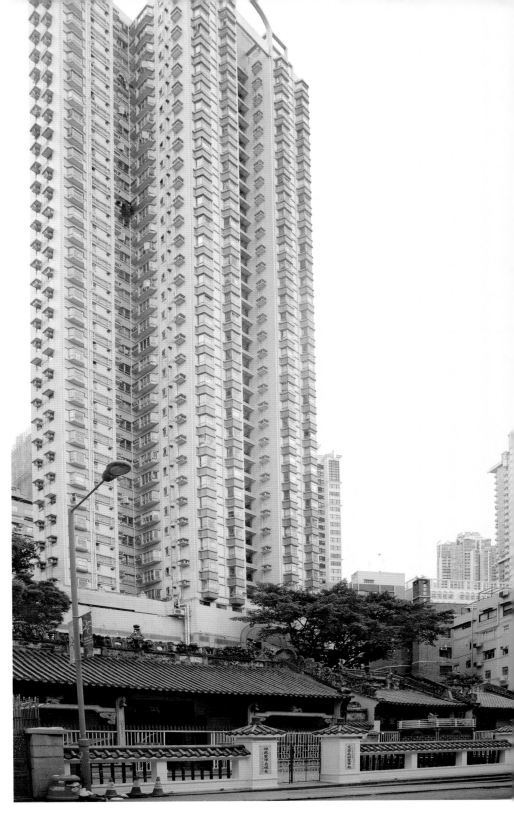

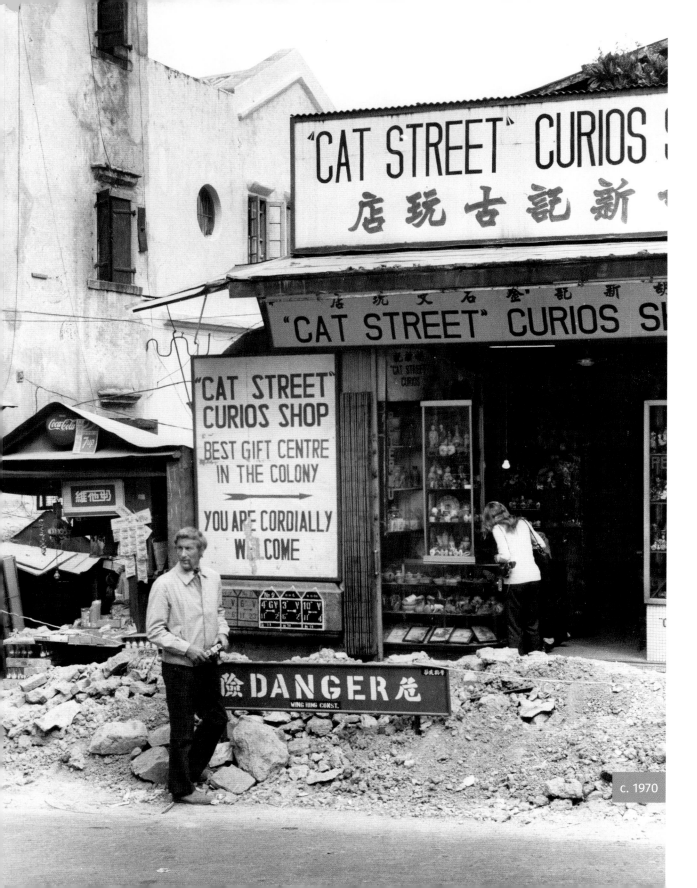

c. 1970

CAT STREET

Once a red-light street, it is now famous for antiques and curios

LEFT: Cat Street's official name is Upper Lascar Row. Lascar is derived from the Urdu for East Indian seaman, who once lived here in some numbers. Its alternative name comes from the visitors, or cats, who came here to buy 'mouse' (stolen) goods. Cat Street became known as a red-light street, and that name has stuck, although since the 1920s it has been completely focused on antiques and curios, a spin-off from the nearby Hollywood Road. The man and woman in this photo, both equipped with cameras, are presumably tourists who have been drawn here to visit 'the best gift centre in the colony'.

RIGHT: This section of Lascar Row was renamed Lok Ku Road, as the shop sign here attests. The surrounding buildings have been heavily added to and remodelled, with air-conditioning units now sprouting from windows. Tung Street, the narrow ladder street on the left, has been opened up. When the c. 1970 photograph was taken many of these streets were being demolished and built over, or filled with temporary buildings. This one has been rescued and restored to use. This area is still popular for buying curios and antiques and is packed with small apartments, making it one of the most densely populated neighbourhoods of Hong Kong. The image below is of an adjacent ladder street, Tank Lane, which runs from Upper Lascar Row to U Lam Terrace.

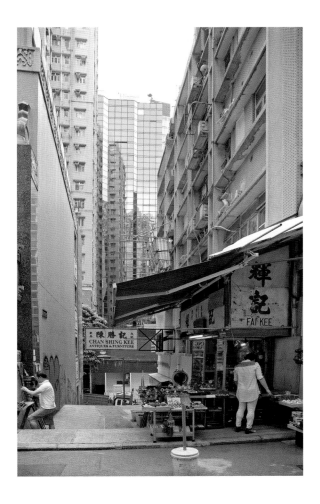

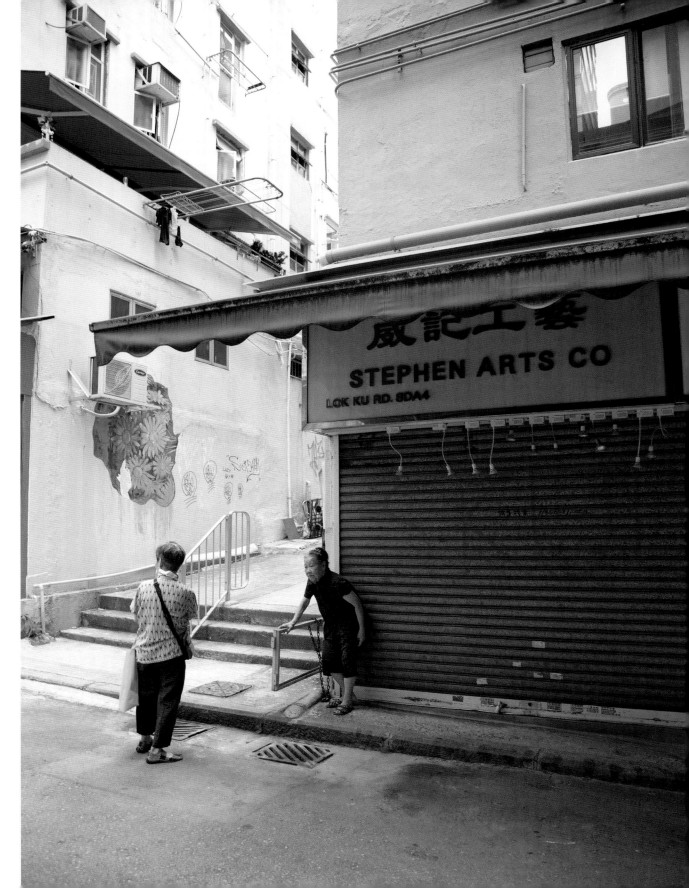

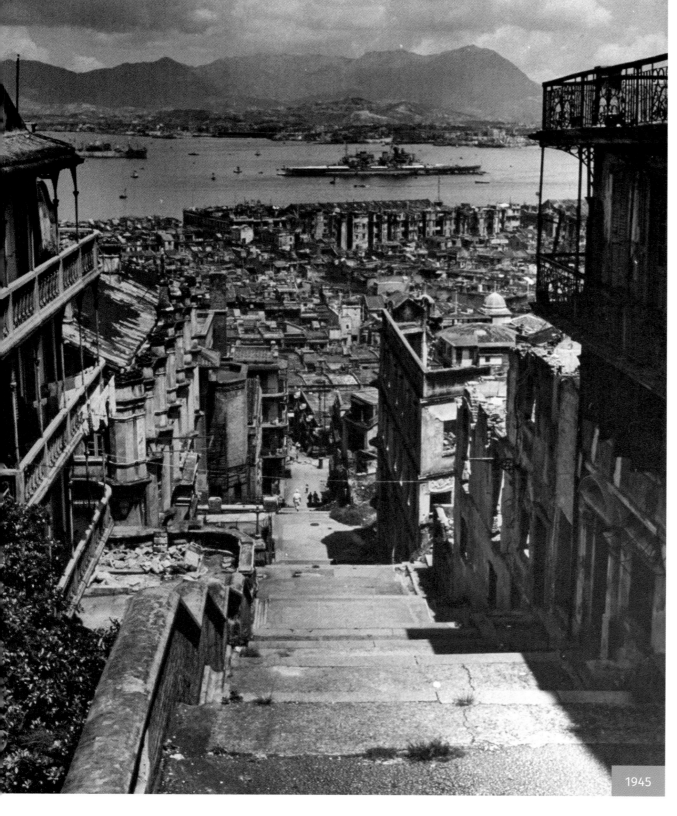

1945

LADDER STREET
Breathtaking vistas are now obscured by residential high-rises

LEFT: This view from the junction with Caine Road was taken on 1 September 1945. Seen here is Kowloon peninsular, the Victoria Harbour and the British battleship HMS *Duke of York*, a flagship of the British Pacific Fleet and in port to accept the surrender of the Japanese. Ladder streets were a direct way of connecting the main streets of Hong Kong, which run roughly parallel to the shoreline and are stacked above one another as they rise up towards the Peak (Victoria Peak). The aptly named Ladder Street, which links Queen's Road with Seymour Road on the Mid-Levels, is the only ladder street remaining built entirely of stone steps. Before the Peak Tram was built, Europeans were carried up via ladder streets to the Mid-Levels and even the Peak itself in sedan chairs (see below), which had been used for millennia in mainland China, a mountainous country, for transporting aristocrats, mandarins and precious goods.

1931

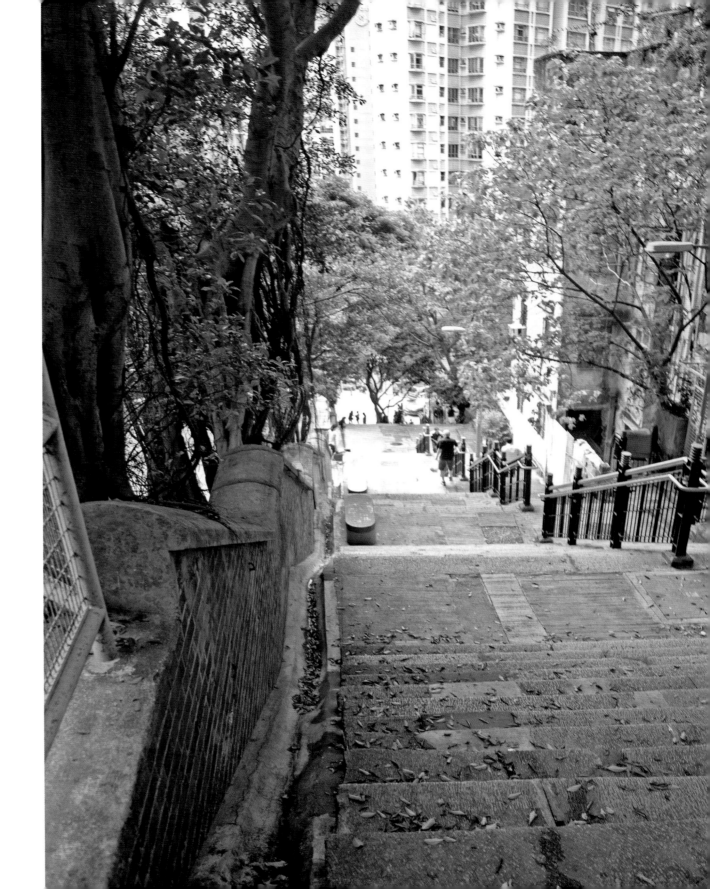

RIGHT: Ladder Street has been widened and the buildings on the right replaced. Trees have been introduced but the magnificent vista of the harbour and Kowloon has gone forever. Many streets in Hong Kong once enjoyed stunning views, but the growth of tower blocks in the last 30 years has shut in the streets, especially those in the Mid-Levels. This means that a major renting or selling point for an apartment in Hong Kong is an unimpeded view, usually and ironically in a building that has contributed to the very problem.

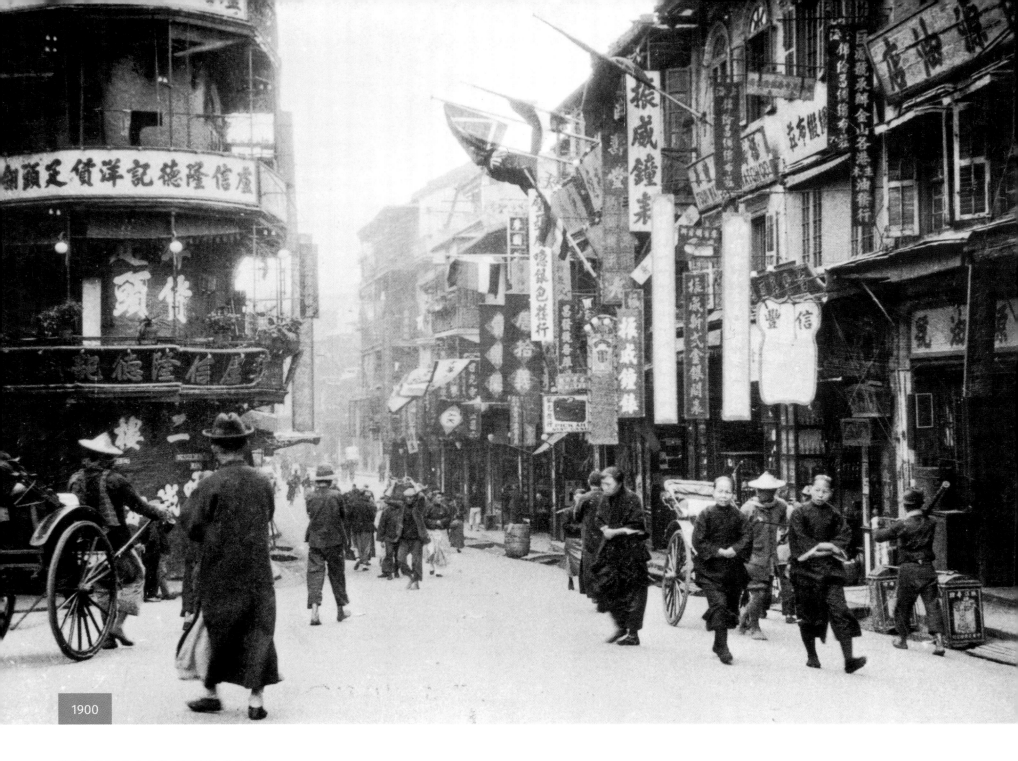

1900

BONHAM STRAND

A place where traditional Chinese businesses continue to thrive

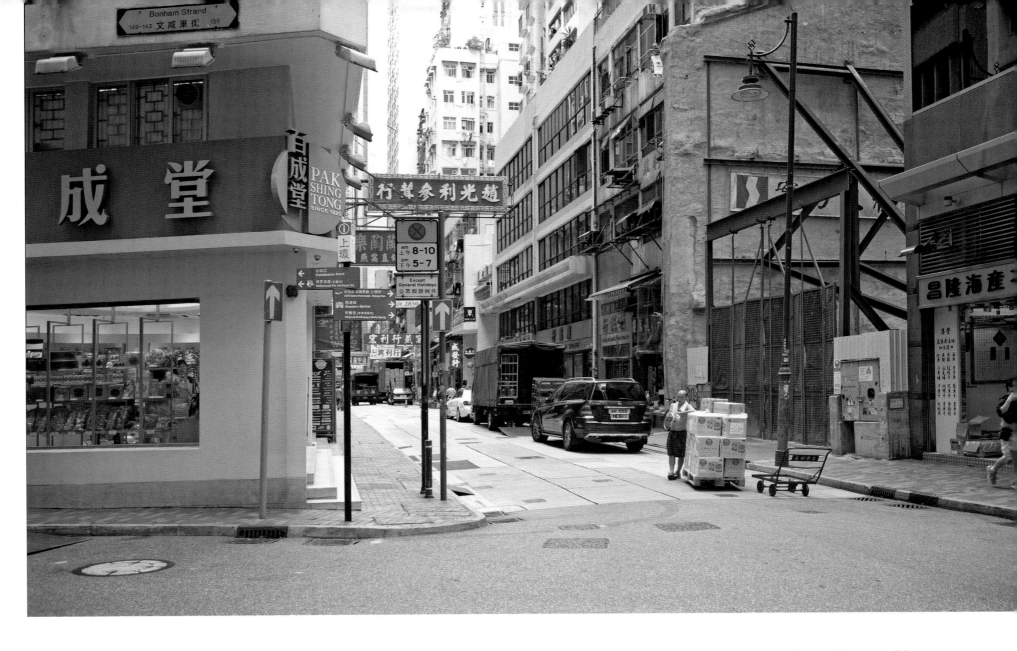

LEFT: Bonham Strand was named for Sir George Bonham, the third Governor of Hong Kong. As part of its name indicates, the seashore used to reach this point. Because the land rises to the left and the more densely compacted reclaimed land lies to the right, Bonham Strand was subject to flooding and still is. Chinese traders established themselves here in the 1840s and by the 1860s these importers and exporters had established their guild, the Nam Pak Hong. As seen here, shops specialising in traditional Chinese medicine line the road. A man pairs traditional Chinese dress with a homburg hat, while ahead of him another does the same but with a fedora. These dress styles help illustrate Hong Kong as a cultural hybrid with one foot in the east, the other the west. Even so, the traditional Chinese farmer's hat is still being worn.

ABOVE: Bonham Strand is still where one shops for traditional Chinese medicine, although the shops themselves have changed beyond recognition. Birds' nests and ginseng roots are particularly popular ingredients for, among other things, hangovers, impotence and postponing death for three days. The Pak Sing Tong shop on the left carries an impressive range of herbs while opposite are shops with spices of every conceivable type. Some of the larger ginseng traders have their offices on Bonham Strand and it is not uncommon to see newly arrived boxes of ginseng being sorted, chopped and prepared for sale.

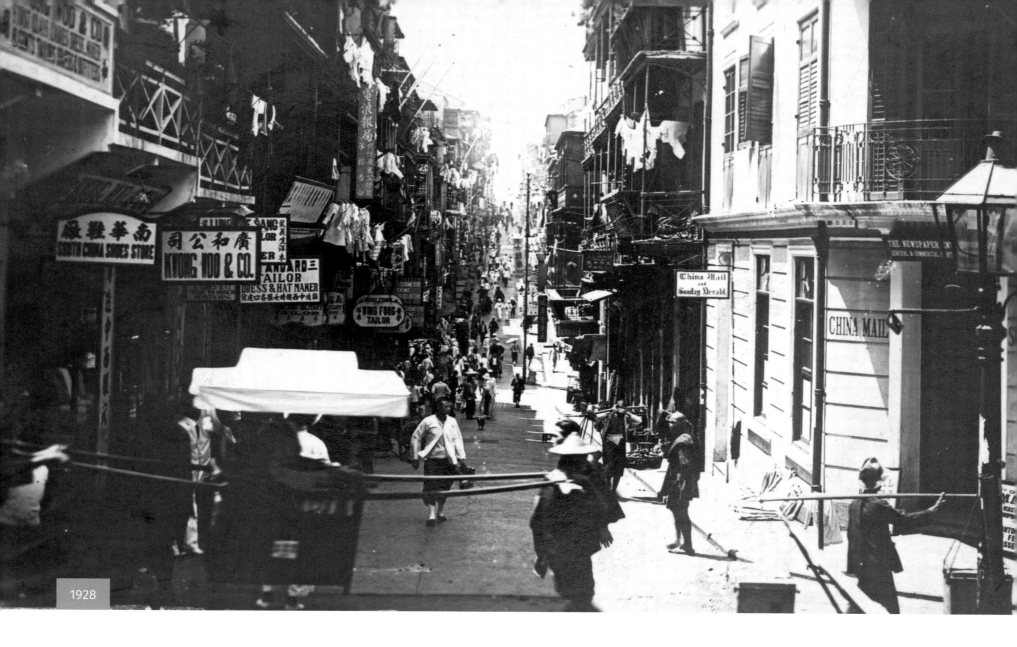

1928

WELLINGTON STREET

The straightest street in Hong Kong

ABOVE: Wellington Street, named after the victor of the Battle of Waterloo, is the straightest street in Hong Kong. It runs parallel to the foreshore, while to the right the ground rises towards the Peak. By 1901 there were 132 registered Japanese prostitutes operating in 13 licensed brothels in and around Wellington Street. In this photograph, taken on 18 August 1928, it is the more obvious activities we can see. A passenger in a sedan chair is being turned into the street while goods are being carried in boxes

suspended from a pole balanced on shoulders. This is a traditional Chinese method of porterage, eminently practical in a mountainous country. On the left are a row of men's tailors and shoe shops while on the right-hand corner are the offices of the *China Mail* and *Sunday Herald*. The precise date of the photo comes from the partially obscured newspaper hoarding. The *China Mail* was established in 1845 and closed in 1974, making it Hong Kong's longest-running newspaper.

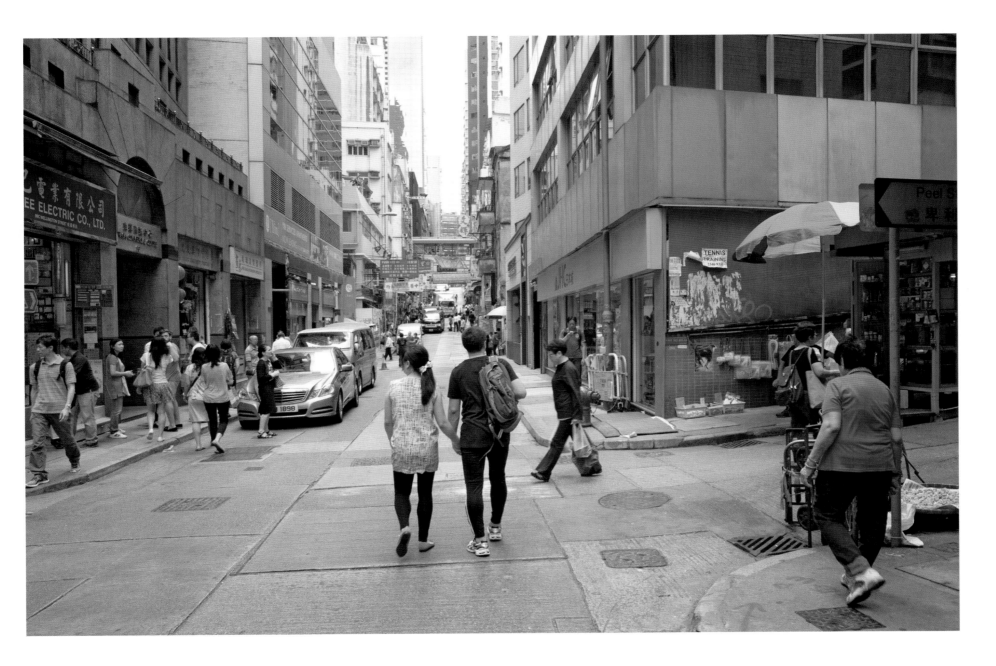

ABOVE: The buildings may have changed but life continues, albeit differently. Wellington Street is in the centre of the business district of Hong Kong and is particularly popular with the young because of its many shops, businesses, supermarkets and restaurants. Although Hong Kong was returned to Chinese administration in 1997, there is today a social freedom and a greater demonstration of equality between races and sexes, especially with the young. A Hong Kong couple walking hand in hand was a rare site, even 30 years ago. As in the old photograph, this view looks east, with Wellington Street swooping down and then up, yet remaining arrow-straight.

CENTRAL MARKET, QUEEN'S ROAD

The first road to be constructed in Hong Kong under British rule

1895

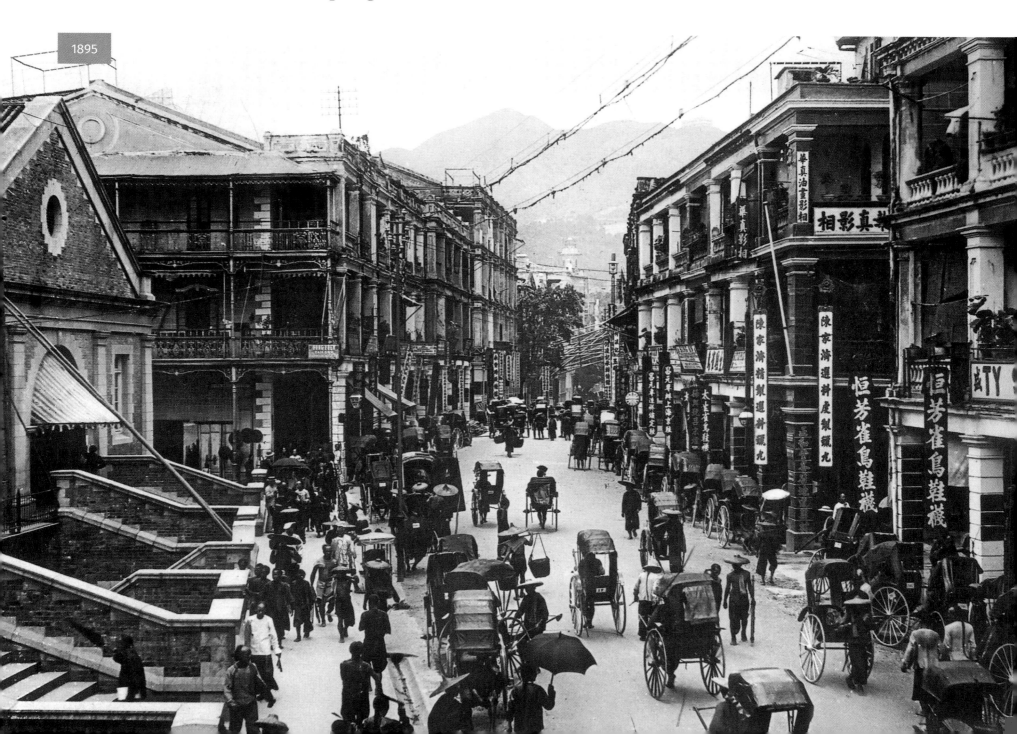

LEFT: In this 1895 photograph, Hong Kong's Central Market is to the left and Queen's Road is shown crowded with rickshaws. What is missing is anything horse-drawn, unusual in a city at this time. In Hong Kong, human-drawn was clearly cheaper and more suitable for some of its narrower streets. Queen's Road Central, constructed in 1841–43, was the first British-built street in Hong Kong and the most important in the colony. The road was constructed by the Royal Engineers with the help of 300 Chinese labourers from Kowloon, then a part of China. Queen's Road was first named Main Street when central Hong Kong was known as Queenstown. When Queenstown was changed to the City of Victoria, this street assumed its present name. The new colony's key buildings were erected here: the Governor's house, the Post Office, churches, clubs and the market. Only the market stayed. On Christmas Day 1878 a fire broke out which destroyed a large area of Queen's Road, making many of the buildings seen here less than 20 years old.

BELOW: It is difficult to believe that this is the same place. The 1895 market building was replaced in 1938 by a structure designed in the 'streamlined moderne' style. Some of this can be seen in the proportions of the window openings, although the glazing bars have probably been replaced as they are thicker than one would expect for this type of architecture. The door opening and the rounded corner appear authentic. In 1994 the Central Market building was joined to the other side of Queen's Road by a walkway, which joins escalators to the Mid-Levels. At the time of writing, the market is not used, although there are shops in the linking arcade. The building is now called Oasis, pending further development. This section of Queen's Road Central continues to generate large crowds with its department stores, banks and luxury brand shops dedicated to such things as eye-wateringly expensive wristwatches.

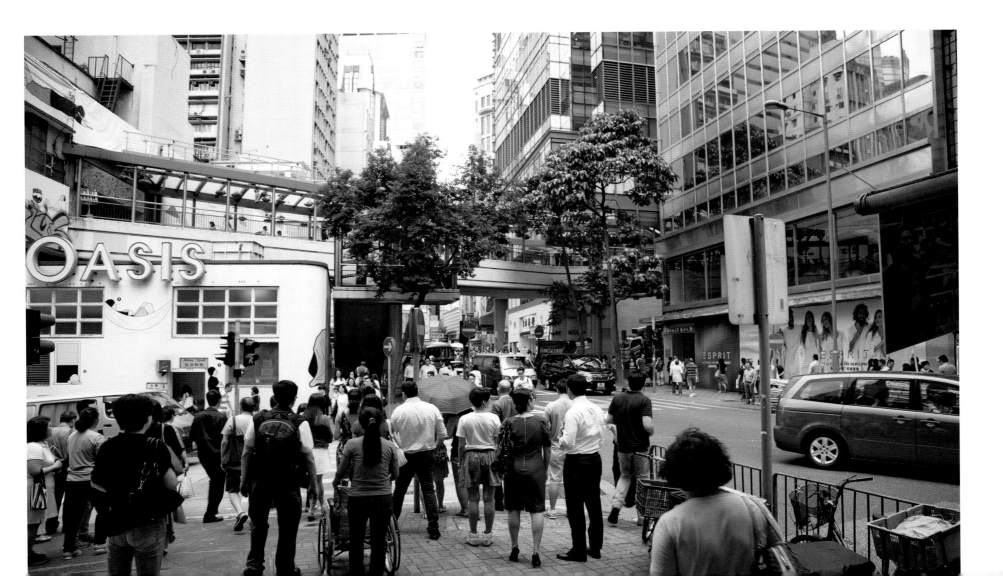

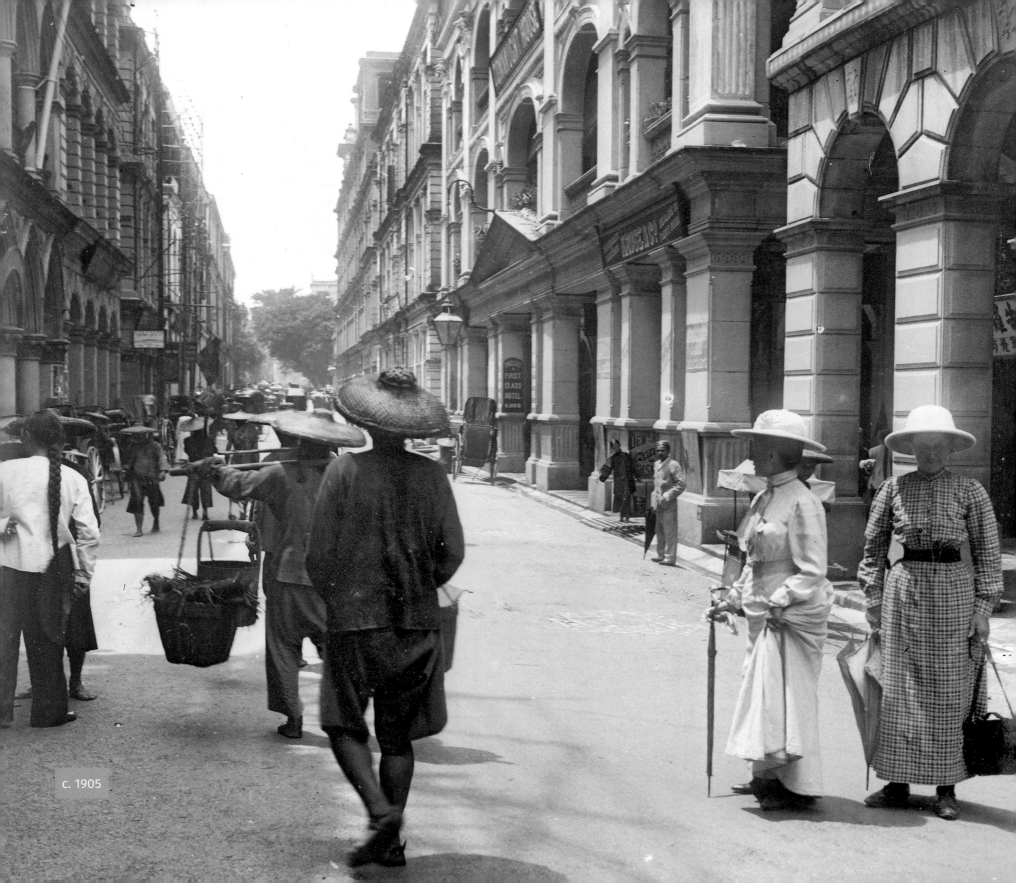

c. 1905

LEFT: Running from Wan Chai to Happy Valley, Queen's Road East is the longest straight section of Queen's Road. This is also the section that today lies furthest from the shore, although when it was built it actually ran along the shore. This photograph was taken in 1945, by which time the main thoroughfares of Johnston Road, Hennessy Road, Lockhart Road and Gloucester Road lay between Queen's Road East and the sea. Tramlines run along the full length of Queen's Road and in the centre of the roadway is a tram stop. The buildings lining Queen's Road east are uniform in their design, with arcading below and apartments with verandas above. Wan Chai Post Office, the oldest post office building in Hong Kong, is behind the photographer. Although only built in 1912, it would have been regarded as ancient, by Hong Kong standards, when this photo was taken. The Wan Chai foreshore was one of the few areas of Hong Kong already inhabited by the Chinese before the arrival of the British in 1841.

ABOVE: At first glance, there does not seem to be anything in common between these Then and Now photographs. But look carefully at the fawn-coloured building in the centre of the picture. It is the only section remaining of that range of uniform buildings lining either side of Queen's Road East in 1945. The top floor facing the roadway has been converted into an open veranda. The verandas below have been filled in and glazed. Windows at the side have been changed but the building's street arcading and pillars remain. It is a pity that the permanent arcading following the rest of Queen's Road East has disappeared. Even the dramatic view of mountains in the old photo is now obscured by high-rises stretching into the distance. What does remain is the old Wan Chai Post Office, which is now a listed building operated by the Environmental Protection Department as a resource centre.

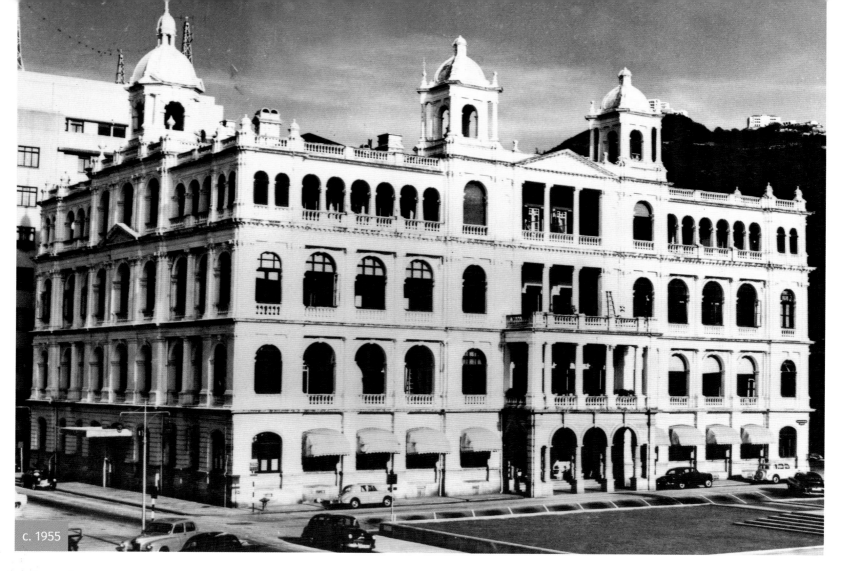

c. 1955

THE HONG KONG CLUB

Hong Kong's oldest and most exclusive club

ABOVE: Hong Kong's oldest and most exclusive club was established in 1846 by leading British businessmen and senior British government officials of the colony, to create 'a greater community of feeling among these classes'. This was where important issues facing Hong Kong could be discussed and decided over a drink or a meal. The building shown in this 1950s photograph was completed in 1897 on Jackson Road and was the club's third. One governor, Sir Cecil Clementi (1925–30) wanted it closed down unless it was prepared to take members of all races. There were no written rules banning non-

white gentlemen from membership; indeed, anyone 'suitable' could be proposed by a member, although no non-white gentleman had ever been elected. The first Chinese member joined in 1965 and women were not allowed in as guests until 1996, one year before Britain ceded control of its colony to China. The view of Statue Square on the right shows the monument to Queen Victoria in the foreground with the Cenotaph and the Hong Kong Club behind. The statue of Queen Victoria was moved to Victoria Park in 1952.

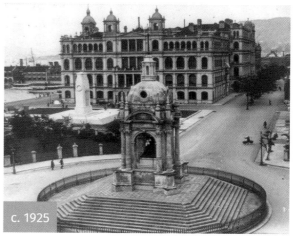

c. 1925

RIGHT: Still on Jackson Road, opposite the Cenotaph in Statue Square (shown below), the present Hong Kong Club building dates to 1984. There had been a long-running battle, in and outside the club, to retain the old building as it was considered the last Renaissance-style structure in Hong Kong, but the club's finances, and the building, were parlous. The building was demolished in 1981 and replaced by the present 21-storey building designed by Austrian-born Australian architect, Harry Seidler. The new building was constructed with the rental income of the 17 upper storeys going to the developers for 25 years while the four storeys below were occupied by the club. In 2009 the club took ownership of the whole building. Today several banks, finance houses, law and accounting firms rent the upper storeys, providing substantial income for the club. The Hong Kong Club now offers a choice of bars, restaurants, private dining and banqueting rooms, a library, a card room, two squash courts, a billiards room, a bowling alley, a fitness centre and a barber shop.

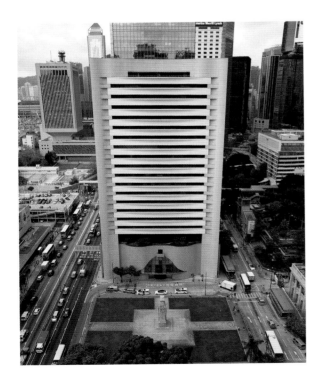

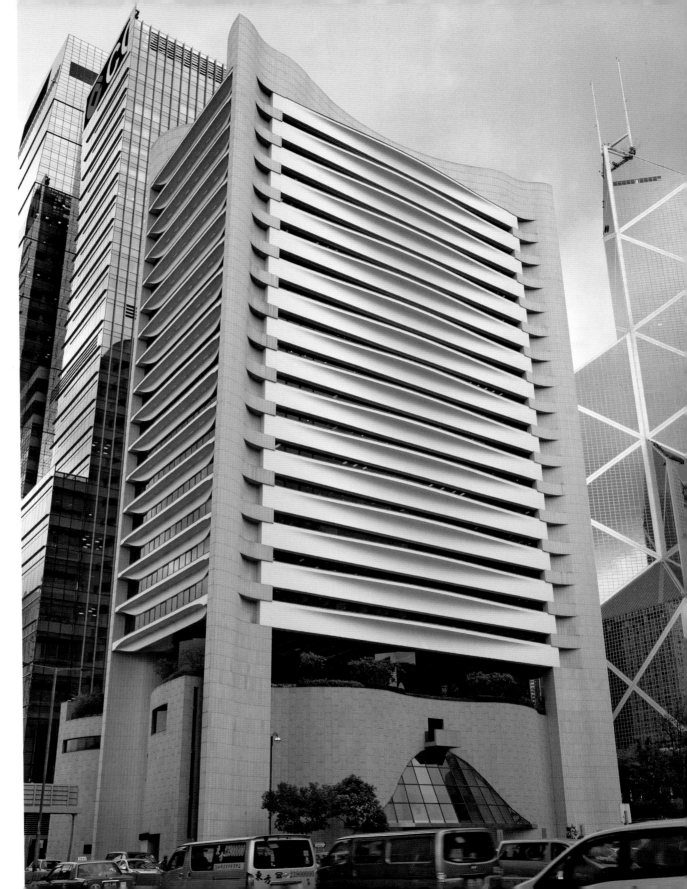

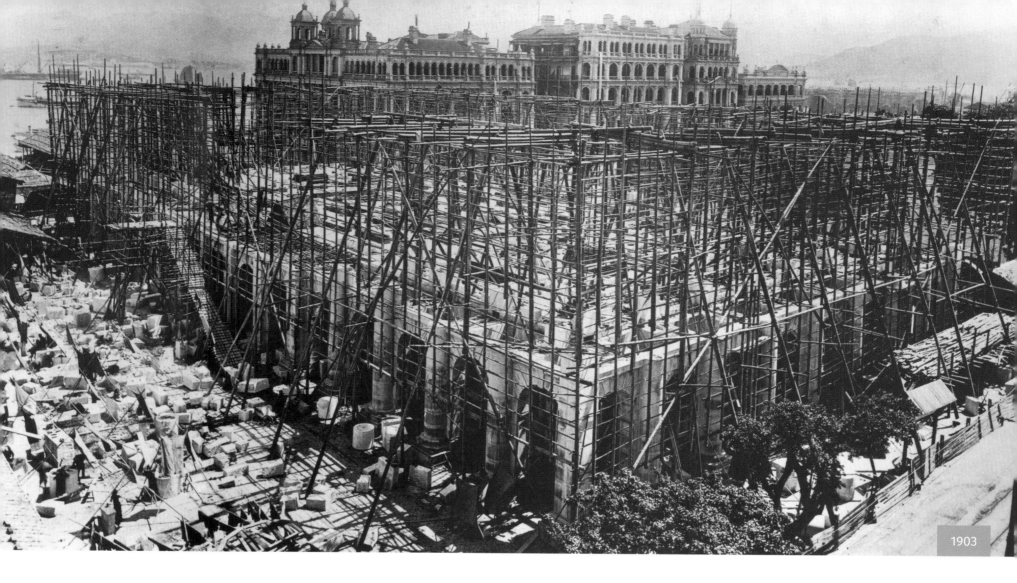

1903

SUPREME COURT BUILDING

Now surrounded by towering bank buildings

ABOVE: If the Hong Kong Club was the private face of colonial power in Hong Kong, the Supreme Court building was the one designed for public view. Here would be the majesty and authority of British imperial law. This photograph, looking towards the harbour, shows the Supreme Court being built in Statue Square in 1903. Wooden piles have been driven into what is recently reclaimed land to support the immense weight of the granite structure. Powerful water pumps were installed in the basement to stop the piles drying out

and the structure collapsing. The project, which started in 1900, was so extensive that it was not completed until late 1911. The architect was Sir Aston Webb, aided by Ingress Bell. They were also responsible for the main facades of London's Buckingham Palace and the Victoria and Albert Museum. Behind is the Hong Kong Club and trading houses, which lined the waterfront before further land reclamation altered the shoreline. The photo on the right shows the Supreme Court with the monument to Queen Victoria far right.

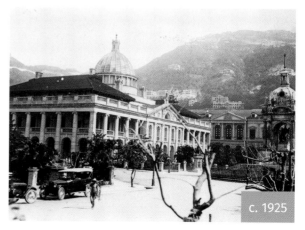

c. 1925

RIGHT: The Neoclassical-style Supreme Court features Ionic columns with a statue of Themis, the Greek goddess of law and justice, at the main entrance. This statue is similar to the one of Lady Justice outside London's Central Criminal Court, the Old Bailey. In World War II, this was the headquarters of the Kempeitai, the Japanese Military Police. In 1985, it became the Legislative Council, or LegCo, and from 2015 it has housed the Final Court of Appeal. Nearby are later arrivals. Immediately behind the dome in this inland-facing view is the Bank of China Tower. Opened in 1990, the architect was I.M. Pei. Opposite is its predecessor, the old Bank of China, by Palmer and Turner and opened in 1952. To the right is a glimpse of the headquarters of HSBC. Completed in 1985, the architects were Foster & Partners. These later buildings took into account the ancient Chinese philosophy of feng shui to orient and design them auspiciously; a process considered essential when building in China.

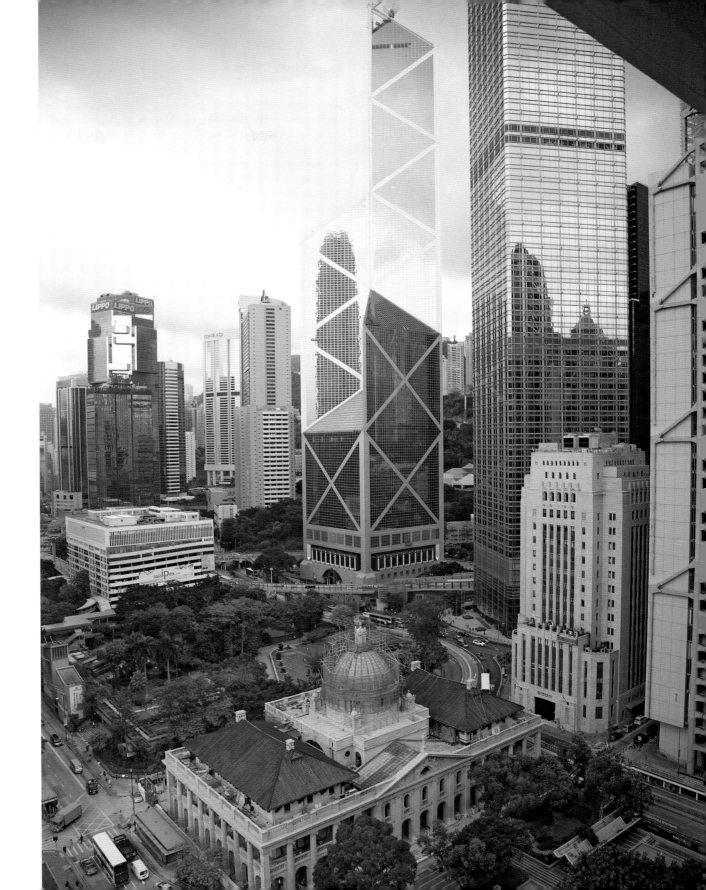

THE PRINCE'S BUILDING

Now home to one of Hong Kong's most exclusive shopping malls

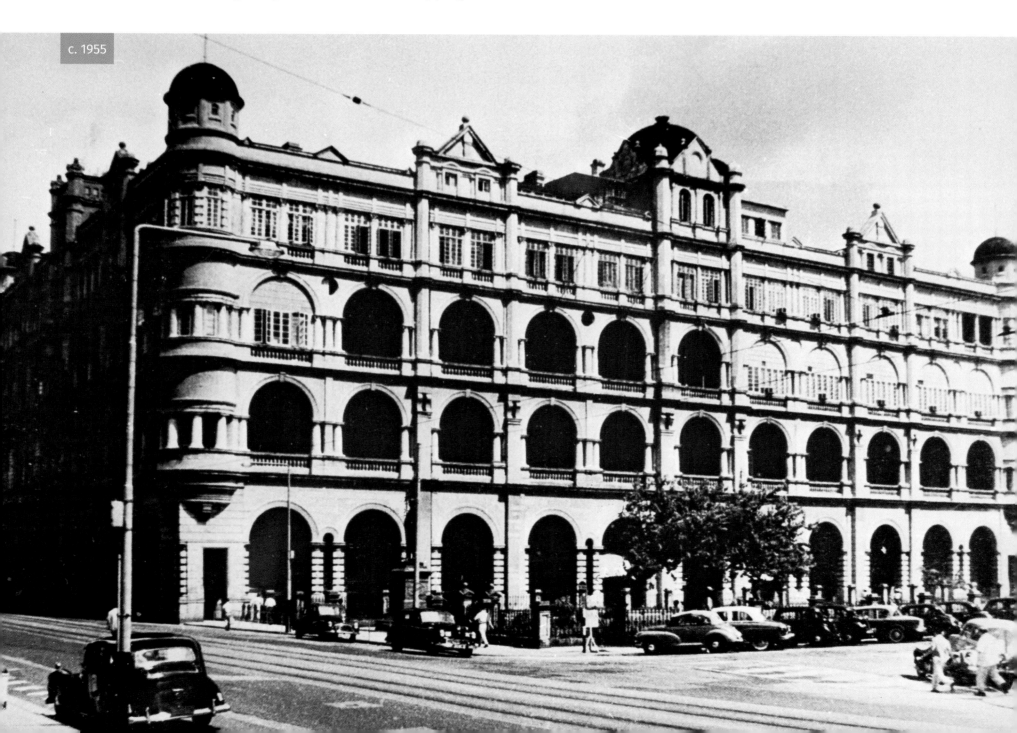

c. 1955

LEFT: This 1950s photograph shows the Prince's Building with British cars parked outside. Change the tropical clothes worn by passers-by, and the picture could have been taken in Glasgow or Leeds. The Prince's Building was erected in 1904 on reclaimed land on the western flank of Statue Square in Central. Similar in appearance to the old Hong Kong Club, it was built in a style that could be termed British Empire Renaissance. It was designed by Leigh & Orange, an architectural practice founded in Hong Kong in 1874 and still in operation. The Prince's Building housed the offices of banks such as Williams Deacon, the Yokohama Specie, the Bank of Taiwan, and Banque de l'Indochine. It also housed Johnson Stokes & Master, then the largest law practice in Asia.

RIGHT: The Prince's Building was demolished in 1963. Its replacement, which opened in 1965, stands on the same site. Next door (to the right) is the Mandarin Oriental Hotel, completed two years earlier. Hong Kong's first air-conditioned walkway was built linking the two. The Prince's Building has 29 storeys with major tenants such as KPMG and PricewaterhouseCoopers, but it is most famous for its designer mall, which set the benchmark for Hong Kong shopping. Keith Griffiths, chair of the practice Aedas, who were responsible for designing the mall, explained: 'If you go to the West, name brands are far more constrained. In the East, brands have complete sway with what they want to create. In designing a mall, entire sections of it become showcases for brands. Cartier, Van Arpels and Chanel fronts almost create a set of individual, terraced buildings.' Connecting designer malls with Michelin-starred restaurants, exclusive hotels, nail bars, hair salons and expensive watch outlets – the whole gamut of Hong Kong's top-end retail therapy started here.

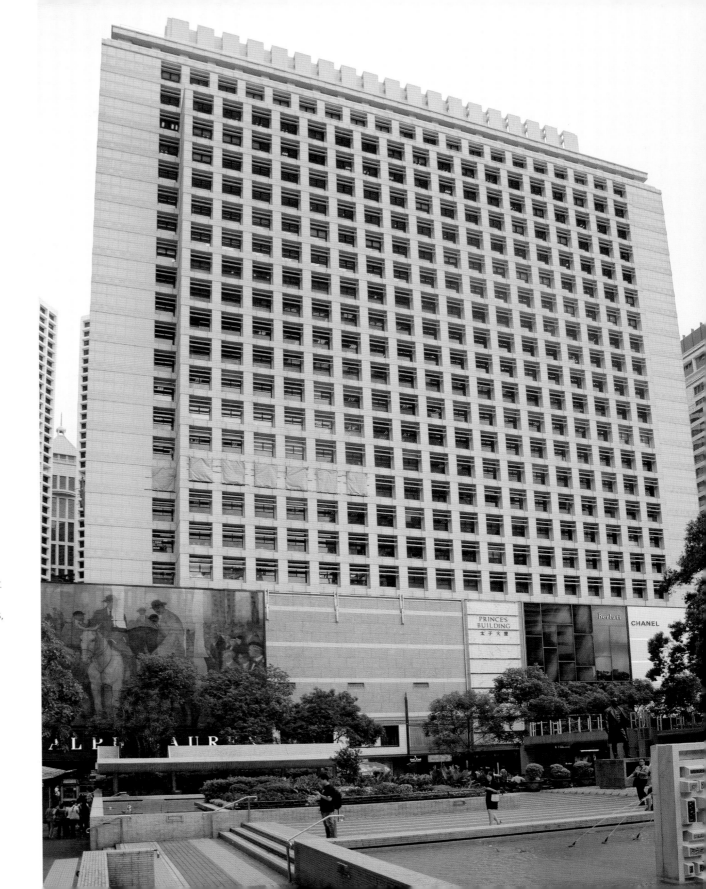

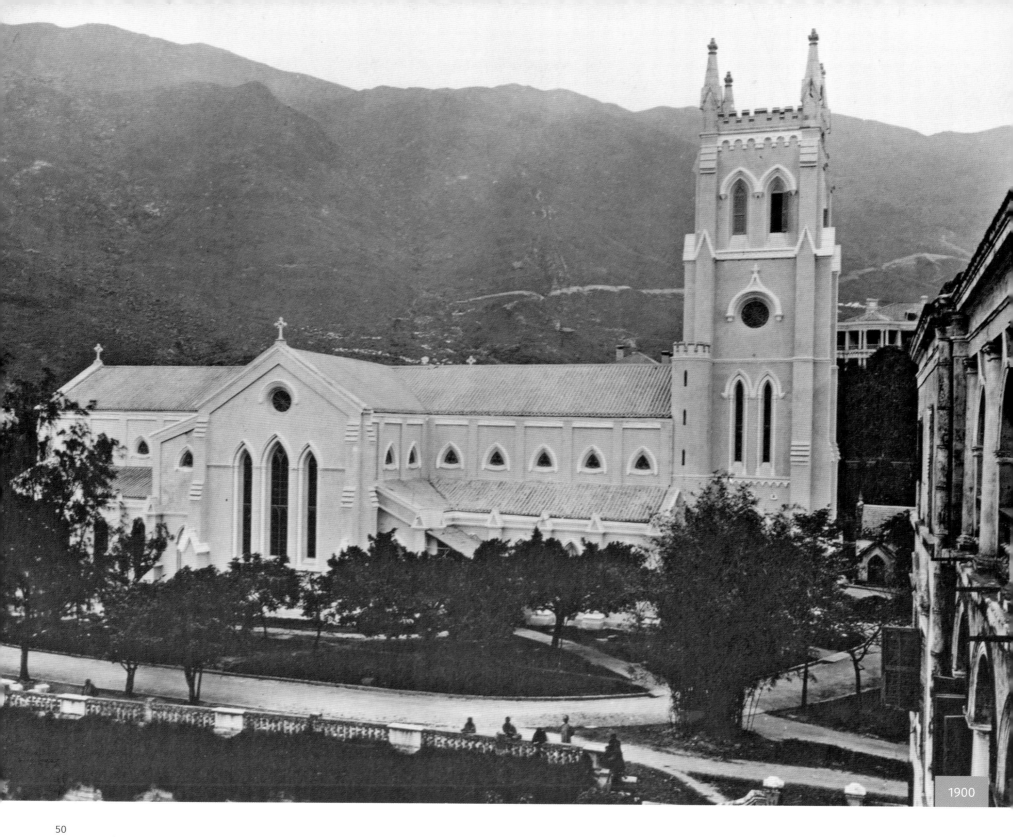

1900

ST. JOHN'S CATHEDRAL
The oldest Anglican church in East Asia

LEFT: Designed in the then-favoured style, a toned-down version of 13th-century English Decorated, St. John's is the oldest Anglican church in East Asia. The Cathedral Church of St. John the Evangelist, to give it its full title, was consecrated in 1849. In this photograph, taken in 1900, Hong Kong's mountains remain largely unoccupied. To the right is the French Mission building. Emblazoned on the west tower are the initials VR (Victoria Regina) in honour of Queen Victoria, Sovereign of the British Empire. The Hong Kong Club may have been the principal place where the colonial establishment played, but St. John's was where they prayed. The front pew on the south side was reserved for the Governor or visiting members of the British Royal Family.

RIGHT: The cathedral was used as a club by the Japanese during World War II and interior fittings were destroyed, including the stained glass. Much has been replaced. The west door is made from the timber of HMS *Tamar,* from which the headquarters of the Royal Navy in Hong Kong gained its name. Peter Kwong Kong-kit, the first Chinese bishop in Hong Kong, was enthroned in St. John's Cathedral in 1981. Traditional services are held with the *New English Hymnal* still in use, although 'Jazz Vespers' is also on offer. St. John's congregation includes a substantial Chinese and Filipino community with services in English, Mandarin and Filipino. There is a good bookshop selling cards and souvenirs as well as books. In this photograph, a wedding reception is about to begin in the cathedral's grounds; one of the few places in Central with a generous expanse of greenery. Freehold tenure has never been granted in Hong Kong, with the exception of St. John's.

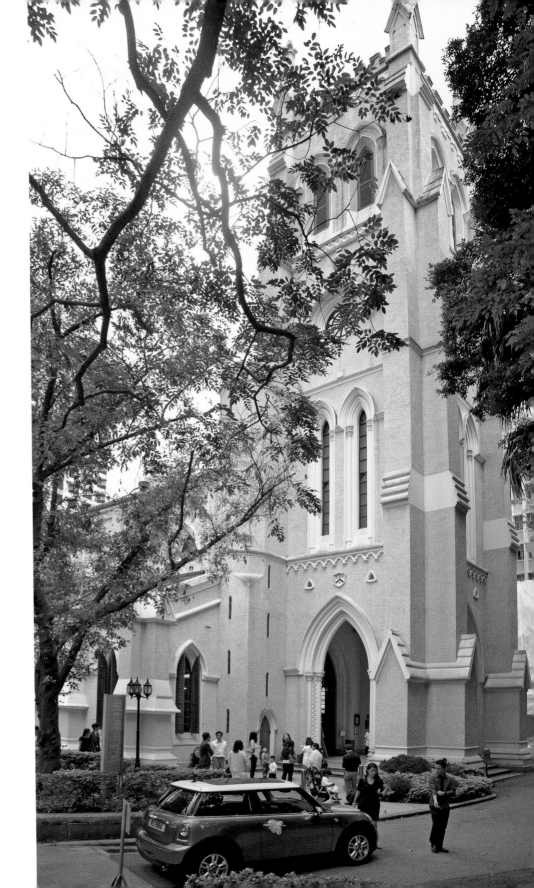

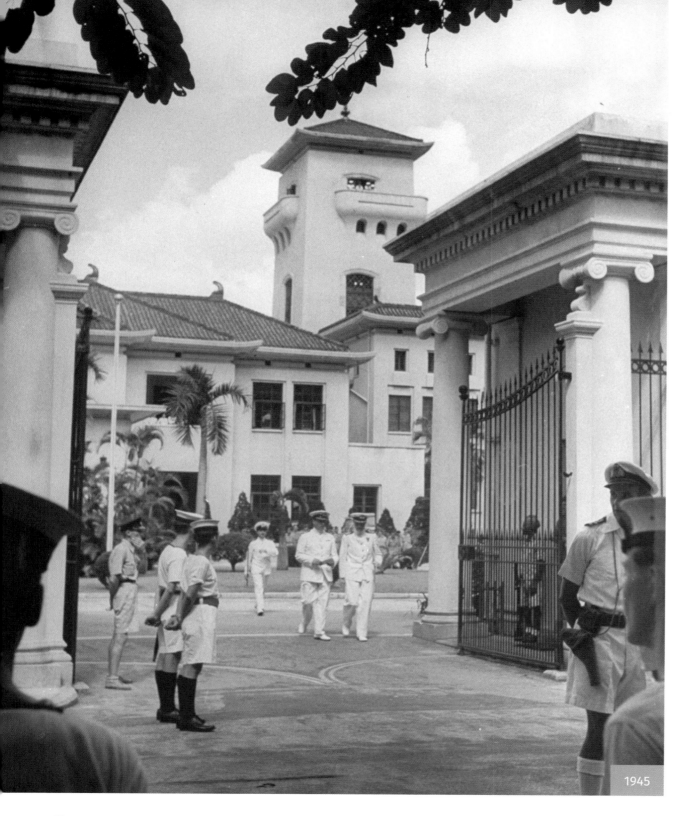

1945

GOVERNMENT HOUSE
The official residence of the Chief Executive of Hong Kong

LEFT: In this photo it is 1945 and Hong Kong has just been handed back to the British by the Japanese. The Governor (the representative of the British Crown in Hong Kong) has returned to Government House, his official residence since 1855. Senior officers from HMS *Duke of York*, the flagship of the British Pacific Fleet, stroll through the main gateway as Naval ratings stand to attention. A Japanese Military Governor occupied Government House from 1941 to 1945. It was partly remodelled in 1944 by Seichi Fujimura who added a tower and some roof embellishments. Charles St. George Cleverly's original 1850 design (shown below) now looks a cross between a European Neoclassical building and a Japanese one. To protect the Governor and to demonstrate power, the lodges either side of the main gates house armed guards supplied by whichever British Army contingent happens to be stationed in the colony.

c. 1870

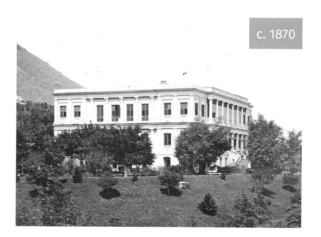

RIGHT AND BELOW: Government House became the official address of the Chief Executive of Hong Kong in 1997, although the first incumbent did not take up residence; some say because he did not like the feng shui, others that he did not wish to be associated with the building's former colonial role. The well-maintained gardens of Government House are now open to the public for a few days each year. The flag of Hong Kong as a Special Administrative Region of China flies in the photo below. Fujimura's tower still stands. A security barrier which rises up is set in the entrance drive. Behind, modern buildings arise. From left to right in the main photo are the Cheung Kong Centre (1999), the Bank of China Tower (1989) and the Citibank Tower (1992).

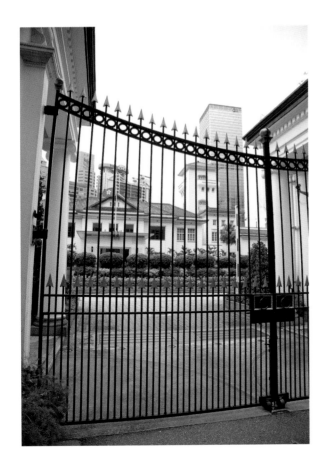

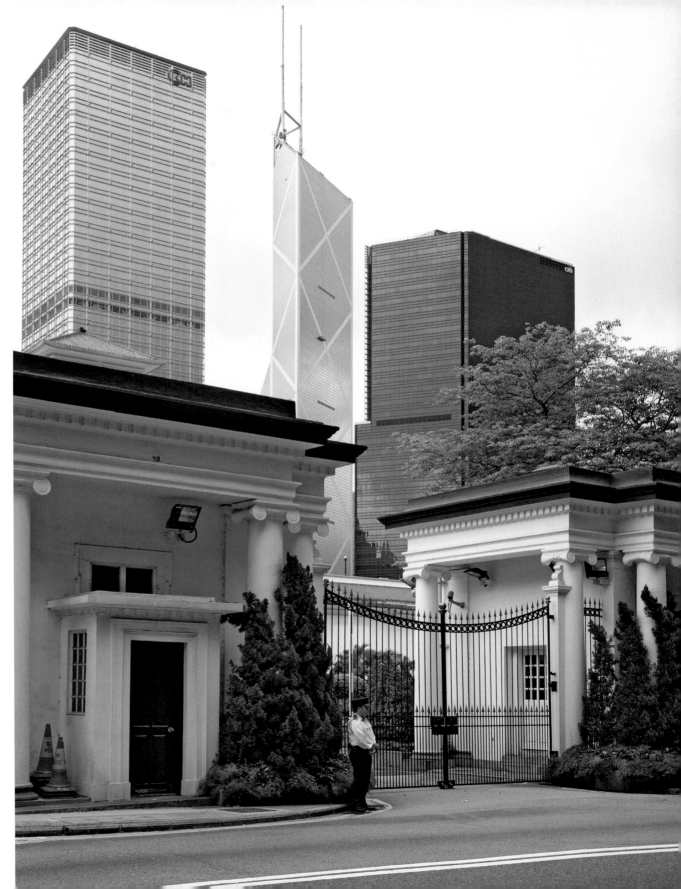

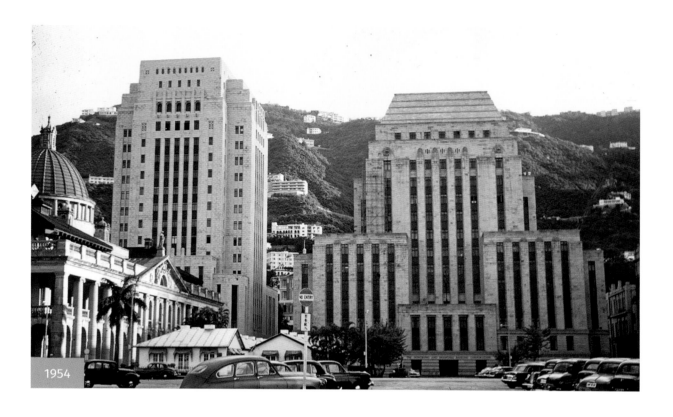

1954

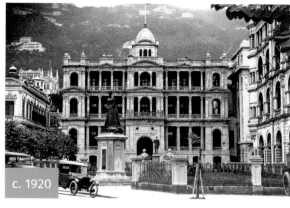

c. 1920

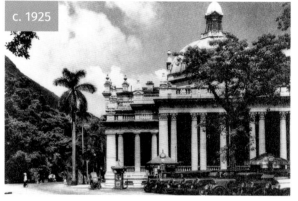

c. 1925

HSBC BUILDING

The present HSBC building is the fourth to be built on this site

ABOVE: Established on 3 May 1865 in Hong Kong by Sir Thomas Sutherland as the Hongkong and Shanghai Banking Company Limited, the first head office in Hong Kong stood on 1 Queen's Road Central overlooking what would become Statue Square. This first building lasted only 21 years before the bank decided to demolish it and replace it with an Italian Renaissance style palazzo in 1886 (top right). The back of the building (above right) followed a Neoclassical style with Corinthian pillars and a dome. The 1886 building managed to last 49 years. Although erected in the same vicinity as its predecessors, the 1935 building (above) took substantially more land, including some of the land the demolished Hong Kong City Hall had stood on. HSBC's famous bronze lions, named Stephen and Stitt, were commissioned to sit outside the main entrance and went on to feature on the Hong Kong dollar bill. This iteration of HSBC was a semi-Modernist building, with undecorated walls and a roofline, making it look from a distance a little like one of the huge war memorials built in the previous decade on the Western Front. In the picture above, the taller building on the left is the Bank of China (1951), with the Supreme Court (1912) far left. The 1936 building was the first in Hong Kong to boast air-conditioning. During World War II the Japanese requisitioned it as their government headquarters in Hong Kong.

RIGHT: By the late 1970s HSBC decided it needed a new headquarters. Designed by Norman Foster, the current HSBC became the world's most expensive building when it opened in 1985. The final cost reached HK$ 5,000 million (£375 million). Stephen and Stitt were again installed, with HSBC consulting feng shui experts on their correct location. This building is 180 metres (590 feet) high with 47 storeys and four basement levels. In 2006 the ground floor lobby was remodelled to provide greater security and a more prestigious entrance including a huge multi-plasma screen installation exhibiting the history of the bank. From 2011 to 2012 the plaza in front of the bank was taken over by Occupy Central, the Hong Kong branch of Occupy, an international protest movement which drew attention to social and economic inequality caused by the global financial system. HSBC is currently the fourth largest bank in the world. Its name follows the early convention of 'Hongkong'; hence HSBC rather than HKSBC.

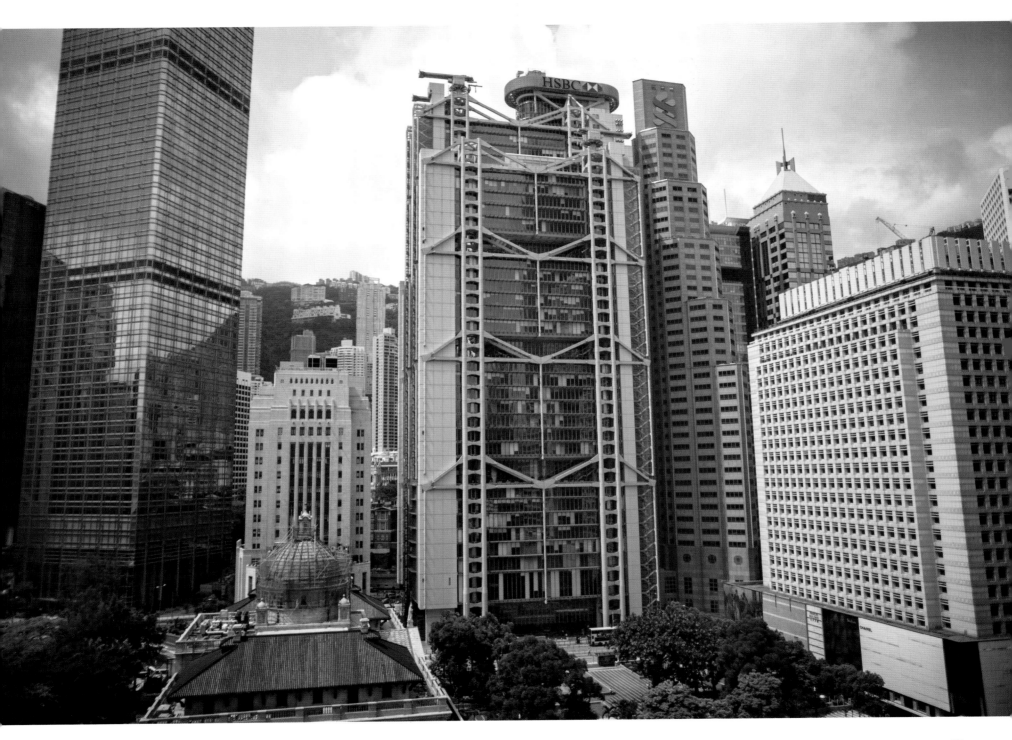

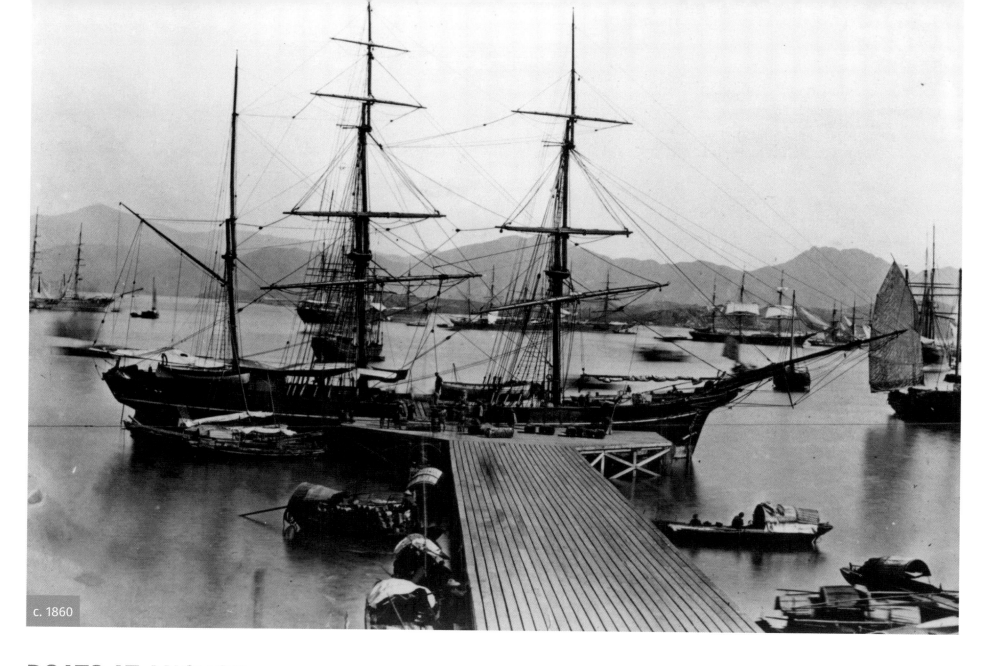

c. 1860

BOATS AT ANCHOR

Kowloon's skyline has been dramatically transformed since the 1860s

ABOVE: Before piers were constructed, wooden jetties were built projecting out into Victoria Harbour from Hong Kong Island. The number of ships at anchor in this photo is considerable, given that Hong Kong had only been established as a British colony for less than 20 years. There is a Chinese junk to the right. The long exposure, necessary at the time, is demonstrated by the flag fluttering on the stern of the ship in the foreground. What is also interesting about this photograph is the view of Kowloon on the other side of the harbour. In the year 1860, Kowloon was transferred in perpetuity from Imperial China to Great Britain. For years the British did not use it very much, other than for tiger hunts. It was regarded more as a way of securing both sides of the harbour.

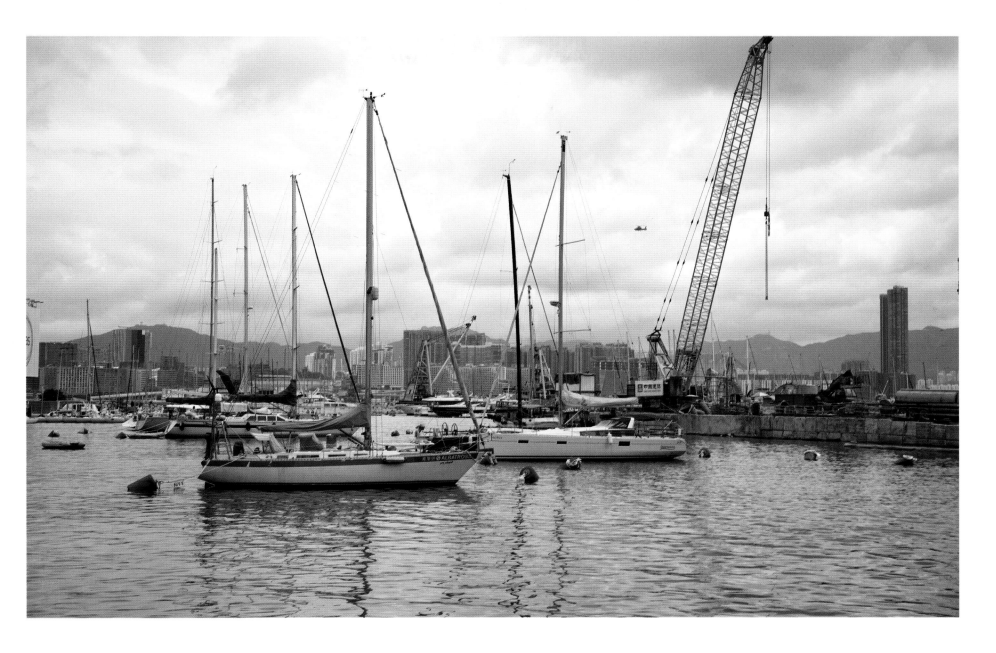

ABOVE: In Causeway Bay Typhoon Shelter, smart sailing yachts bob at anchor. The typhoons of the South China Sea have always been a major challenge for Hong Kong, making journeying impossible for boats and aircraft when they are in full flow. This is one of the reasons the Cross Harbour Tunnel was opened in 1972, linking Hong Kong Island with Kowloon and the mainland. It may be difficult to envisage, but the tunnel runs right under this scene. Having an exclusive shelter is a characteristic of Hong Kong, and not just for boats. Opposite and near the tunnel entrance is the Royal Hong Kong Yacht Club, which, despite the handover in 1997, kept its 'Royal'; unlike, for example, the Jockey Club and the Golf Club. Yet there is still only one club referred to simply as 'the Club' and that is the Hong Kong Club. To the right, land reclamation continues apace.

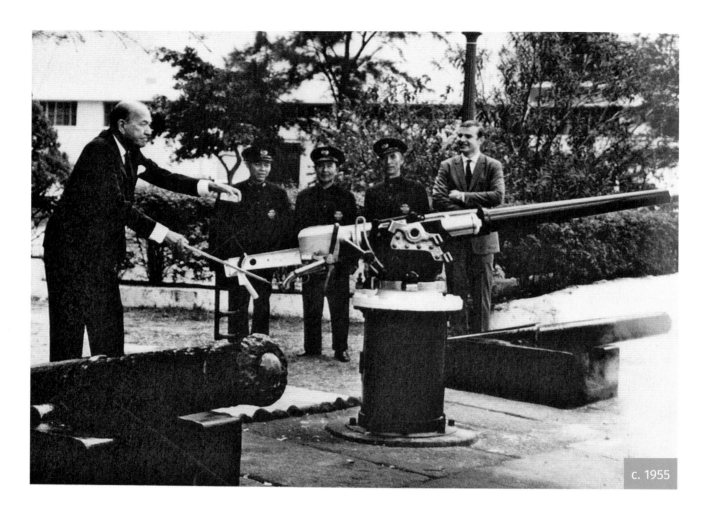

c. 1955

NOONDAY GUN

The firing of the Noonday Gun has become an essential spectacle for tourists

ABOVE: 'In Hong Kong/they strike a gong/and fire off a noonday gun/to reprimand each inmate/who's in late.' When Noel Coward wrote his ditty 'Mad Dogs and Englishmen', these lines celebrated a gun owned by Jardine Matheson, the oldest British trading house in China. Their godowns (warehouses) lay opposite where the gun now stands overlooking Causeway Bay. In the 1860s, Jardine Matheson's private militia would fire a salute every time one of their taipans arrived on the

dock, to the irritation of the Royal Navy who ruled that a salute could only be fired by them to announce the arrival of a member of the Royal Family, the Governor, or British and foreign admirals and generals. Jardines (as they are also known) were instructed to use their own gun solely as a timekeeper every day at noon and in perpetuity. In this photograph Noel Coward fires the gun, some time in the 1950s, attended by three of Jardines' guards and an amused director of the company.

RIGHT: The tradition of firing the Noonday Gun every day continues. New Year's Eve has been added. The tradition was only broken during the Japanese occupation of World War II when the gun was removed and lost. A new 6-pounder gun was supplied after the war. It was replaced in 1961 by a 3-pounder as residents of Causeway Bay complained that the gun was too loud. Photographing the Noonday Gun is a tourist essential, especially when it is being fired.

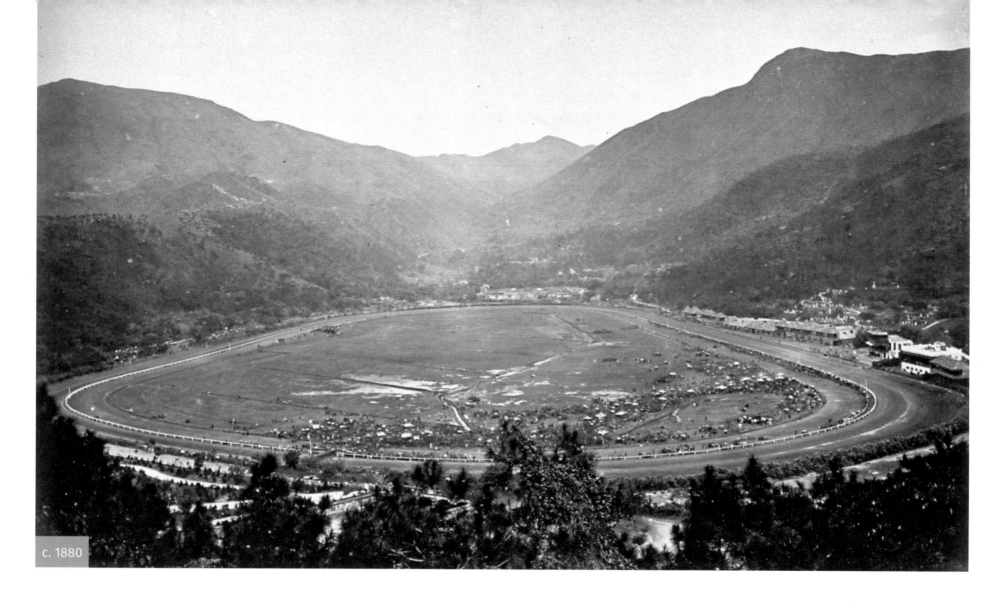

c. 1880

HAPPY VALLEY RACECOURSE

One of the world's most famous horse-racing tracks

ABOVE: In 1841 there were no large areas of flat land on Hong Kong, with one exception: a swampland used by the Chinese to grow rice. In 1845 the British evicted the rice-growers and installed one of their own staples – a racecourse. It wasn't presented entirely like that. There was a British military camp nearby and many soldiers were catching what was undoubtedly malaria from the swampy surroundings. So the paddy fields were drained and a racecourse built. In December 1846

the first horses galloped round the track. Happy Valley takes its name from the euphemism for a cemetery, of which there are many in the area, the first being for those unfortunate British soldiers. One of the stands collapsed during a race in 1918, knocking over food stalls and setting bamboo matting ablaze. At least 590 died in the fire. The main image shows Happy Valley Racecourse before the stands were built. The photo on the right shows a race day around 1910.

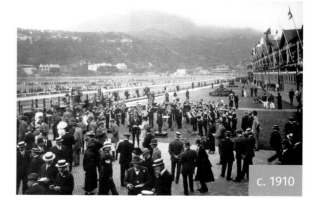

c. 1910

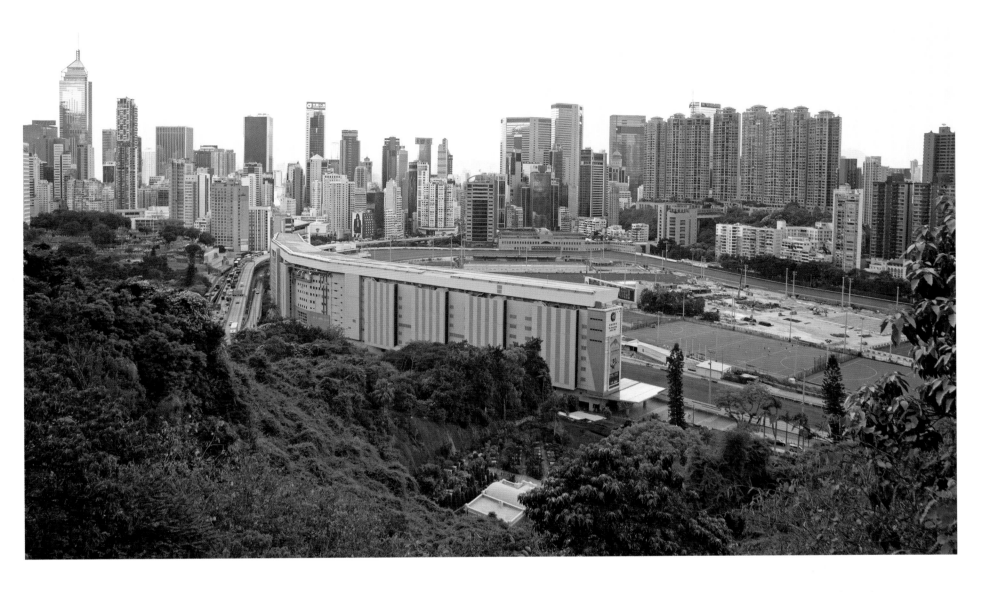

ABOVE: The racecourse's latest extensive rebuild was in 1995 and it now accommodates 55,000 spectators. Today it is one of the best and most famous racecourses in the world. The rebuild included a Hong Kong Jockey Club Archive and Museum, which has eight galleries describing, for example, where horses historically came from in mainland China and profiles of famous jockeys. Also on display is the skeleton of Silver Lining, the three-time Hong Kong Champion. The racecourse is owned by the Hong Kong Jockey Club and the museum explains the history of the club, which was founded in 1884 and is still one of Hong Kong's leading power clubs. The Jockey Club donates a percentage of the considerable profits accrued in betting on horses to worthwhile causes through its Charitable Trust, which is why Jockey Club schools, clinics and social centres can be seen throughout Hong Kong. The racing season runs from September to mid-June and race meetings are usually held on Wednesday evenings. The tall building on the far left is Central Plaza office block. Reaching 374 metres (1,227 feet), it was the tallest building in Asia when it was completed in 1992.

ZOOLOGICAL AND BOTANICAL GARDENS

Open to the public since 1864

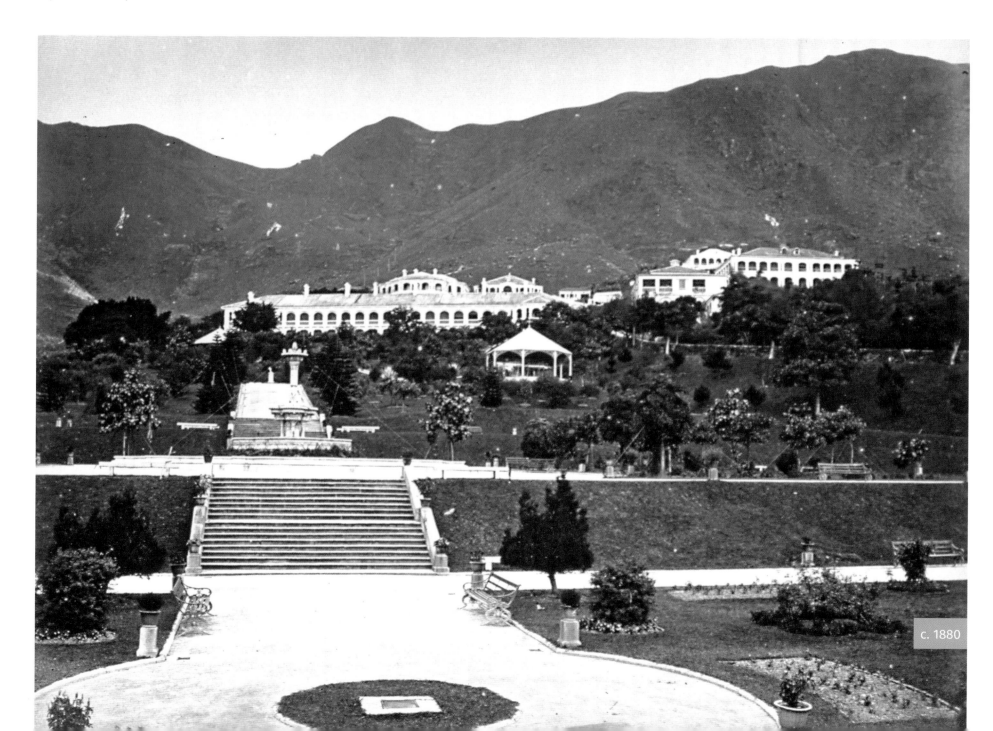

c. 1880

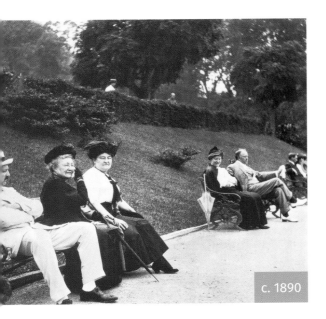

c. 1890

OPPOSITE AND LEFT: The gardens on the Mid-Levels were originally the private reserve of the Governor of Hong Kong and so were known by the Chinese as Bing Tau Fa Yuen or 'Head of the Soldiers'. An alternative explanation is that Bing Tau is a transliteration of Botanical. The Zoological and Botanical Gardens were first made available to the public in 1864. The extensive earthworks necessary to provide flat areas were largely completed by 1871. Broad terraces with fountains and bandstands were created, using wide steps to connect one terrace to another. Above the gardens on the exclusive Mid-Levels is an elegant residential building that would have offered splendid views of Victoria Harbour. The photo on the left shows Europeans enjoying a rest at the Botanical Gardens. At the top of the embankment is a man in a boater and a Chinese gardener; the only person in this photograph wearing clothes suitable for the climate of the South China Sea, rather than London's St. James's Park.

BELOW: The gardens are one of the oldest botanical centres in the world with over 1,000 species of tropical and sub-tropical trees and plants. These are now so extensive that it is not at first glance easy to discern the original layout, with trees filling the embankments between one terrace and the next. Nevertheless, although the gardens have been extensively remodelled in the intervening years, the original topography is largely still intact. Further up the terraces is the comprehensive zoological element, with many species of primates and reptiles, such as orangutans, lemurs, pythons, alligators and turtles. There are over 600 birds in the park, including flamingos and peacock pheasants. Rising above the gardens are the smart apartment buildings of the Mid-Levels. Admission to Hong Kong's Zoological and Botanical Gardens is free to everyone.

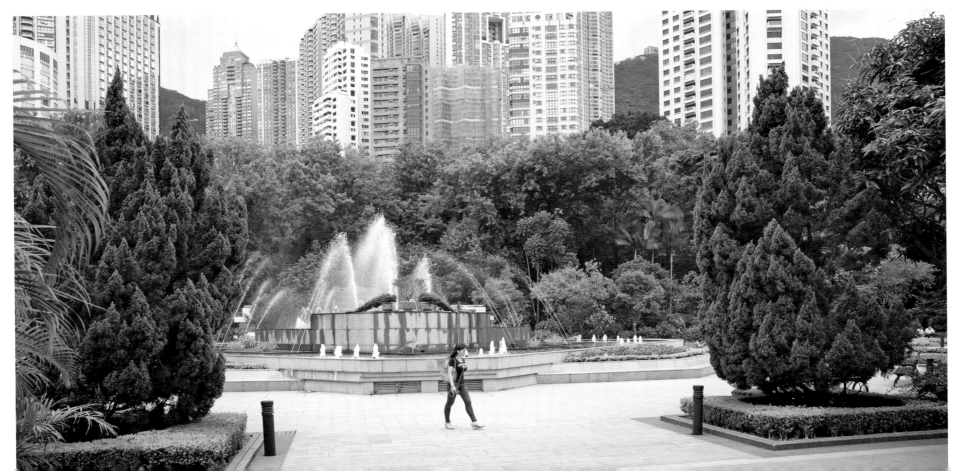

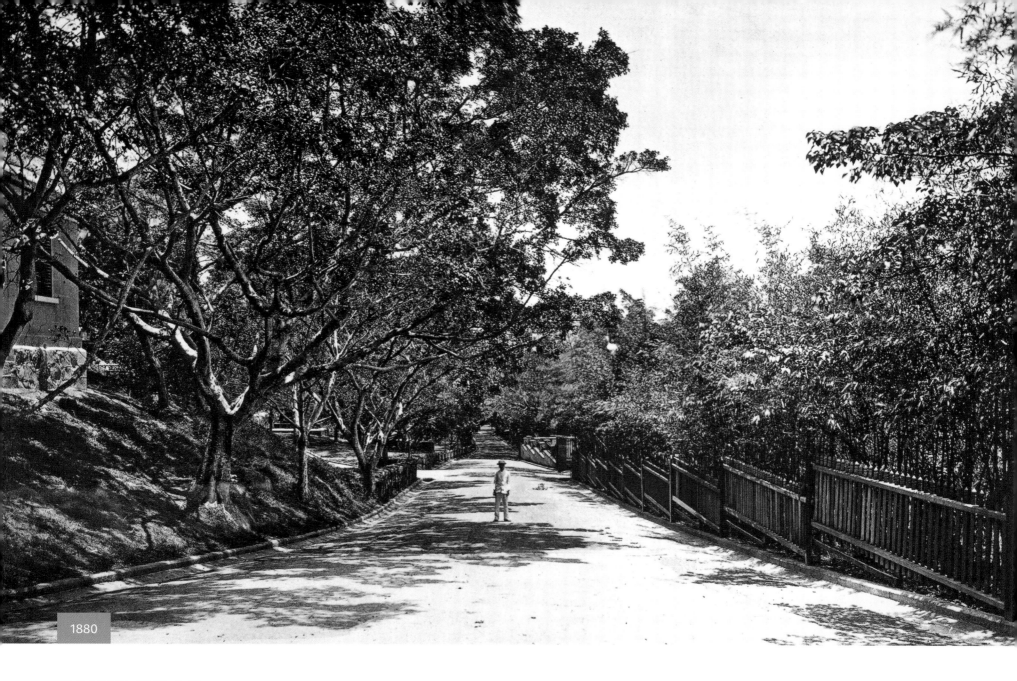

1880

CAINE ROAD

At the heart of the affluent Mid-Levels

ABOVE: Caine Road runs on the Mid-Levels from Upper Albert Road and Government House in the east to Bonham Road in the west, which is the direction of this 1880 photograph. The road was named after William Caine, a British Colonial Secretary and acting Governor of the colony from May to September 1859. In 1880, Caine Road was just starting to be developed for residential use. For the young, ambitious colonial, this was the place to live. It was below the Peak (up to the left) yet above the busy foreshore roads (down to the right). Thus personal elevation was demonstrated in more ways than one.

ABOVE: This photograph was taken just beyond the position where the man in the 1880 photograph was standing. The land to the left has been embanked, while to the right, high-rises crowd the scene. On Caine Road is the Roman Catholic Cathedral of the Immaculate Conception. It opened in 1888 after its predecessor on Wellington Street was destroyed by fire. Also on Caine Road is the Dr Sun Yat-sen Museum, which charts the career of the founder of post-imperial China. Sun Yat-sen (1866–1925) attended secondary school and university in Hong Kong and his museum is housed in Kom Tong Hall, built in 1914 for the prominent Ho family, the first Chinese permitted to live on the Mid-Levels. Caine Road and its connecting streets are still popular with affluent expats, especially those with young families, for there are good schools and other supportive facilities in the immediate area.

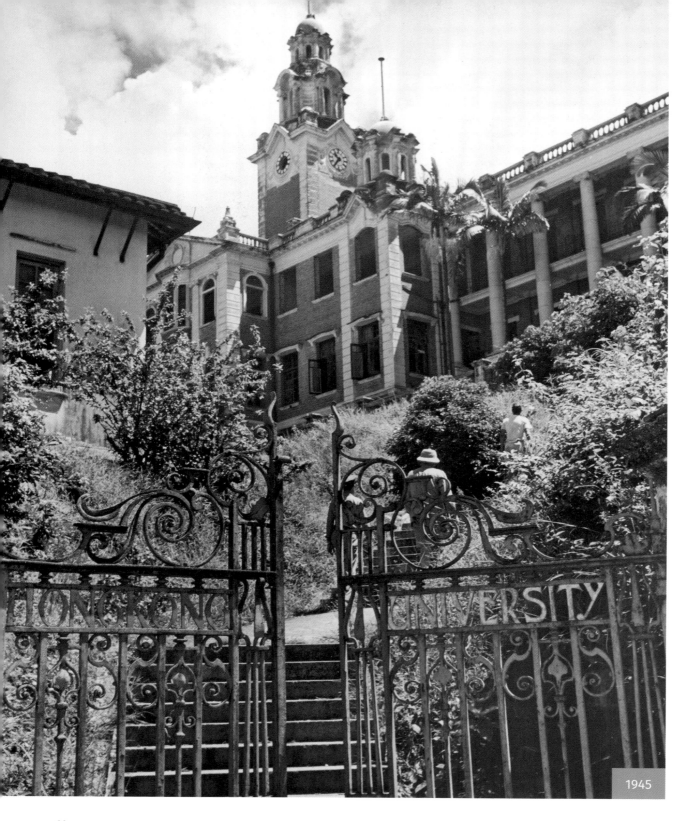

1945

UNIVERSITY OF HONG KONG
The oldest higher education institution in Hong Kong

LEFT: Founded in 1911, HKU (as it is often abbreviated) is the oldest higher education institution in Hong Kong. Seen here in 1945 is the Main Building of the university, which had only just reopened, having been closed by the Japanese occupiers of Hong Kong during World War II. The Main Building was designed by the leading architectural practice Leigh & Orange, founded in Hong Kong in 1874 and still operating. Built in red-brick and granite in a post-Renaissance style between 1910 and 1912, it was funded by Sir Hormusjee Naorojee Mody, a Parsi businessman, while the clock tower and turrets were gifted by Sir Paul Chater, a British businessman of Armenian descent, in the then colony. The photo below shows the Main Building shortly after completion.

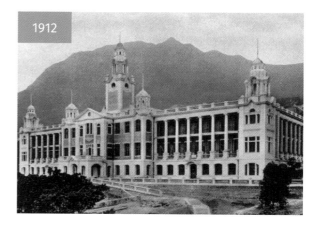

1912

RIGHT: The University of Hong Kong has grown enormously and today it has around 30,000 students and 7,000 academic and support staff. Several student halls of residence were funded by the Jockey Club of Hong Kong. HKU ranks as one of the top three universities in Asia. The language of tuition is English. In recent years the medical faculty isolated the coronavirus, the agent responsible for the SARS epidemic. HKU's teaching hospital is the Queen Mary Hospital, further down Pok Fu Lam Road. The Main Building, which is in an immaculate state of repair, is still discernible, although it is now surrounded by campus buildings and an overpass with busy Bonham Road and Pok Fu Lam Road cramming in close to its entrance.

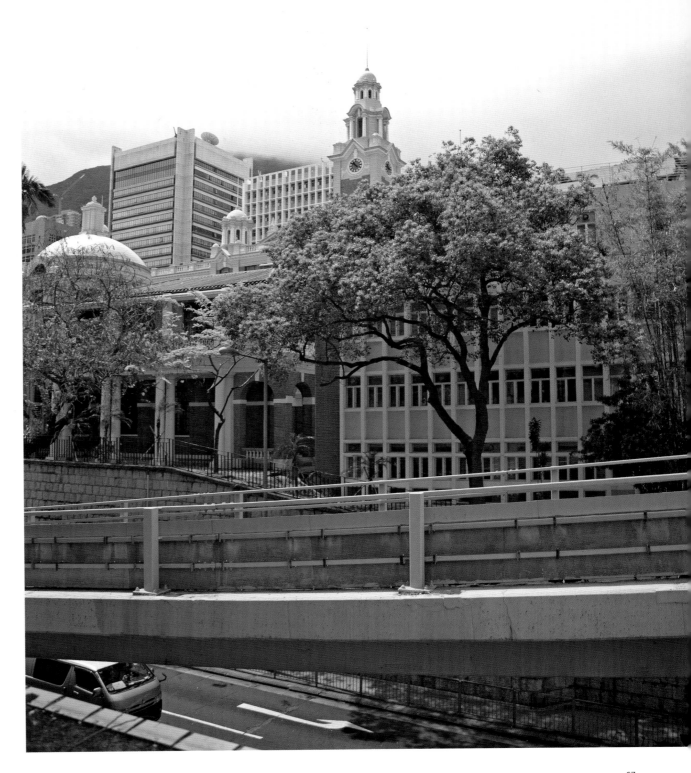

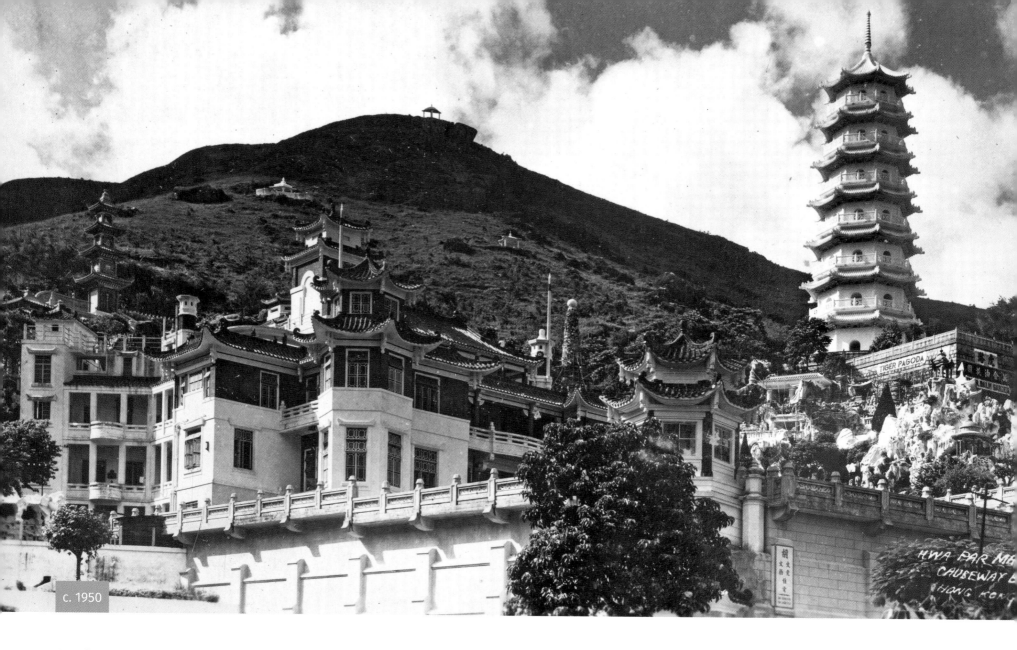

c. 1950

TIGER BALM GARDEN

The garden and its iconic pagoda were sold for redevelopment

ABOVE: Also known as the Aw Boon Haw Garden, the Tiger Balm Garden on Tai Hang Road, near Causeway Bay, was built in 1935 as part of the Haw Par Mansion estate, which was opened to the public in the 1950s. The garden was named after Tiger Balm, a brand of heat rub introduced in 1871 by an ancestor of the Aw Boon Haw family, the builders of the mansion and the garden. In this image, the seven-storey pagoda, once a landmark of Hong Kong, overlooks the garden from where this photograph was taken. The garden was intended to be a place for recreation and it contained many statues and dioramas depicting stories from Chinese folklore, especially Confucianist tales. Later, rides replaced these attractions, with the gardens becoming the first amusement park in Hong Kong. These were replaced in more recent times and the statues and dioramas were reintroduced.

RIGHT AND BELOW: The Tiger Balm Garden was sold for redevelopment in the late 1990s. The garden and its distinctive pagoda were demolished in the mid-2000s to make way for luxury housing. At present what is left of the gardens is a dumping ground and a place of refuge for some of Hong Kong's homeless. The tall apartment buildings that have spring up on part of the former gardens, and which dominate this view, are known as 'the Legend', one of Hong Kong's more exclusive residential developments. The entrance to the Haw Par Mansion is shown in the photo below. The mansion has been preserved but is not open to the public. It was awarded Grade I status by the Hong Kong Government in 2009.

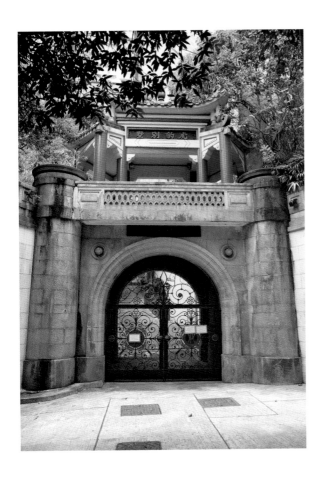

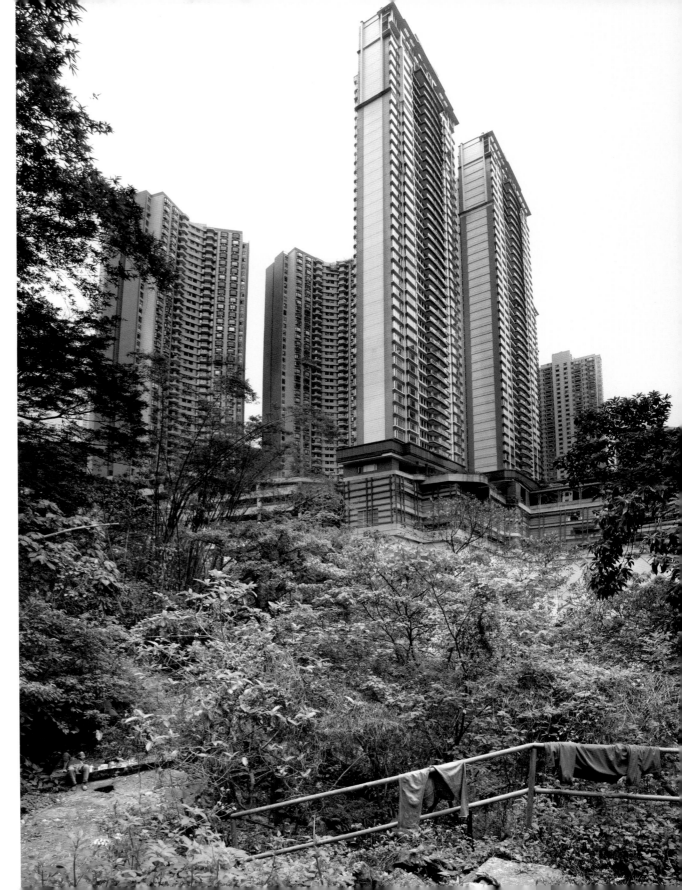

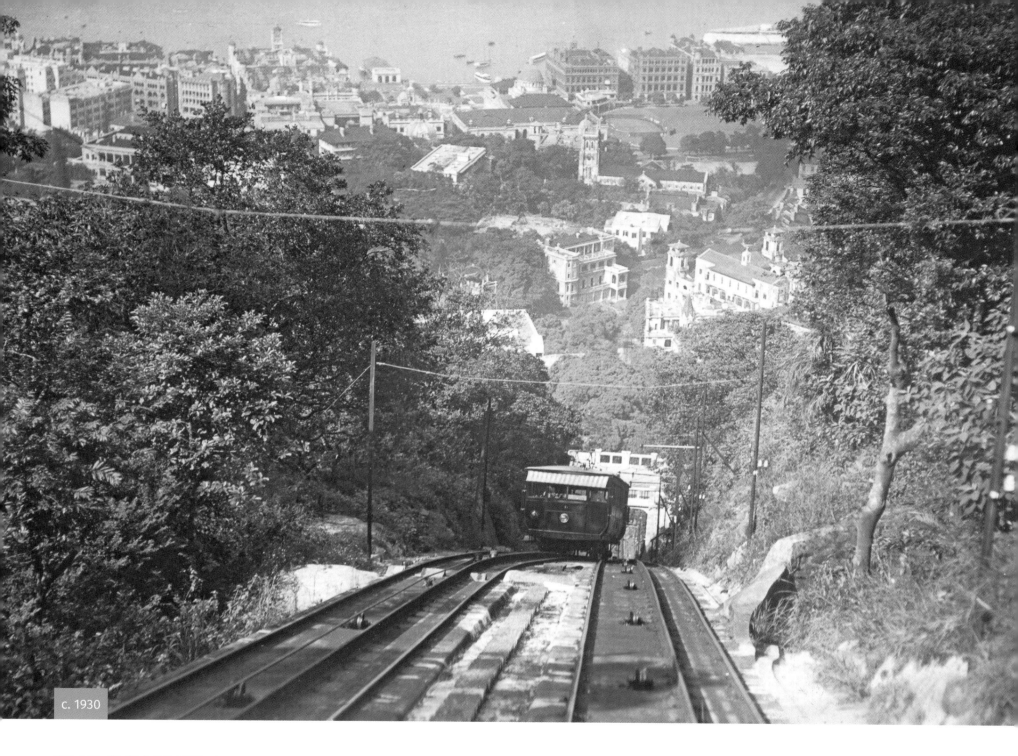

c. 1930

THE PEAK TRAM

Transporting locals and tourists to Victoria Peak since 1888

LEFT: This view from the Peak shows Hong Kong before the post-World War II high-rise building boom. The Peak Tram was an engineering marvel of its day. It was opened in 1888, running from St. John's Cathedral (shown top centre here) to Victoria Peak. It took three years to build and was the first mountain funicular in Asia. The rails and machinery were hauled up the Peak by hand. The funicular finished off the sedan chair and made possible the development of the Peak and the Mid-Levels, which became popular places for the affluent to live, for stations were provided en route. At first, only white residents of the Peak were allowed on the tram. In 1926, three classes of travel were introduced: First (British officials and residents of the Peak); Second (British military and Hong Kong Police officers); Third (other people and animals). In which class the Governor's dog rode, we can but guess.

RIGHT: Today over 11,000 people ride the Peak Tram daily. It is used by many tourists, mostly during the daytime, and by commuters in the morning and the evening rush hours. The highest station is located in Peak Tower, from where this photograph was taken. Due to its shape, Peak Tower is known to Hong Kongers as the Flying Wok. It and the Peak Galleria opposite provide splendid views of Hong Kong harbour, as well as extensive shopping opportunities. The 1.4 kilometre (0.87 mile) tram ride reaches a height of 400 metres (1,312 feet), but the view of the harbour is now glimpsed through high-rises. There is some compensation though – the exciting, if for some disconcerting, experience of travelling past and above skyscrapers.

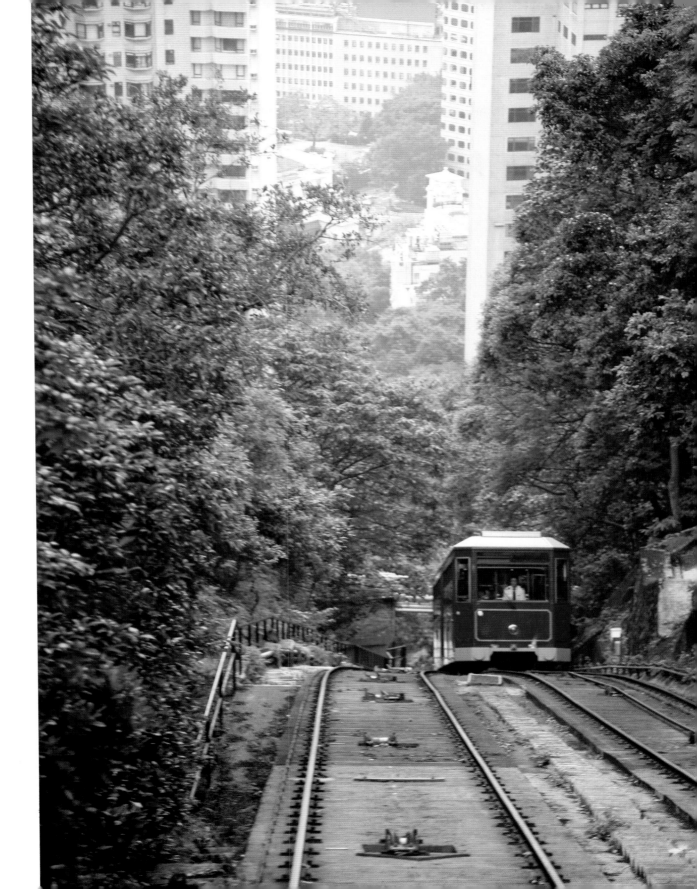

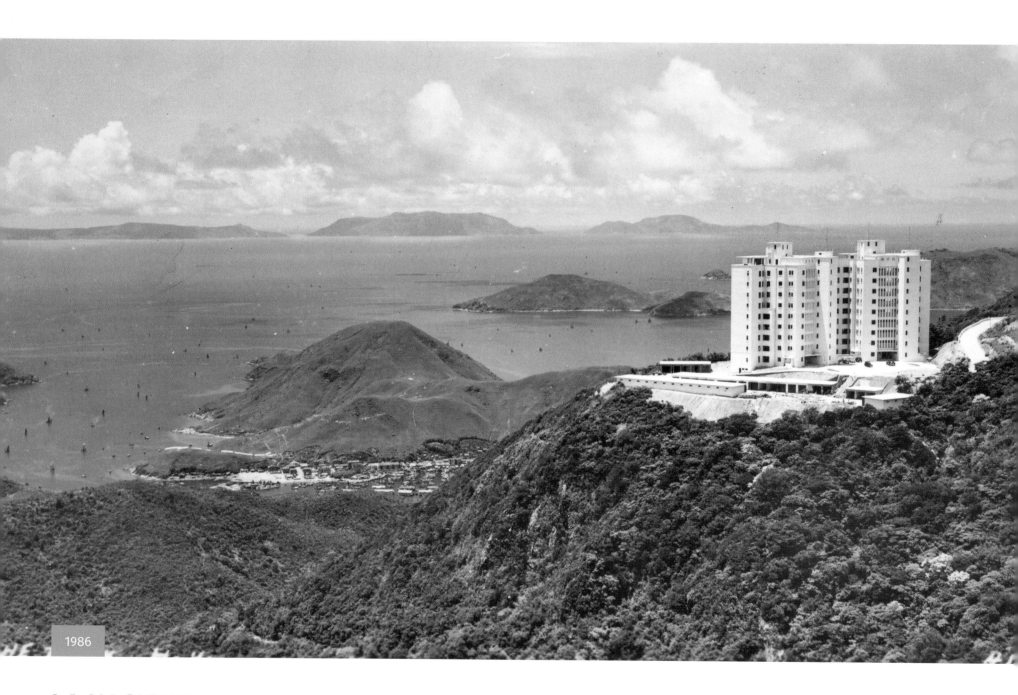

1986

LA HACIENDA
Now a luxury apartment complex aimed at wealthy expats

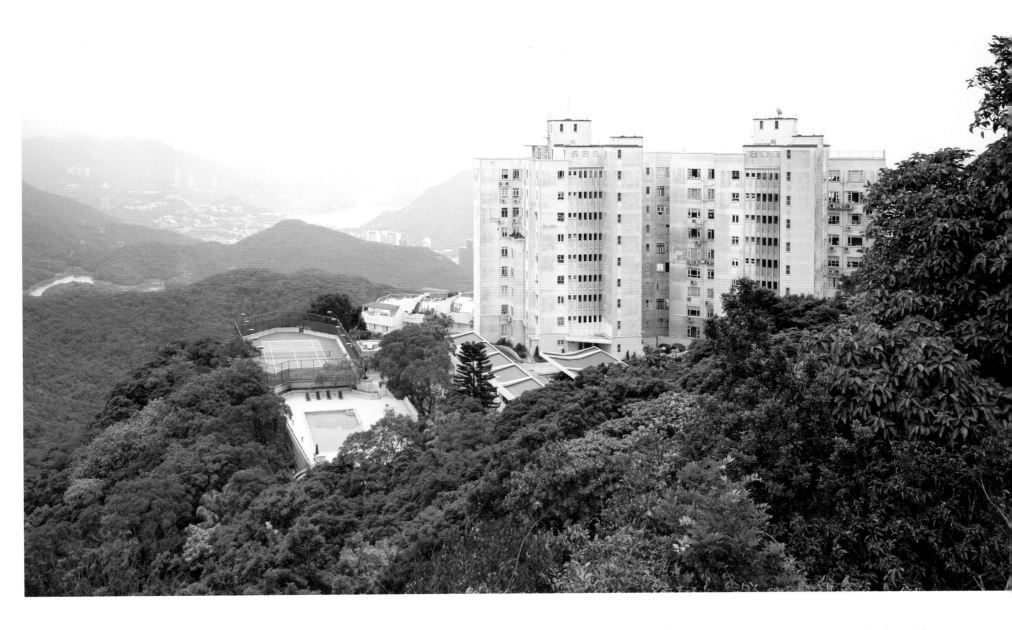

LEFT: Living on the Peak tended to be a summer-only activity to escape the stifling heat of Central until the opening of the Peak Tram in 1888. In the early 1890s, the owner of Dodwell & Co., a leading trading house in Hong Kong, built a large house in a Spanish Colonial style on Mount Kellett Road, which he named appropriately La Hacienda. This photograph was taken in 1986, when La Hacienda was rebuilt as one of Hong Kong's most prestigious apartment buildings, celebrating its undeveloped surroundings on the Peak and its spectacular views of the harbour.

ABOVE: La Hacienda has been further renovated and now boasts a swimming pool, tennis courts, squash courts, an outdoor children's play area and its own Club House; the last an essential for expats since the founding of Hong Kong. This photograph is taken to the left of the 1986 image, as newer residences have blocked the original view. The city's topography and its me-too spirit means glorious isolation does not last long in Hong Kong.

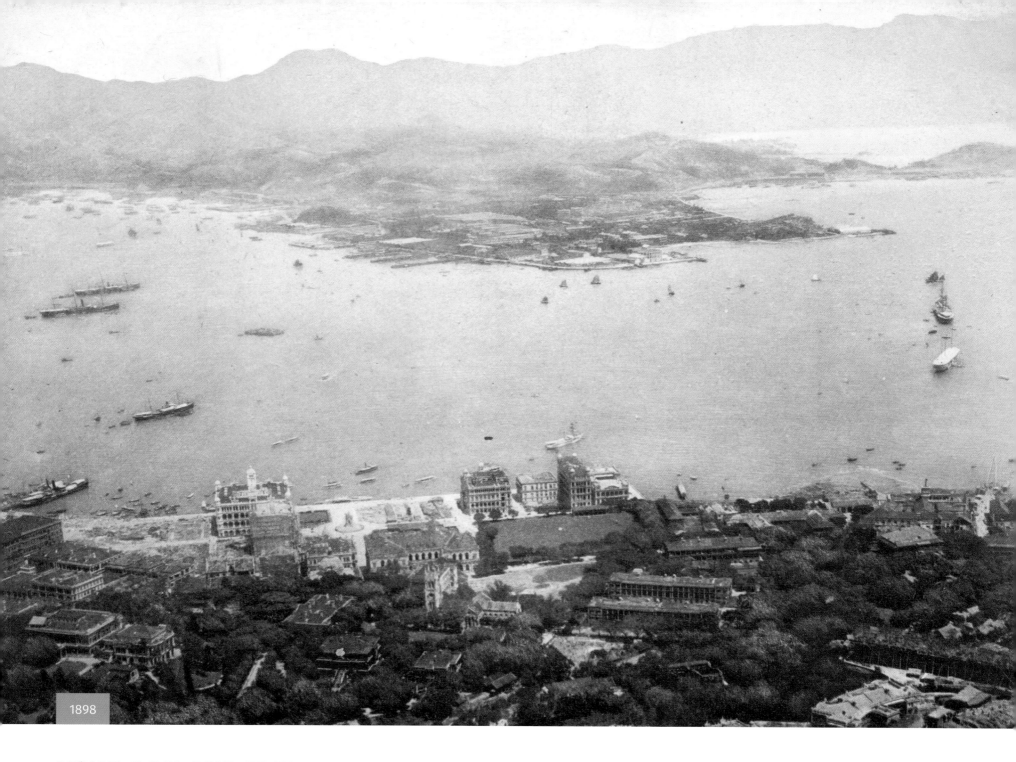

1898

KOWLOON AND THE NEW TERRITORIES FROM THE PEAK
Everything in view was ceded to Britain when this photo was taken

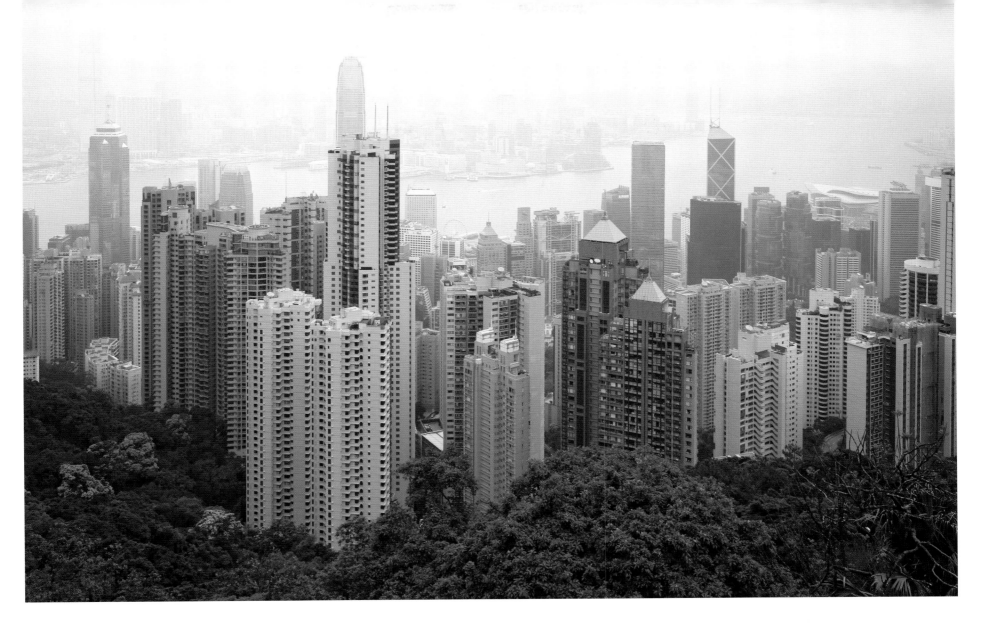

LEFT: When this photograph was taken, Kowloon had been in British possession for 38 years. A straight line that bisected Kowloon, from the top end of the nearest bay shown here, became Boundary Street. South of this frontier was British territory and in 1898 the north was also ceded to Britain, not 'in perpetuity' but on a 99-year lease. It was called the New Territories. Looking down at Hong Kong Central, the prominent structure to the left is the Queen's Building. Opened in 1899 and dubbed 'the city's most prestigious commercial building' it was demolished in 1963. The Mandarin Oriental Hotel took its place. Opposite, and also overlooking Statue Square, with its statue of Queen Victoria in prominent position, is the Hong Kong Club. On the south side, among others, are HSBC's building and the old law courts. Nearer the camera, is St. John's Cathedral. There is a clear view here of the recently reclaimed land on which

some of these substantial buildings have been erected. In contrast, Kowloon remains underdeveloped. In 1898, when this photograph was taken, the view as far as the eye could see was now British territory.

ABOVE: Not only is the view of Central obscured over a century later but also Kowloon. To get one's bearings, in the right centre of the picture is Norman Foster's HSBC building. It occupies approximately the same site as its Victorian predecessor; to the right of the Queen's Building in the previous photograph. Today's high-rise developments do not allow for an exact match but what this photograph does show is the expansion of Central and the Kowloon peninsular, which is now nearer. Land reclamation has shrunk Victoria Harbour.

THE STAR FERRY

Transporting passengers between Hong Kong and Kowloon since 1888

BELOW: 'Sunset and evening star/And one clear call for me!/And may there be no moaning of the bar/When I put out to sea.' The first line of the first verse of Alfred, Lord Tennyson's elegiac poem 'Crossing the Bar' provided Hong Kong's most memorable brand name. The Kowloon Ferry Company was founded by an Indian Parsi businessman, Dorabjee Naorojee Mithaiwala, in 1888, a year before Tennyson's poem was published. Naorojee, a lover of Tennyson's works, decided in 1898 to rename his company in his hero's honour and so it became, and remains, the Star Ferry. Here in 1949 a Star ferryboat crosses over to Central from Kowloon. To the left is the domed Supreme Court, followed by HSBC's Art Deco headquarters and the ornate Queen's Building. Victoria Peak is relatively undeveloped. The photograph on the right, of a lady sensibly clutching her dress, was taken not long after the ferry assumed its new name in 1898.

c. 1900

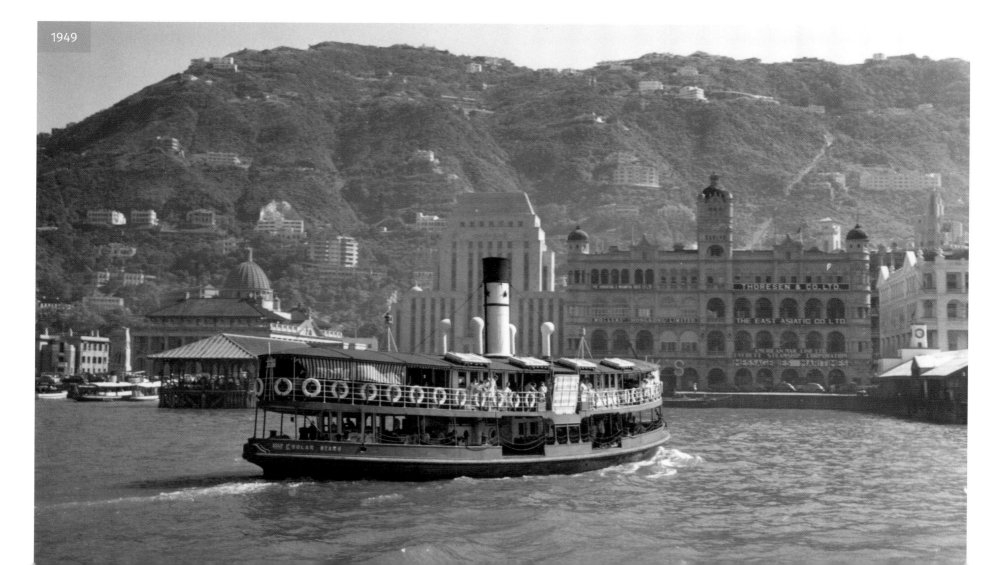

1949

BELOW: In 1960 a smash-hit movie *The World of Suzie Wong* brought the Star Ferry to an international audience. The opening scene on the ferry was of William Holden meeting, for the first time, a seemingly scornful Suzie Wong (played by Nancy Kwan). In 1972 the Cross Harbour Tunnel was launched, breaking the Star Ferry's monopoly. The fall-off in ferry passengers was temporary as an increasing number of tourists continued to take the ferry to savour the iconic view of Hong Kong, and perhaps even recall Suzie Wong's appearance on screen. Many of Hong Kong's important buildings are in this shot including HSBC, to the right of the Ferris wheel; the Mandarin Oriental Hotel, regularly voted the best hotel in the world; and Jardine House, the building with the porthole windows. This is the headquarters of Hong Kong's oldest company. When it was completed in 1972, the 179 metre (586 foot) building was the tallest in Asia. The heads of Jardine Matheson have their offices on the top two floors. The photo on the left shows a group of tourists admiring the view from the Star Ferry. On the right is the base of Hong Kong's currently tallest building, the 484 metre (1588 foot) International Commerce Centre (ICC) in Kowloon, which opened in 2010.

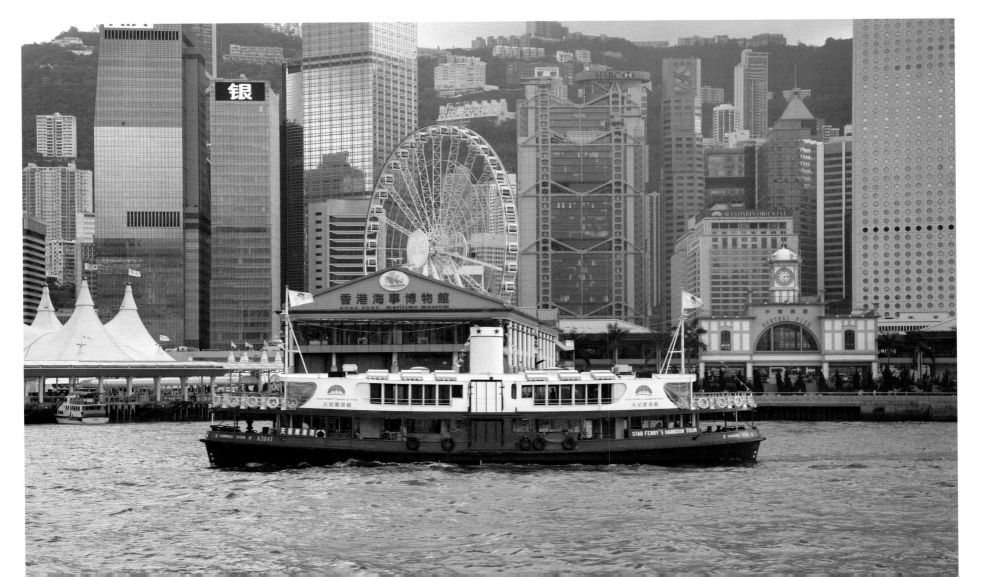

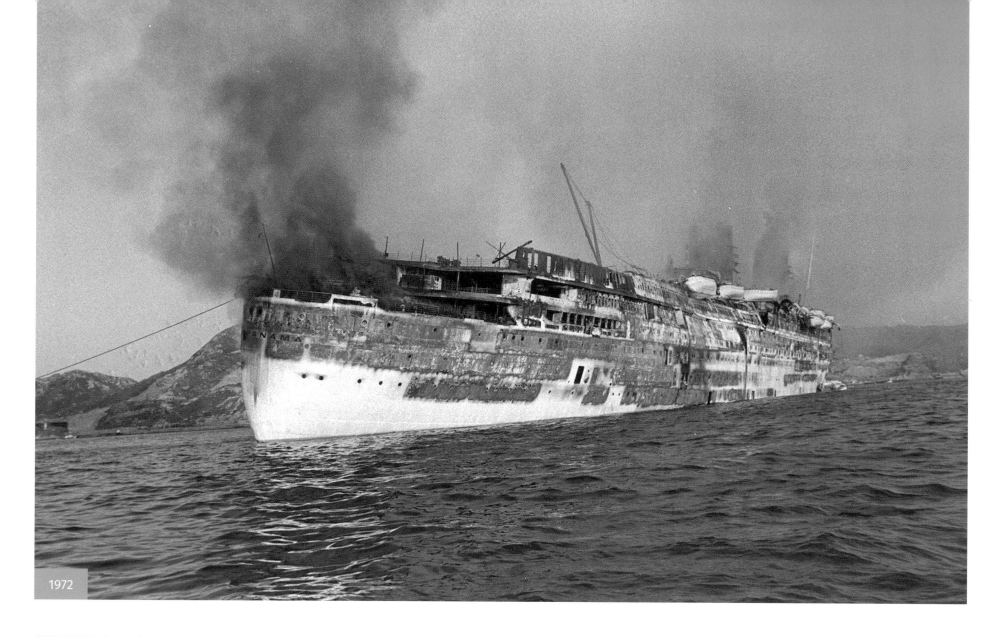

1972

ENTRANCE TO VICTORIA HARBOUR

The site of RMS *Queen Elizabeth*'s untimely end

ABOVE: When the former transatlantic liner RMS *Queen Elizabeth* caught fire in 1972 near the entrance to Hong Kong's Victoria Harbour, transfer of the colony back to China was only 25 years away. Some saw the spectacular episode as a harbinger of doom, for the *Queen Elizabeth*, once the world's largest and grandest passenger ship, was for years a major symbol of British prestige. The last owner was Tung Chao Yung, a leading businessman in the colony who paid $3.5 million for the ship but insured it for $8 million. He planned to convert it into a floating university named *Seawise University*.

When it caught fire with several blazes starting at the same time in different parts, there were rumours of it being an insurance scam, although no evidence of deliberate arson was discovered. In 1974 the wreck featured in the James Bond movie *The Man with the Golden Gun* as the secret Hong Kong headquarters of MI6. Given its size and position in the harbour, it became a serious shipping hazard. In 1974 to 1975 it was dismantled for scrap, which was used in yet another land reclamation scheme.

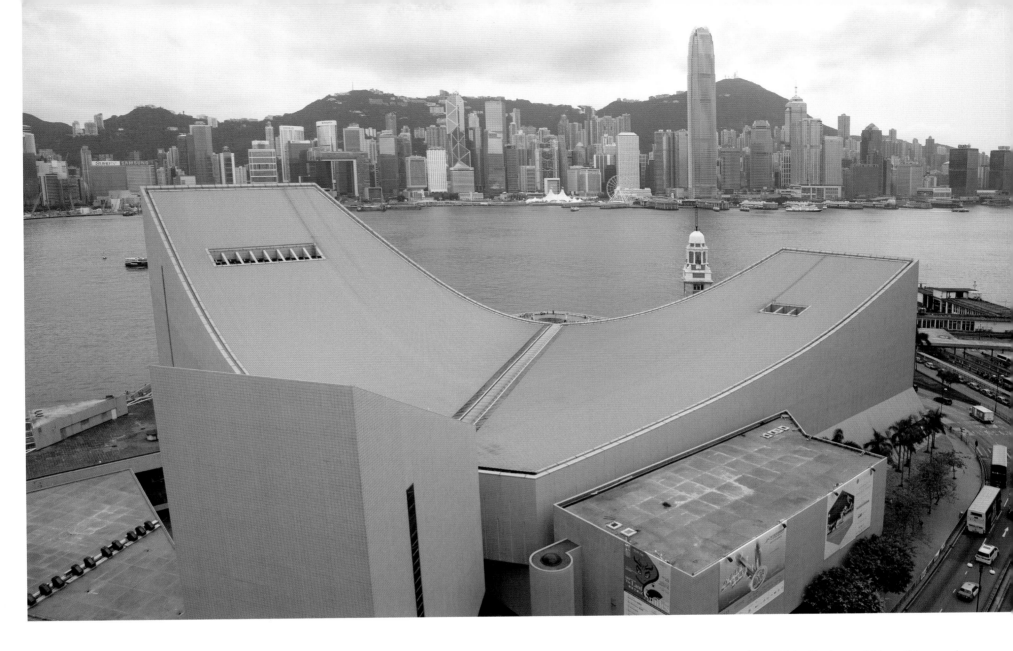

LEFT: The Kowloon–Canton Railway terminus in Tsim Sha Tsui opened in 1910, making it theoretically possible to travel by rail from Kowloon to Calais. Here in 1954 we can see the landmark clock tower, the station itself and its platforms. The bus station is in front. The railway station would last another 24 years before it was demolished to make way for a larger terminus named Hung Hom at the northern end of the Cross Harbour Tunnel. The clock tower was saved and is now a declared monument of Hong Kong. A magnificent liner is being tugged to or from the Ocean Terminal, which is out of shot to the right. Liners themselves, as the principal means of long-distance overseas travel, would only last another 14 years or so. There are no really tall buildings in Hong Kong and the Peak is undeveloped. The Star Ferry boats, however, look pretty much as they do today.

ABOVE: The Hong Kong Cultural Centre, opened in 1989 by Charles and Diana, Prince and Princess of Wales, today dwarfs the clock tower. The building of the Cultural Centre was controversial as it involved destruction of the railway station and escalating construction costs. Then there was the design. Perhaps its architects, the Architectural Services Department of the Hong Kong Government, felt inspired by other dramatically sited concert halls. From the outside it is certainly no Sydney Opera House. The Hong Kong Cultural Centre is home to the Hong Kong Philharmonic and the largest pipe organ in Asia. As well as a 2,019-seat concert hall, the complex houses two theatres and an art gallery. To the right is the Tsim Sha Tsui Ferry Terminal. The very tall building in Central is the 412 metre (1,351 feet) high International Finance Centre, which opened in 2003.

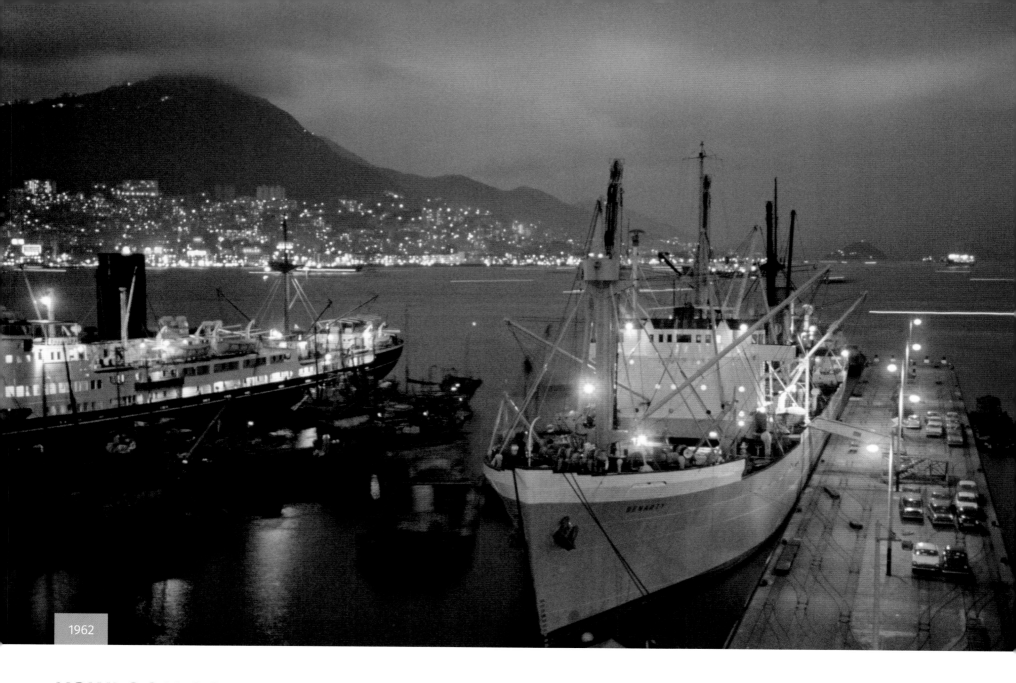

1962

KOWLOON OCEAN TERMINAL
The wharf pier became a cruise terminal in 1966

ABOVE: Two ocean-going ships are being unloaded and loaded at night at the Ocean Terminal wharf in Kowloon. Across Victoria Harbour the lights of Central show a city with few high-rise buildings. There are few lights on Victoria Peak also, despite this photograph being taken as late as the early 1960s. At that time Kowloon Ocean Terminal was still a main point of entry and exit for overseas travel. It would remain so until being displaced by air travel later in that decade. What we see here therefore is the end of an era.

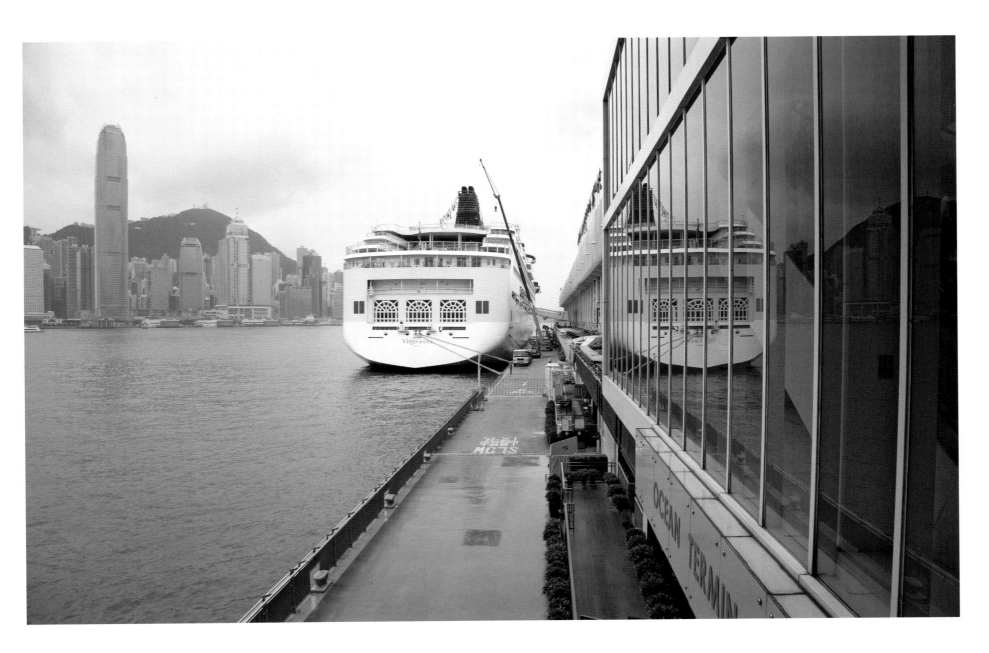

ABOVE: The wharf was extended and developed in 1966 as a terminal for cruise liners, one of which is seen here. Ocean Terminal is now part of a huge subsequent development known as Harbour City with cinemas and extensive shopping malls of branded boutiques. Cruise passengers with little time ashore can thus take a round-trip ride on the Star Ferry followed by shopping here. The development is by The Wharf (Holdings) Limited. Founded in 1886, and until 1986 the Hong Kong and Kowloon Wharf and Godown Company Limited, it built the original wharves. Among its current holdings is the Star Ferry. The 88-storey International Finance Centre is the most prominent building on the Hong Kong Island side.

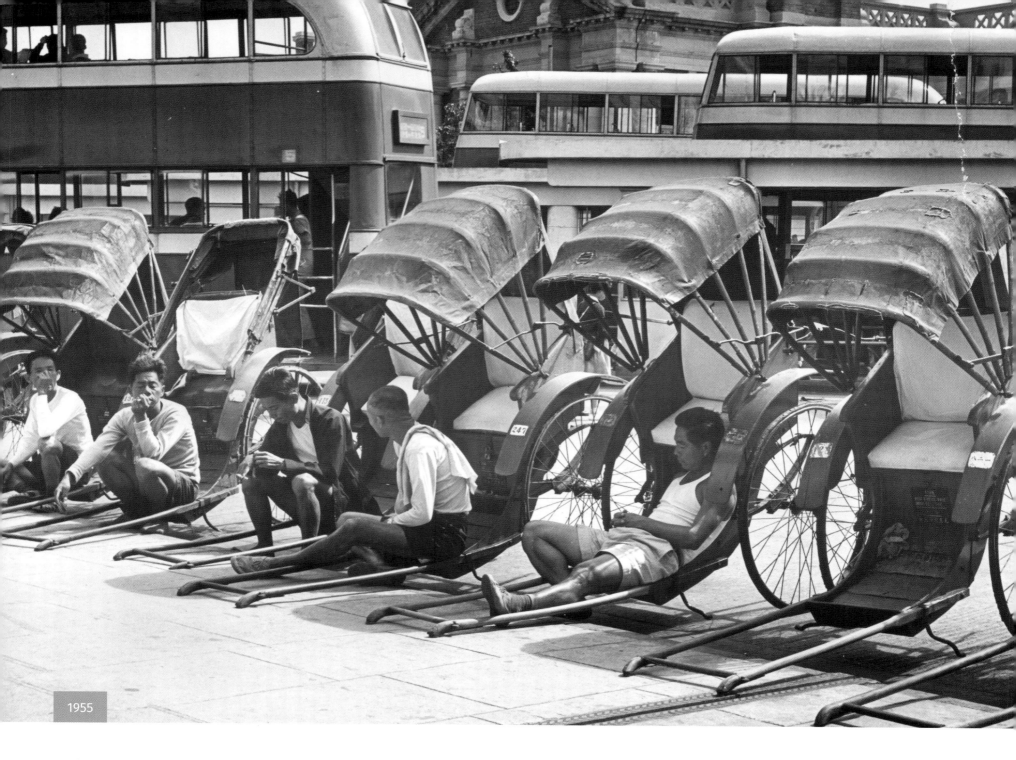

1955

KOWLOON BUS AND TAXI STATION

Once the taxi of Hong Kong, the rickshaw is now reserved for tourists

LEFT: When this photograph was taken, the Hong Kong rickshaw was still a popular form of travel, particularly in relatively flat Kowloon as well as in the reclaimed land parts of Central. The rickshaw, which most of us would initially consider a fairly ancient form of travel, was only invented around 1869. It took advantage of the lifting of a ban on wheeled vehicles in Japan, and the rubber tyres and ball-bearings of the bicycle. The introduction of the rickshaw to Hong Kong hastened the end of the sedan chair, which required two people instead of one, and the Peak Tram finished them off entirely. For many years thereafter, the rickshaw was the taxi of Hong Kong. Here rickshaw boys, as they were then called, irrespective of age, await Star Ferry and liner passengers. The old Kowloon–Canton Railway terminus building is visible behind.

RIGHT: Although the Kowloon–Canton Railway terminus was demolished in 1978, the bus station remains. The number of red taxis has increased in recent years and they remain the principal form of transport, other than buses. Recently, as in many other key world cities, there have been attempts by city authorities to prohibit or at least limit the activities of on-line taxi services. Perhaps modern technology will ultimately decide the fate of the familiar hailed taxi in Hong Kong, as it did the rickshaw and the sedan chair before it. Here a passenger having paid his fare is exiting his taxi in the place where the rickshaw rank once stood. In the background is Star House, which, like the ferry it's named after, is owned by The Wharf (Holdings) Limited. The photo below shows rickshaws for tourist use, especially the Kowloon cruise passenger trade.

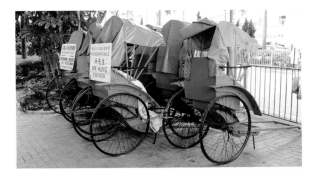

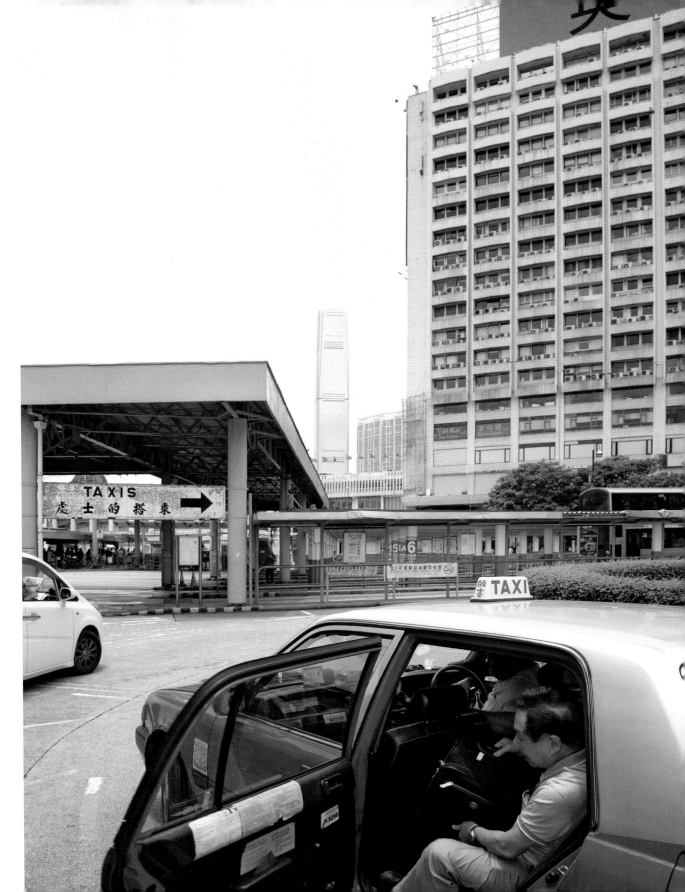

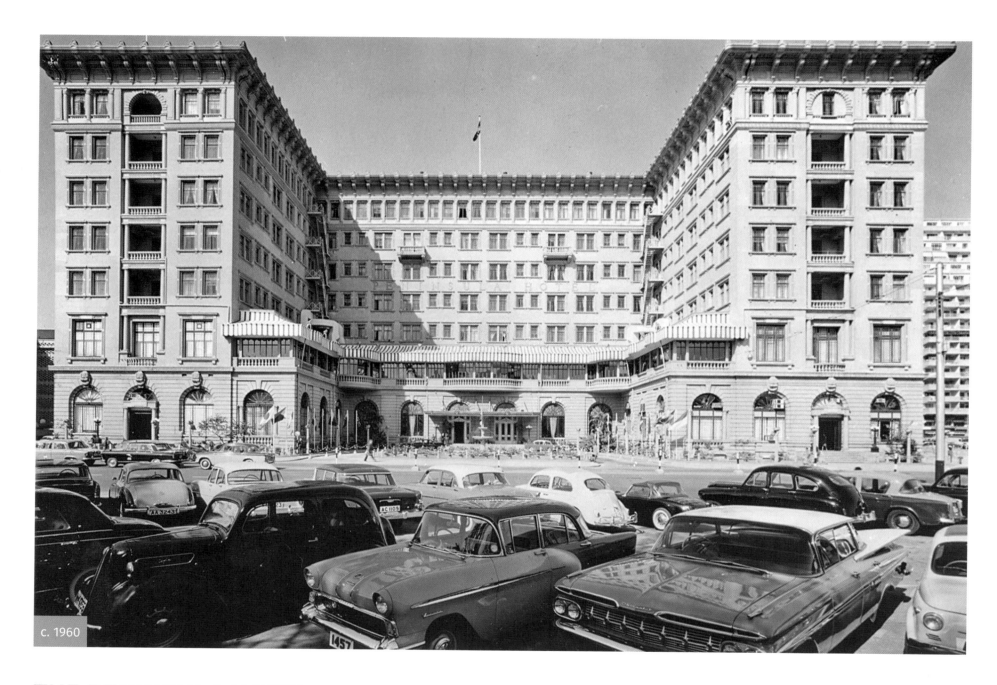

c. 1960

THE PENINSULA HOTEL
Built as 'the finest hotel east of Suez'

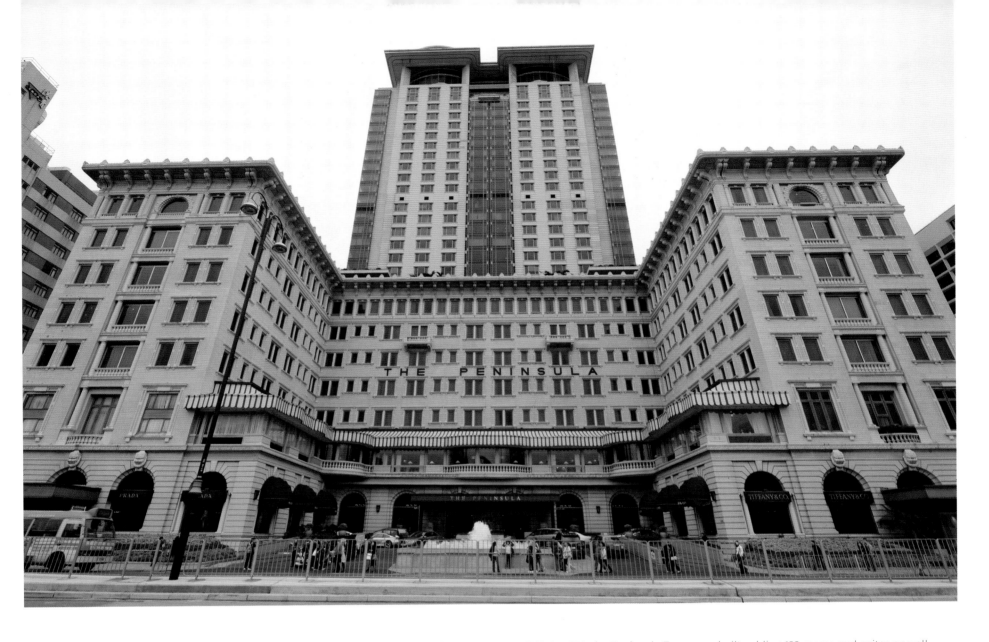

LEFT: The legendary Peninsula, one of the world's most famous hotels, started life in 1928 as *the* place to stay for wealthy passengers disembarking at the nearby quays where ocean liners moored, or at the Kowloon–Canton Railway terminus, the last stop on the Trans-Siberian rail link from Europe. The Jewish-Iraqi Kadoorie family, based in Shanghai, built it as 'the finest hotel east of Suez'. The Peninsula's view of Hong Kong was unsurpassed before land reclamation, car parks and buildings encroached. The Peninsula holds a leading place in the 20th-century history of the colony. Here the British surrendered to the Japanese in 1941 and the British Governor was kept under house arrest for two months. It was the hotel for high-ranking Japanese officers and, after 1945, for American and British ones. In the 1950s the Peninsula was the place where stars of stage and screen would stay.

ABOVE: In 1994, the Peninsula Tower was built, adding 132 rooms and suites as well as offices and other facilities. The hotel has its own fleet of green Rolls-Royce cars, as well as a heliport on the roof of the tower for quick access to and from the airport. The hotel's basement, ground and mezzanine floors contain one of the oldest and most exclusive shopping arcades in Hong Kong. The Peninsula was modernised in 2013 with the exception of the iconic lobby, restaurants and bars. Other than during the Japanese occupation, the lobby has always served English afternoon tea accompanied by a string quartet. In such colonial splendour, it is considered a gaffe to show up and expect to be served in clothes you may wear to the beach. You will be politely steered to the exit, however rich you are.

NATHAN ROAD

The 'Golden Mile' is Kowloon's main thoroughfare

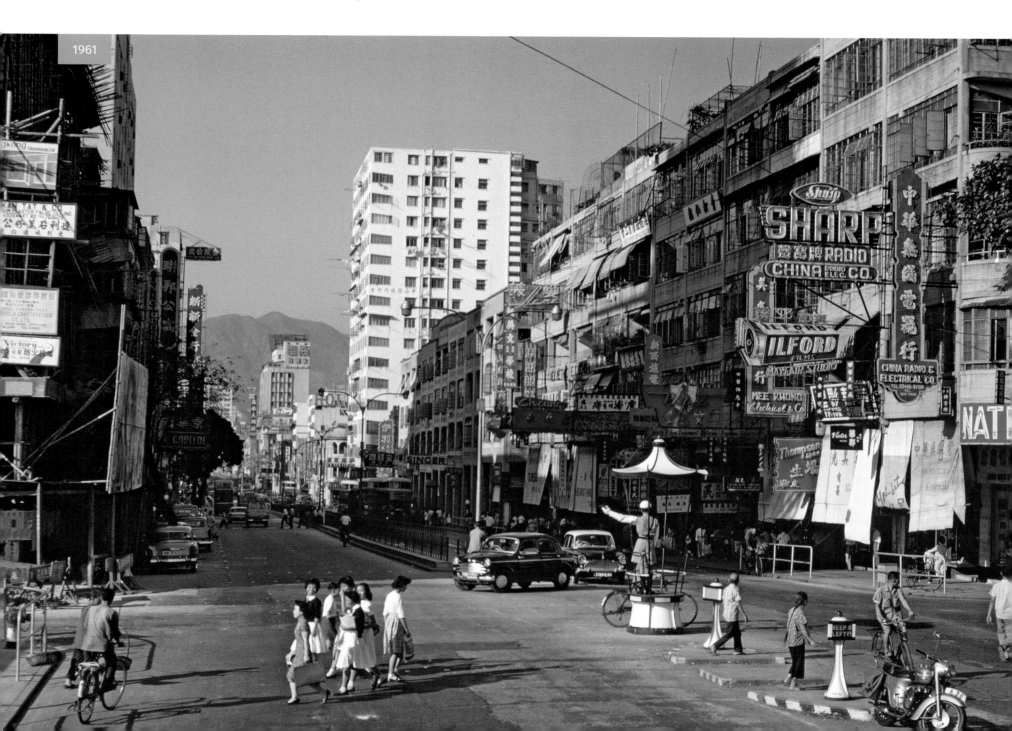

1961

LEFT: Nathan Road runs from Salisbury Road near Victoria Harbour to Boundary Street; the 1860 frontier between the British colony and China. Built in 1865 as Robinson Road, it took its present name in 1904 when Governor Nathan had it widened and extended. After World War II it became known as the Golden Mile on account of the abundance of gold, jewellery and precious stones on sale. Here in 1961, a police officer standing on a dais, topped by a pagoda roof, directs the traffic. High-rises, a few of which we can see here, are beginning to rise along the road. On the horizon is one of the mountains in the New Territories, from where Kowloon derives its name. It was around this time that Nathan Road became notorious, or famous, depending on your point of view, for its relentless street hawkers and maze of shops tucked away in many of the buildings lining the road.

BELOW: Nathan Road today is as busy and as buzzy as ever, although there appears little, if anything, remaining from the 1961 photograph. Yet look to the pink building on the right. At most it has been rebuilt in a similar style; at least it has been adapted and extended. This, the southern end of Nathan Road, is the posh stretch, boasting many up-market stores. There is even a row of lofty palm-trees to signal its status. Some things, however, do not change. The bamboo scaffolding, still ubiquitous in Hong Kong, speaks of another age.

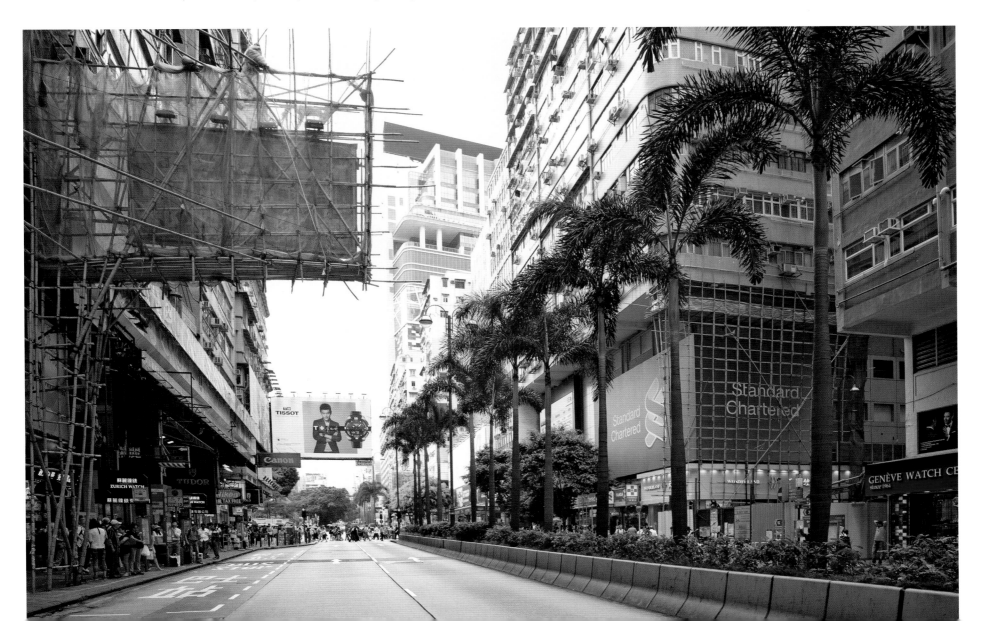

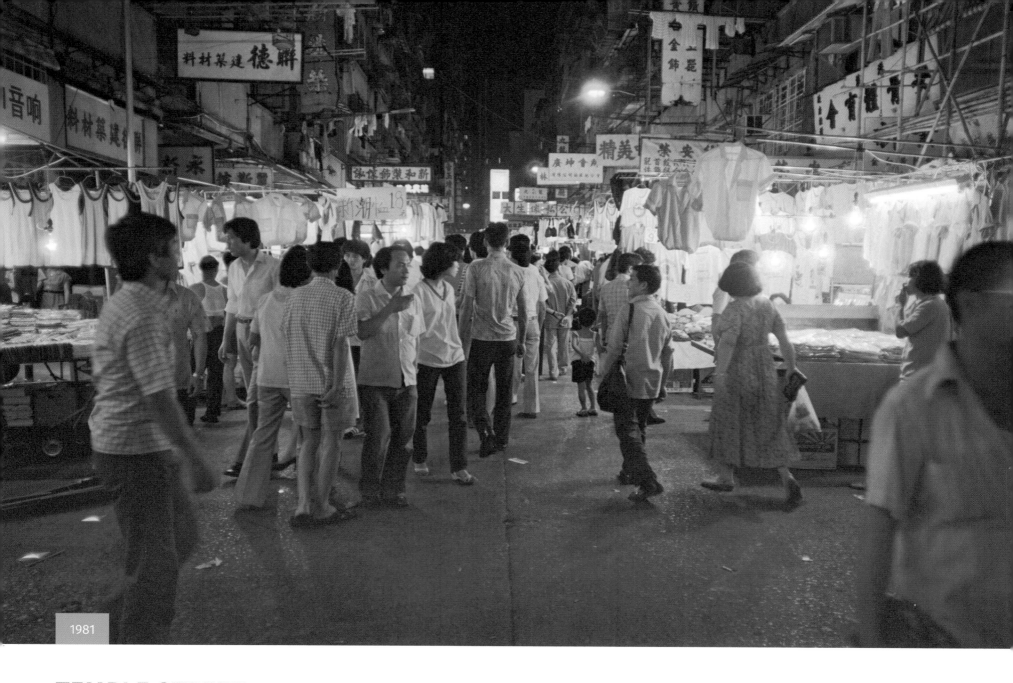

1981

TEMPLE STREET

Famous for its popular night market

ABOVE: Near the junction of Jordan Road with Nathan Road, in the Ya Mei Tei district of Kowloon, is Temple Street. Ya Ma Tei was once a fishing village but various land reclamation projects throughout the late 19th and 20th centuries brought it inland so it is now almost 2 miles (3 kilometres) from the shore. Temple Street is named after a Tin Hau temple built there in 1864 but which can trace its history back to the early Qing Dynasty. It was later rebuilt at nearby Public Square Street. Temple Street became known popularly as Men's Street as everything from men's clothing to condoms could be bought there cheaply.

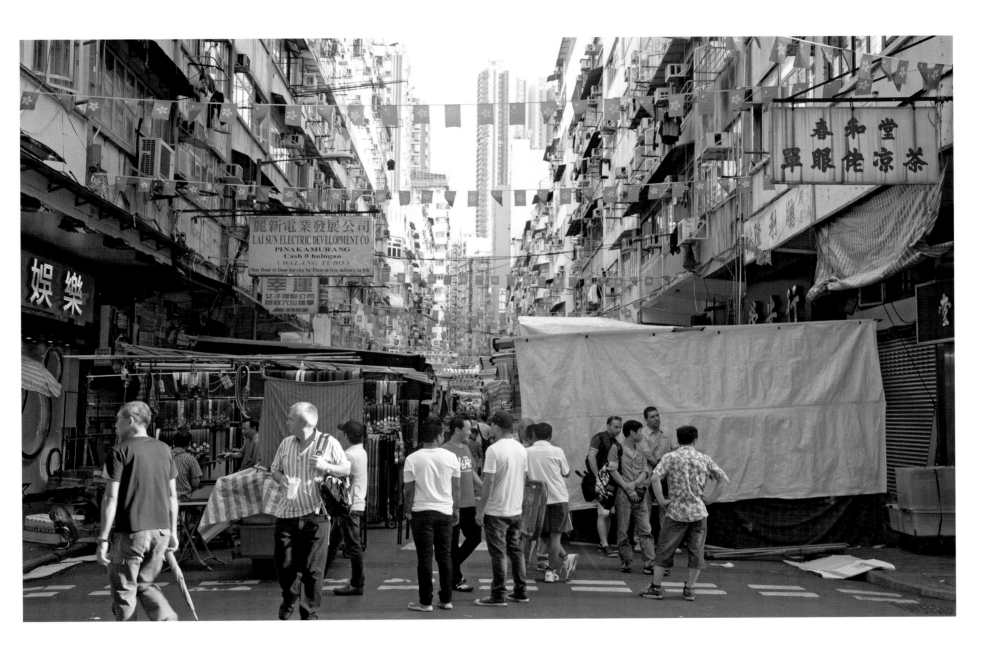

ABOVE: Although it is principally a night market, Temple Street opens around 2 p.m. every day. Men's stuff is still popular, although today there are also techno items at incredibly low prices and stalls overflowing with mobile phones, lighters, glitzy watches and DVDs. All is to be bargained for. Hidden from view by the stalls are shops where sometimes even better bargains may be obtained. Impromptu performances of Chinese opera occasionally take place. Temple Street has been used as the location for several films, often of the gangster variety. There are traditional Chinese clinics specialising in almost every conceivable affliction. For shoppers who find the whole thing too male-oriented, not far away is Tung Choi Street with its extensive Ladies' Market.

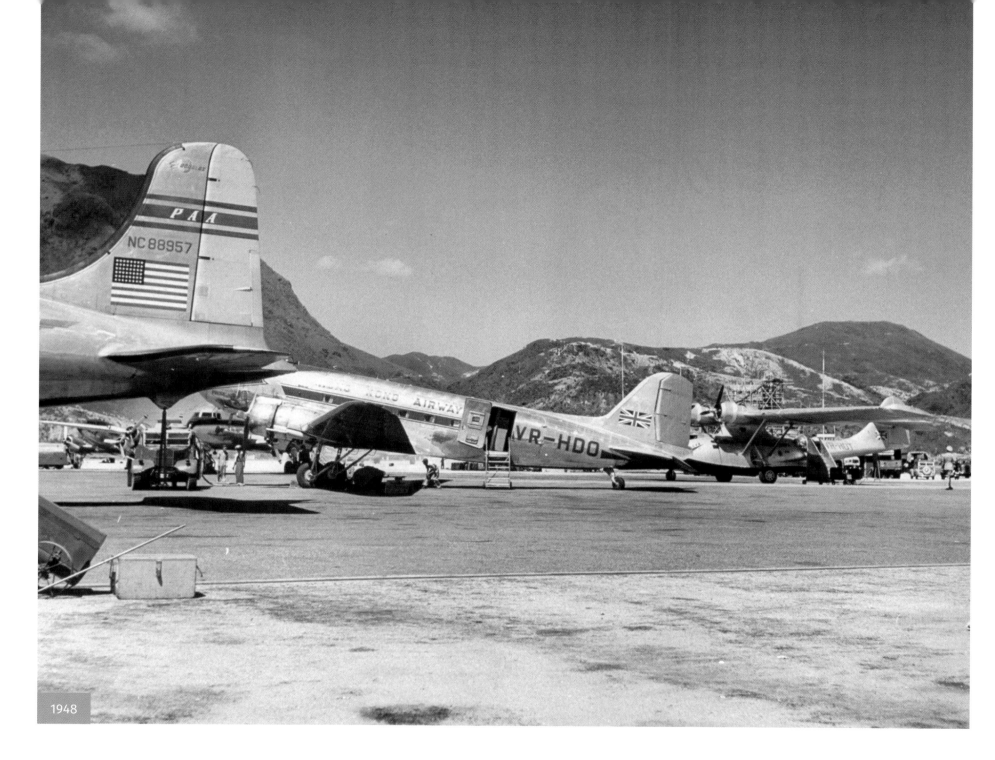

1948

KAI TAK AIRPORT

The final approach to the runway was known as the 'Kai Tak Heart Attack'

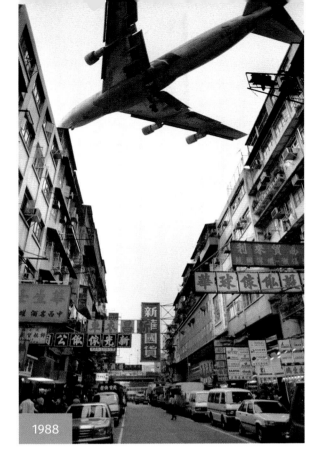

1988

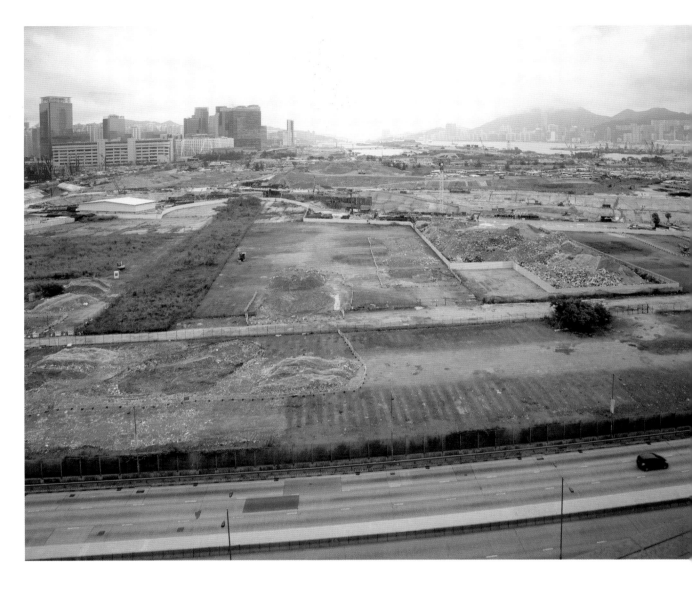

LEFT: In this 1948 photograph, American and British aeroplanes stands next to one another at Kai Tak airport in Kowloon. The airport took its name from two businessmen, Ho Kai and Au Tak, who set up a land reclamation company in 1922. The business failed, so the government took control and turned it into a grass airfield for the RAF and private flying clubs. During World War II, the Japanese built hard runways using POW labour. The materials they used came from a 45-metre (148-foot) memorial to the last Song emperor and parts of the historic wall surrounding Kowloon Walled City. After the war, commercial flights started in earnest with the establishment of Cathay Pacific Airways. Kai Tak was rated one of the most dangerous and demanding airports in the world for pilots. The uncomfortable closeness of mountains and buildings (as seen in the photo above), as well as the relative shortness of the runway, meant pilots received special training to fly in low, making their final turn only 200 metres (656 feet) above the ground. The nickname for final approach was the 'Kai Tak Heart Attack'.

ABOVE: Given the risk at Kai Tak, it is surprising there were not more fatal accidents. Actually there were relatively few; a tribute over the years to the skill and cool-headedness of Kai Tak-trained pilots. But due to a huge increase in traffic, the airport eventually had to move and the last flight took place on 6 July 1998. The new Hong Kong International Airport is at Chek Lap Kok. The question remained what to do with the old airport; a debate that is still not finally settled. Here is a view close to the one experienced by pilots on their final approach; although they would be further over to the right, one would hope. In 2013 a cruise terminal opened at the tip of the former runway and two public housing projects were completed (top left), providing 13,000 rental flats. Commercial property will almost certainly be built here too.

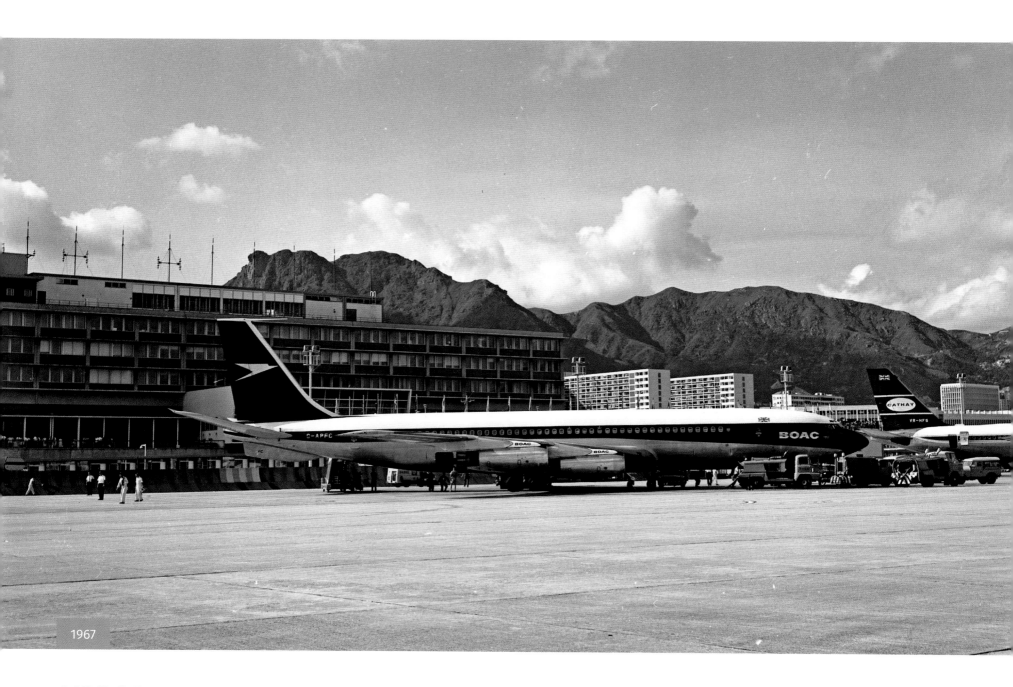

1967

AIRPORT TERMINALS

Chep Lap Kok is one of the world's busiest airports

LEFT: This photograph of the old Kai Tak airport terminal building was taken in 1967. The building stood in the foreground of the photograph on the previous page. Travellers heading for Central by taxi were taken to the nearby ferry terminal, and after 1972 through the new Harbour Tunnel. In the late 1980s crowding in the terminal had to be seen to be believed. This was caused by a sizeable increase in flights and a terminal building with no further room to extend. Added to this was the Chinese tradition of extended family support for the traveller, with lots of relatives seeing you off or welcoming you home. By the early 1990s Kai Tak, one of the smallest international airports, was one of the busiest.

ABOVE AND RIGHT: The replacement, Hong Kong International Airport, opened at Chek Lap Kok on the north-eastern side of Lantau Island in 1998. Like its predecessor, it was built largely on reclaimed land. The photo on the right shows Terminal 1 arrivals hall. The architects were Foster & Partners. When it was completed, Terminal 1 was the world's largest passenger terminal building. It was overtaken in 2008 when Capital Airport Beijing opened, designed by the same London-based practice. Today Hong Kong International Airport (or Chek Lap Kok, as it is commonly known) has more freight and passengers than any other airport in the world.

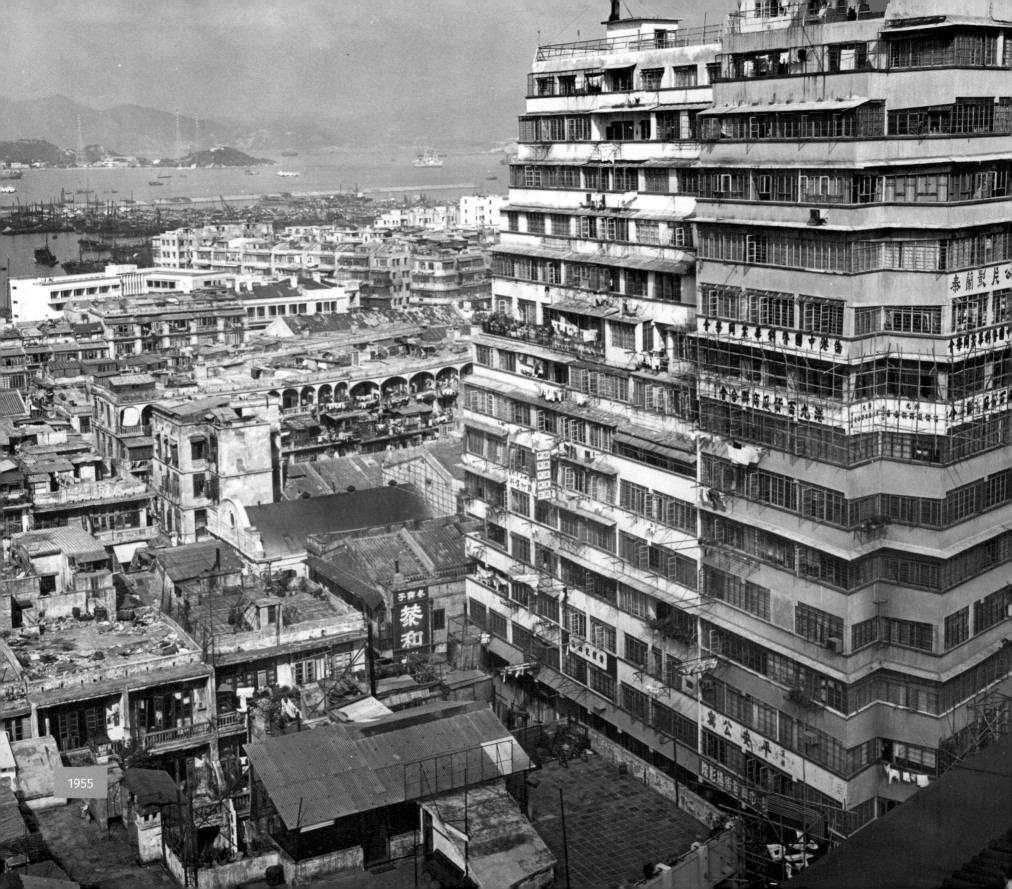

1955

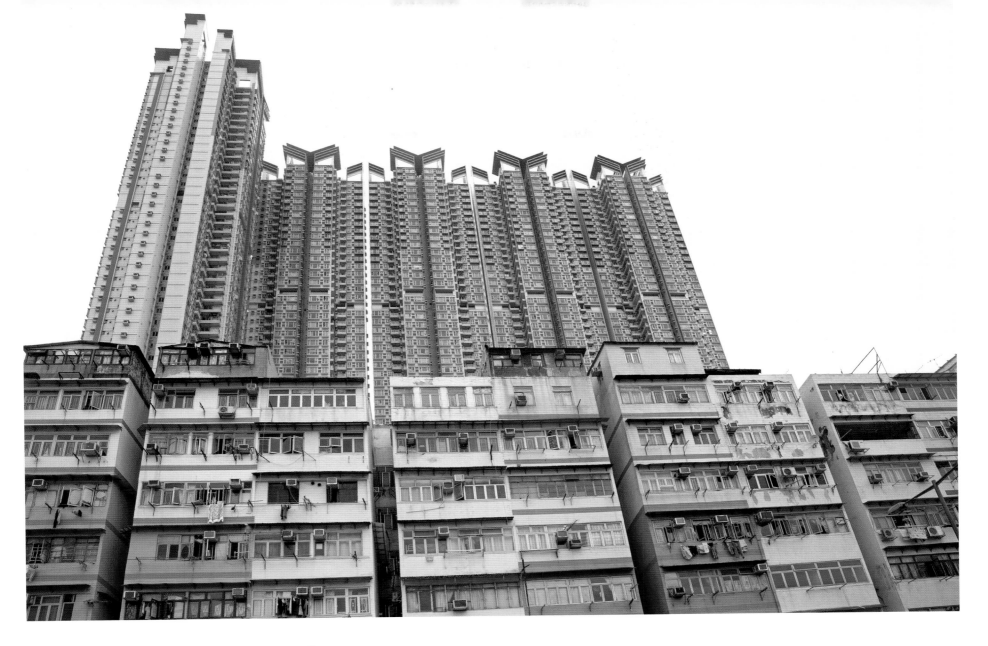

KOWLOON APARTMENTS
Building height restrictions were lifted with the closure of Kai Tak Airport

LEFT: Following the defeat of the Kuomintang and the establishment of the communist People's Republic of China in 1949, Hong Kong experienced an influx of refugees from the mainland. The Hong Kong Government favoured housing migrants in Kowloon, although many were also housed on Hong Kong Island.

Given the circumstances, some apartment buildings were designed and built extremely quickly in the New Territories. Here is one such example in Kowloon. Apartment blocks built close to Kai Tak Airport's perilously abrupt runway were not allowed to exceed 14 stories.

ABOVE: With the removal of Kai Tak Airport in 1998, it became possible to erect taller apartment buildings in Kowloon, which meant that many of the old apartment blocks could be replaced. In this photo modern apartments tower over buildings that were probably erected in the 1960s. Air-conditioning units sprout from most windows; a facility not offered in the 1950s, as the previous photograph indicates. The new tower blocks have central air-conditioning vented to the roof.

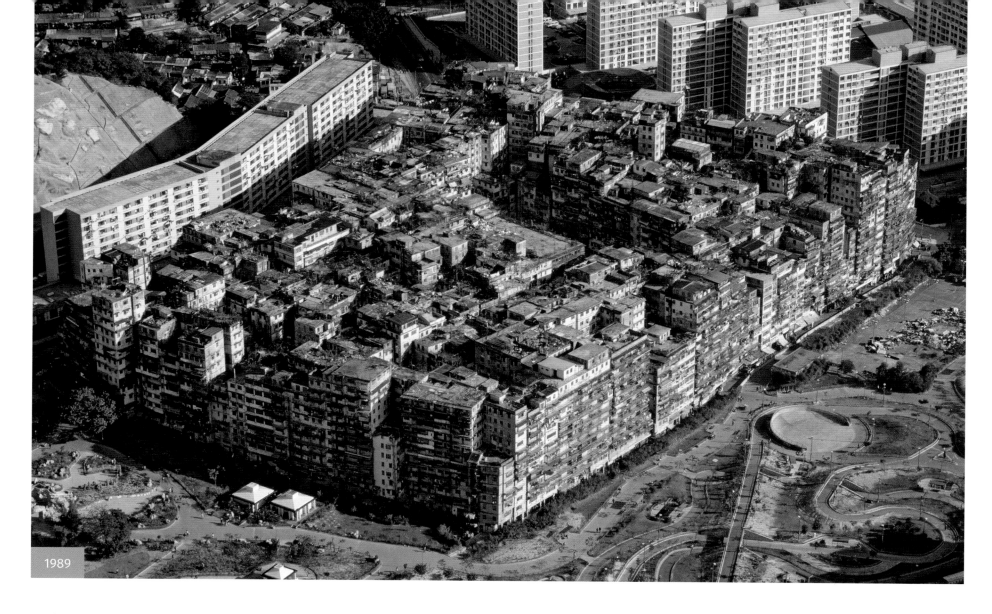

1989

KOWLOON WALLED CITY
The notorious Walled City is now a scenic park

ABOVE: A gripping and gritty 1970s BBC TV documentary series, *The Hong Kong Beat*, followed the Royal Hong Kong Police, whose most challenging work appeared to be dealing with the Kowloon Walled City; a warren of iniquity, packed with dangerous Triad gangs and come-hither ladies. It has often been said that Britain acquired its empire 'in a fit of forgetfulness'. If so, Kowloon Walled City, is an excellent example.

When Britain received the New Territories on a 99-year lease in 1898, the Walled City was left, rather curiously, as part of China. This meant that Britain had no legal control over what took place there. In the ensuing years, China did not involve itself; indeed after the Communist takeover in 1949 they relished the embarrassment it gave the British. In 1987, ten years before the handover of Hong Kong to China and

two years before this aerial photo was taken, both governments agreed to its demolition. The cost of rehousing the 33,000 mostly law-abiding residents – the last of whom were evicted in 1992 – was HK $2.7 billion (US $350 million).

100

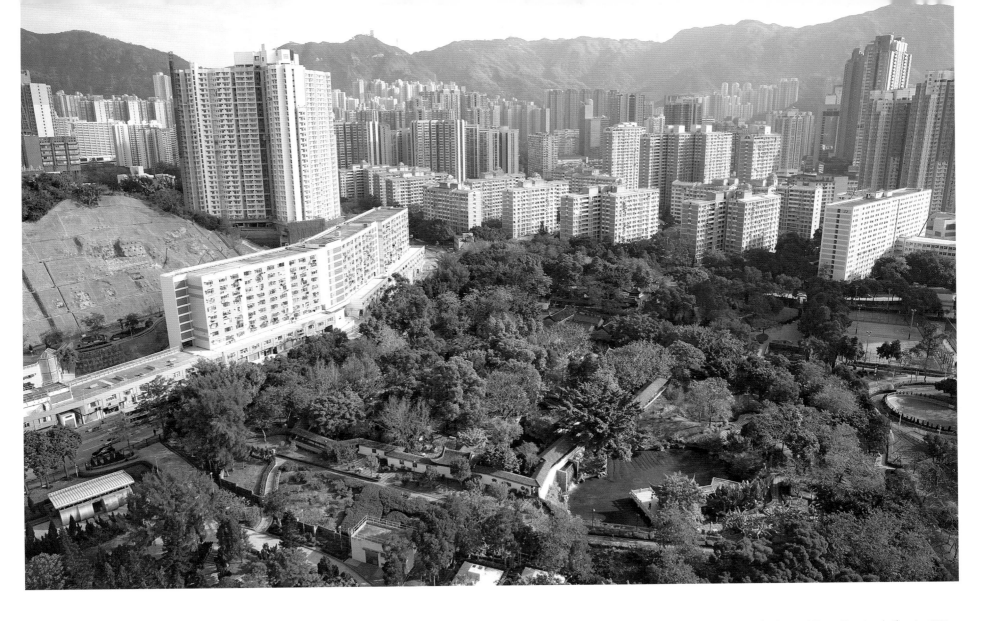

ABOVE AND LEFT: Demolition of the Walled City started in 1993 and Governor Chris Patten officially opened its replacement, the Kowloon Walled City Park, in December 1995. Its design is modelled on the Yangtze Delta's Jiangnan gardens, dating to the early Qing Dynasty. The park covers 31,000 square metres, with each path or pavilion named after one of the streets or buildings in the old Walled City. Visitors can now appreciate a bronze model of Kowloon Walled City in the centre of the park. The model (shown left) is a three-dimensional copy of the 1989 photograph opposite. The long building to the left of the park in the photo above is the Mei Tung Estate, dating to 1974. Rising behind it is the new Mei Tak House, completed in 2014. To the right is the huge Tung Tau Estate, which was built in 1965 and extended in 1982 and 2012. These buildings were all constructed as public housing apartments, but now there is a right-to-buy scheme which is proving popular. On the horizon is Lion Rock Country Park, which includes Tai Mo Shan, the highest peak in the former colony of Hong Kong.

嶺粉 FANLING 嶺粉

1960

FANLING STATION
Fanling is now part of Hong Kong's commuter belt

LEFT: The British chose Fanling in the New Territories as the terminus for rail traffic from the border with China. The station was built in 1912. From 1950 to 1983 a special branch line existed from the station to Wo Hop Shek, the largest public cemetery in Hong Kong. It was designed to take large crowds attending the annual Ching Ming and Chung Yeung festivals when families would visit and sweep the tombs of their ancestors and relatives. Nearby is Fanling walled village (Fanling Wai), built at the end of the 16th century as a new centre for the expanding Pang clan who had lived in the area since the 12th century. Nearby also is the Royal Hong Kong Golf Club. They moved here from Deep Water Bay in 1911. In 1960, when this photograph was taken, Fanling was quiet and undeveloped. It was only busy during the cemetery festivals.

ABOVE: There are now around 25 public and private housing estates in Fanling. The town continues to grow as an important part of the Hong Kong commuter belt; hence the length of the station platforms. Fanling Lodge, the summer residence of the Chief Executive of Hong Kong, is near here. It was built in 1934 for the British Governor and for the same purpose. The Hong Kong Golf Club is still based at Fanling but in 1996 it dropped its Royal prefix in anticipation of the 1997 handover. Fanling Walled Village is today a popular visitor attraction. Fung Ying Seen Koon, one of Hong Kong's most important Taoist temples, is a short walk from Fanling Station.

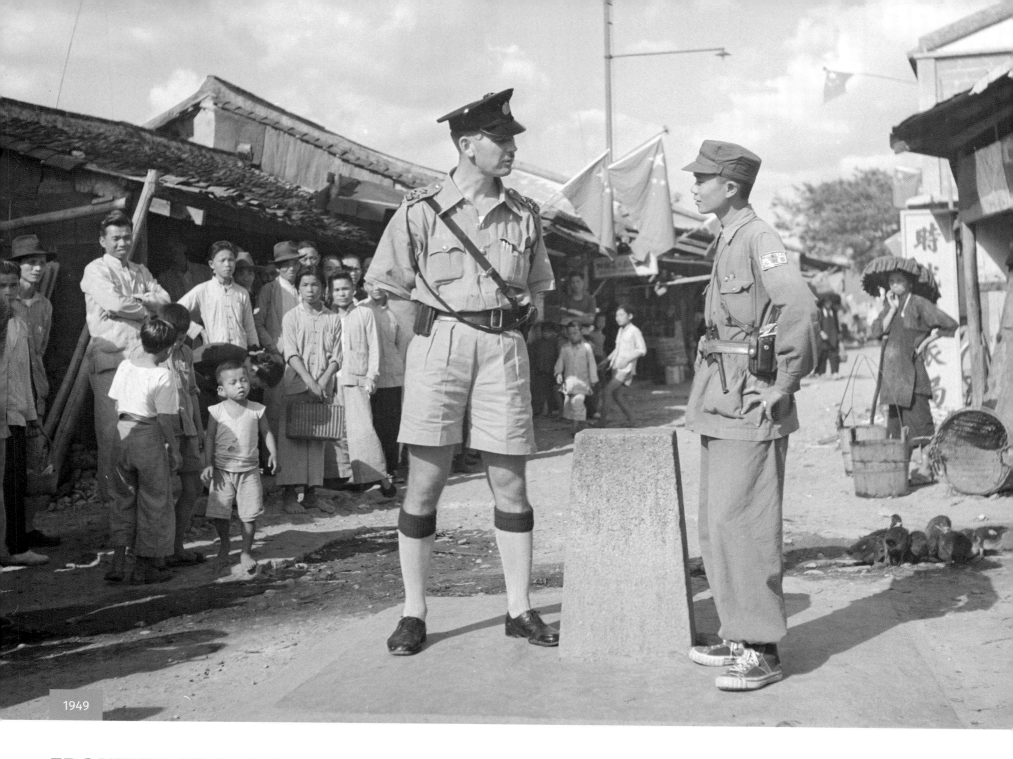

1949

FRONTIER AT SHA TAU KOK

The town still separates Hong Kong from mainland China

LEFT: In 1949, when this photograph was taken, tensions between Britain and China were at an all-time high. On the mainland, the Communists had just defeated the Nationalists. Mao Tse-tung, the Communist leader, denounced Hong Kong as a capitalist enclave stolen from China in the 19th century. The British Government considered whether it could defend the colony at all. At the time, Hong Kong was dealing with a surge of refugees from China, especially Shanghai. Here in the New Territories at Sha Tau Kok, a Royal Hong Kong Police inspector and a People's Liberation Army soldier stand their ground, watched by bemused villagers. Just a squat stone obelisk divides Chung Ying Street and the town between Hong Kong and Communist China.

ABOVE: The Sha Tau Kok frontier still divides Hong Kong from mainland China, but today it is one of the lesser used immigration crossing points, as most travellers cross by train elsewhere. Although Sha Tau Kok has a reputation for minor goods trafficking, most of those crossing regularly are locals who work and study in Hong Kong but live in mainland China. Further down Chung Ying Street a museum has been built which explains how the British took Hong Kong and celebrates the transfer of sovereignty back to China in 1997.

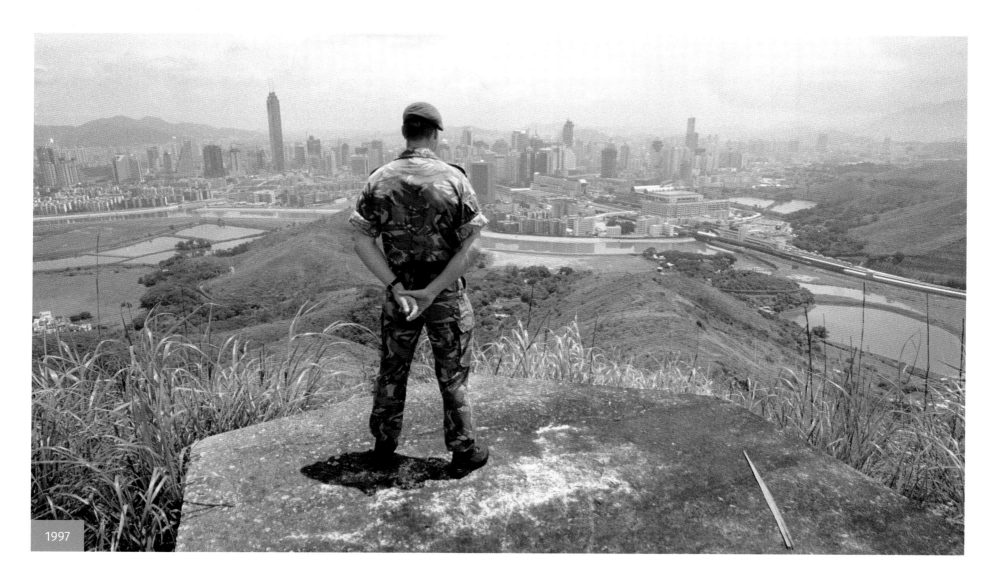

1997

SHENZHEN

Now one of China's wealthiest cities

ABOVE: In 1997, on the eve of the transfer of Hong Kong to China, a British soldier stands on a gun emplacement and sees the future. In front of him, across the Sham Chun River border with mainland China is the city of Shenzhen. Shenzhen became China's first Special Economic Zone (SEZ), built in anticipation of the transfer. Less than 20 years before, Shenzhen was Sham Chun Hui, a small market town which the Kowloon–Canton Railway passed through. Its SEZ status allowed for a freer economy where companies could trade and invest without the same regulations imposed on other parts of China. The tallest building on the horizon is Shun Hing Square, which was completed the year before this photograph was taken. Rising 384 metres (1,260 feet), it is still the tallest all-steel building in China.

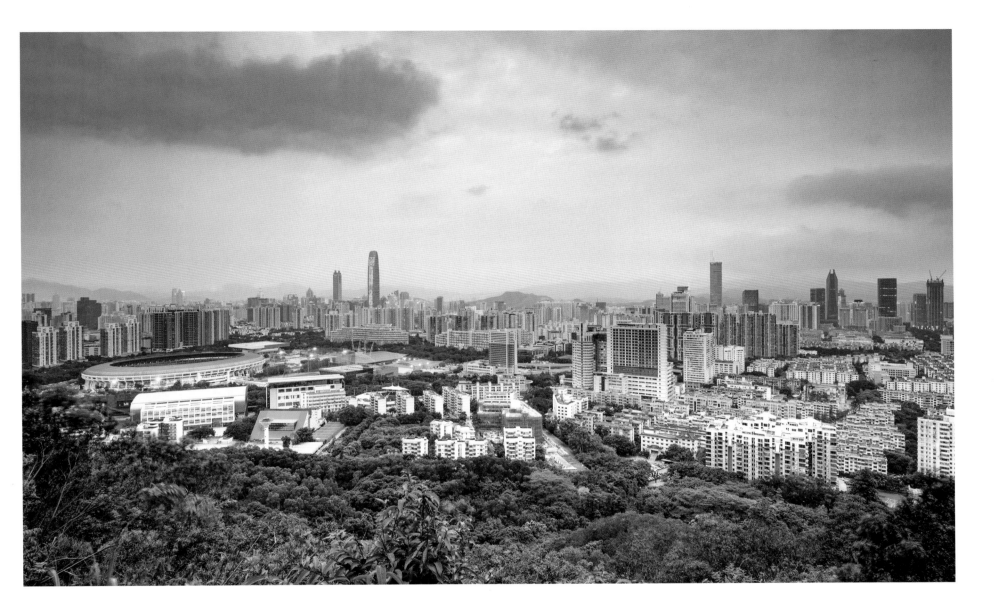

ABOVE: Today Shenzhen City has a population of 11 million, and its metropolitan area has over 18 million. During the 1990s and 2000s Shenzhen was perhaps the fastest growing city on earth. This is where many goods branded as coming from Hong Kong are designed and made. To support this, Shenzhen has one of the world's largest container ports. Yet it is not just a sweatshop for Hong Kong, for the city's service industries have expanded greatly since 1997. Shenzhen is the headquarters of many high-tech companies and is a major financial centre with its own stock exchange. Today Shenzhen is considered one of the most livable cities in China. The tallest building on the horizon now is KK100, also known as the Kingkey Finance Centre Plaza, at 442 metres (1,449 feet). It was designed by the British architect Terry Farrell and completed in 2011. The former high point, Shun Hing Square, is to the left of KK100 and Shenzhen Stadium is far left.

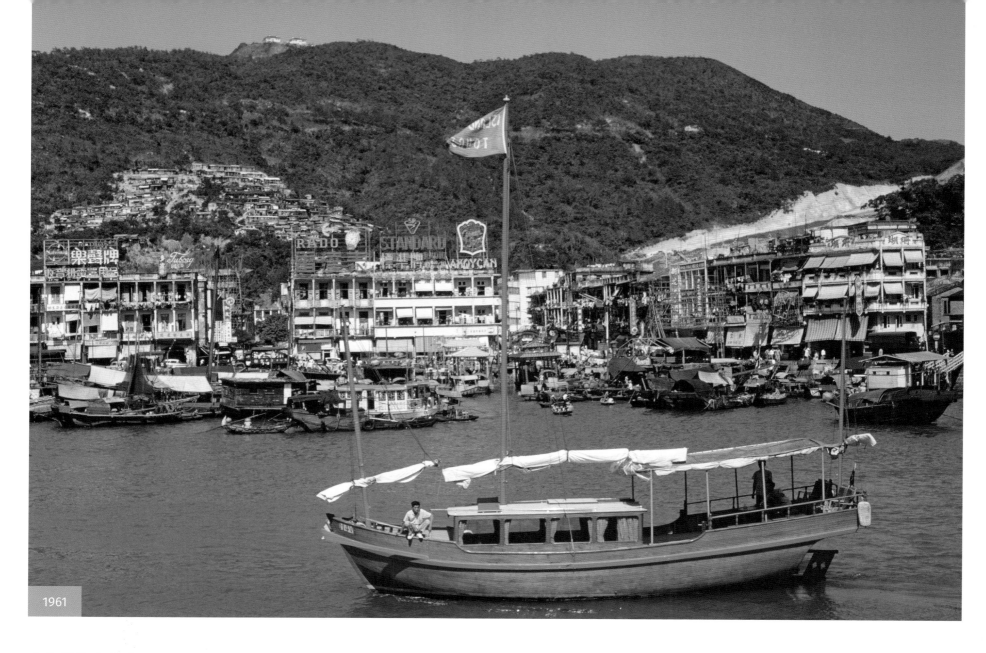

1961

ABERDEEN HARBOUR
Famous for its floating village and restaurants

ABOVE: Typhoons are a major threat for Hong Kong, so a secure mooring in a typhoon shelter is essential. The Hoklo and Tanka, or 'boat people', had been using this harbour on the southern coast of Hong Kong Island as a typhoon shelter for centuries when the British showed up in 1841. As well as fishing, the Tanka specialised in cultivating incense trees, in what is now the New Territories, for export from here to mainland China. That is why they called it Fragrant Harbour, or 'Heung Kong' in Cantonese. The

British, thinking they were referring to the whole island, decided that this harbour should be named after the then British Foreign Secretary, Lord Aberdeen. In 1961, when this photograph was taken, Aberdeen was a fishing village and already a popular tourist spot, famed for its Cantonese restaurants, its tourist boats for hire, such as this one, and as a venue for the annual Dragon Boat Festival.

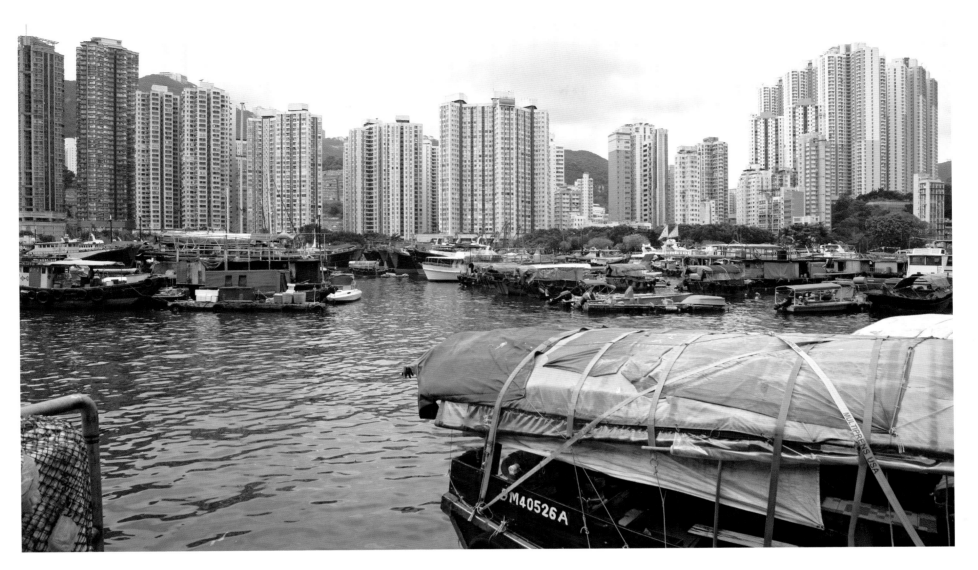

ABOVE AND RIGHT: The towers blocking the view of the Peak are the Aberdeen Centre, a private estate and home to nearly three thousand residents. Hoklo and Tanka people still live on fishing boats in the sheltered harbour and it is possible to hire a boat for a trip. Most tourists ride commercial sampans, which are touted relentlessly on the quay. Aberdeen still boasts top-quality restaurants specializing in dishes such as Aberdeen fish balls with soup noodles. Aberdeen's Jumbo Floating Restaurant (shown in the photo on the right) opened in 1976 and was modeled on a floating palace from Imperial China. It attracts over 30 million tourists a year. Private motor launches are moored outside the restaurant. This photograph was taken from the luxurious Aberdeen Marina Club, an exclusive members-only establishment. It opened in 1984 to meet a need not then supplied by institutions such as the Hong Kong Club, which only began accepting women as guests in 1996, the year before the return of the colony to China.

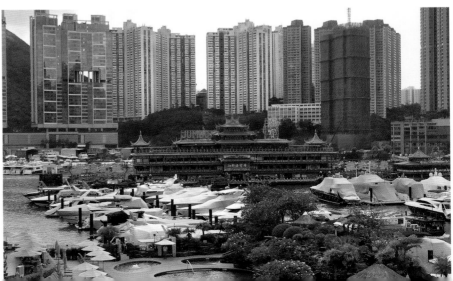

REPULSE BAY

A strategic location in the Battle of Hong Kong

BELOW: It is unclear where Repulse Bay's name originates. Some say it was taken from HMS *Repulse*, a Royal Navy ship that rid the seas around Hong Kong of pirates in the 19th century. However, the nearest that particular ship ever came to Hong Kong was the eastern shores of the Pacific. Here is the bay before World War II, with bathing huts built in traditional materials lining the beach and grand hotels perching above it. In December 1941 some of the fiercest fighting in the colony took place on this beach, and its hotels, between British, Canadian, Hong Kong and Indian troops on one side and the Japanese invaders on the other. The British side was heavily outnumbered. The Japanese committed many atrocities, including the murder of casualties in field hospitals. Hong Kong fell and so this bay's name became a bloody misnomer.

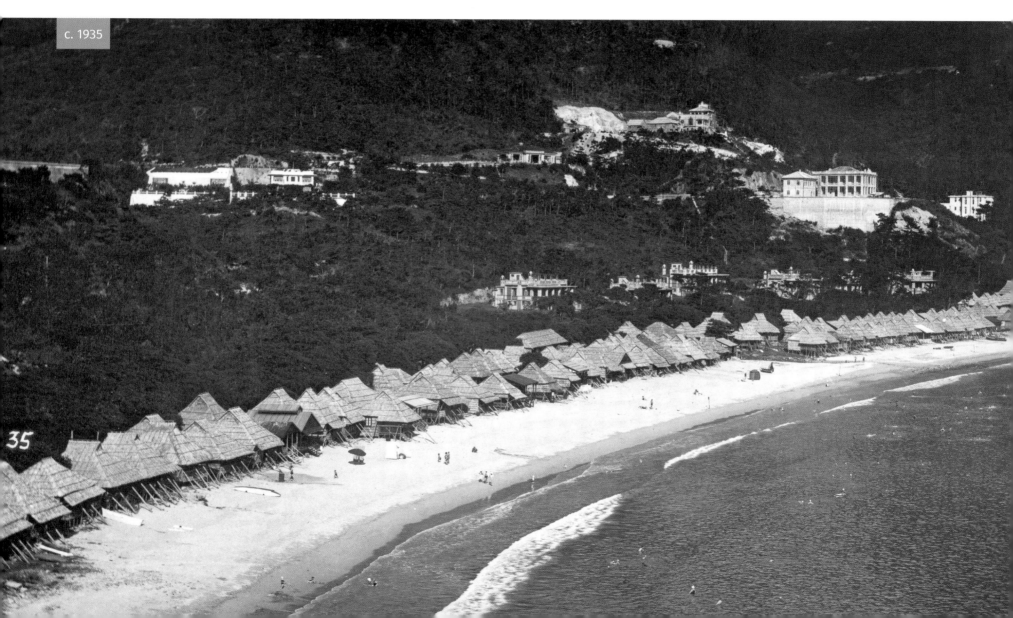

c. 1935

35

BELOW: Today Repulse Bay has some of the most expensive housing in Hong Kong. At beach level, partly obscured by foreground foliage, is The Pulse, a five-storey shopping mall opened in 2014. The prominent and unusually shaped building is the Norman Foster-designed Lily, a 24-storey apartment block completed in 2002. There have been attempts to limit the heights of some of the new developments, if not the style. But construction work continues, though the surrounding mountains remain undeveloped at the moment. Protecting bathers is a shark net.

1948

REPULSE BAY BEACH
Luxury apartments now surround the beach

LEFT: In this photo, from 1 June 1948, people gather at Repulse Bay beach where a flag flies. It is the flag of the British Colony of Hong Kong; a Blue Ensign that aptly displays (although it's not visible here) a local waterfront scene. The Colony has been free of the Japanese occupation for less than three years but for these Hong Kongers, what took place here in December 1941 will not have been forgotten. 'Eucliffe', the castle-like structure on the other side of the bay, was built in 1930 for Eu Tong Sen of the Eu Yan Sang company, a producer of traditional Chinese medicines.

ABOVE: Eucliffe was demolished in the late 1980s and in the following decade the beach at Repulse Bay was developed for holidaymakers. In recent years it has been extended, which means that the sand closer to the shore is coarser. It continues to be beautifully maintained: smart apartment buildings line the shore, a lifeguard station stands on the beach, and out in the bay a shark net is in place. In this photo a coach party of tourists from the mainland has just arrived for a brief visit.

c. 1931

REPULSE BAY HOTEL

All that remains of the hotel is its terrace

ABOVE: This photo of Repulse Bay was taken in the early 1930s before the castle Eucliffe was built in 1933. It shows the Wong Chuk Hang Road (across the bay) and Middle Island (far left) as viewed from the famous terrace of the Repulse Bay Hotel. Middle Island, or Tong Po Chau, separates Repulse Bay from Deepwater Bay. The Repulse Bay Hotel was built in 1920 and became known for its Roaring Twenties parties. During World War II it was a British stronghold and field hospital. After the war it was known for hosting royal guests, such as Juan Carlos and Sofia of Spain, who spent their honeymoon here, as well as celebrities such as George Bernard Shaw, Noël Coward and Marlon Brando. In 1955 it was brought to a world audience in the movie *Love is a Many-Splendored Thing*, a drama about racial division, and in 1978 in *Coming Home*, a drama about the Vietnam War starring Jane Fonda, Bruce Dern and Jon Voight. The photo on the right is a 1930s postcard view of the hotel and beach.

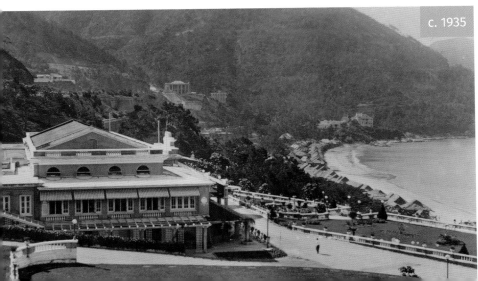

c. 1935

ABOVE: The terrace is undergoing another refurbishment; it is all that is left of the original hotel, which was demolished in 1982 to make way for The Repulse Bay, a prestigious 37-floor residential high-rise with a shopping arcade and private club. The Repulse Bay has two restaurants, Spices and the Verandah – the latter inspired by the colonial atmosphere of the old hotel with its Palm Court and afternoon tea on the terrace. The view of the bay remains largely unspoiled, despite the arrival of the low-rise private apartment buildings and houses on either side of the Wong Chuk Hang Road.

c. 1945

STANLEY BAY

The former British military base is now a popular beachside getaway

LEFT: This building was erected as housing for the families of British military personnel who were quartered here in World War II. The British made the town of Stanley – which they named in 1841 after the then Colonial Secretary, Lord Stanley – their first administrative and military headquarters for the whole of Hong Kong Island. Although later moving to present-day Central, the British Army maintained a large barracks called Stanley Fort, right up to the handover in 1997. Married military personnel could enjoy a more private life, as well as a splendid view of Stanley Bay, should they be lucky enough to be quartered here.

ABOVE: The People's Liberation Army of China took over Stanley Barracks in 1997. The military quarters shown in the 1940s photo have since been rebuilt and remodeled. The building now has the look of an upmarket, private development. A view as splendid as this attracts a hefty premium in Hong Kong. With its popular street market, restaurants and beach (which is never as crowded as Repulse Bay), Stanley is an attractive weekend getaway for those living in Central Hong Kong. The most important boat races of the annual Dragon Boat Festival are held in Stanley in early June.

STANLEY PRISON

Hong Kong's oldest maximum-security prison

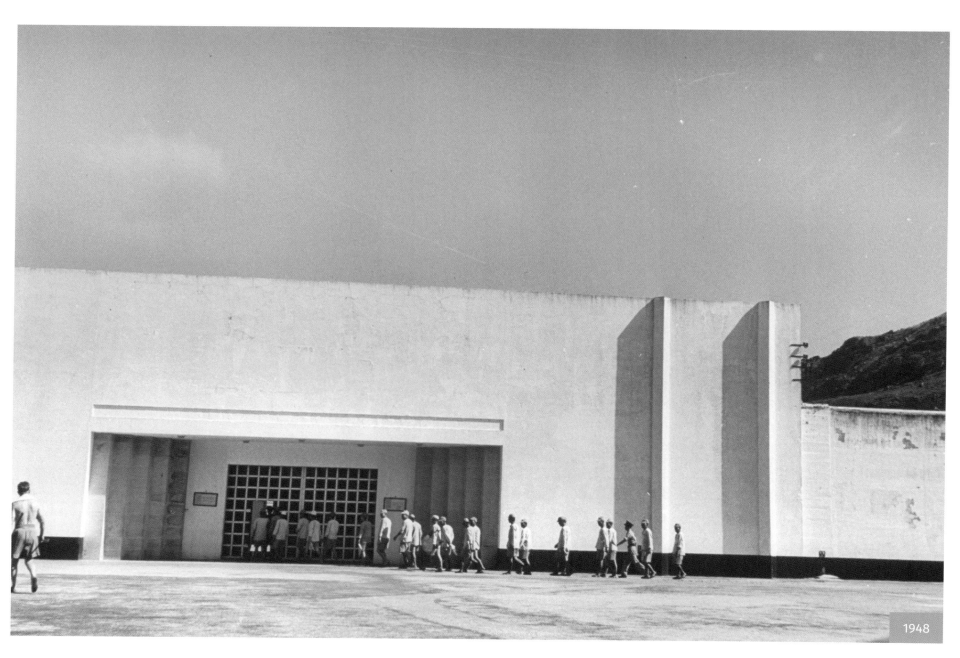

1948

LEFT: Stanley Prison was built in 1937 and was considered at the time to be one of the finest jail buildings in the British Empire. A Modernist architectural structure, it was constructed in concrete, steel and stone not far from Stanley Fort, a major British military base in the colony. On Christmas Day 1941 the colony fell to the Japanese and many Hong Kongers and others were interned here in horrific conditions. One of these was Captain Mateen Ansari of the Indian Army. After leading resistance and escape attempts, Ansari was tortured and beheaded here in October 1943, together with 30 other British, Chinese and Indian internees. They are buried in the nearby Military Cemetery. In 1946 Captain Ansari was awarded the George Cross posthumously; the highest decoration for bravery out of combat and equal in rank to the Victoria Cross. In this photograph, taken after the war, Japanese prisoners of war are being marched through the prison gates.

BELOW: Stanley Prison, one of six maximum-security facilities in Hong Kong and the oldest still in service, is run by the Hong Kong Correctional Services Department. For capital offences, this was the place for execution; the last of which took place in 1966. Thereafter until 1993, when the death penalty was abolished in the colony, the British Governor always exercised the royal prerogative of mercy. The 1993 abolition was enacted in case the Chinese Government decided to recommence executions following the 1997 handover of the colony to China. Next to the prison is the Hong Kong Correctional Services Museum, with an exhibition of over 600 artefacts representing the area's criminal and rehabilitative past from the Qing dynasty through the British colonial period to the present. Also on display are various handicrafts produced by the prison's current residents.

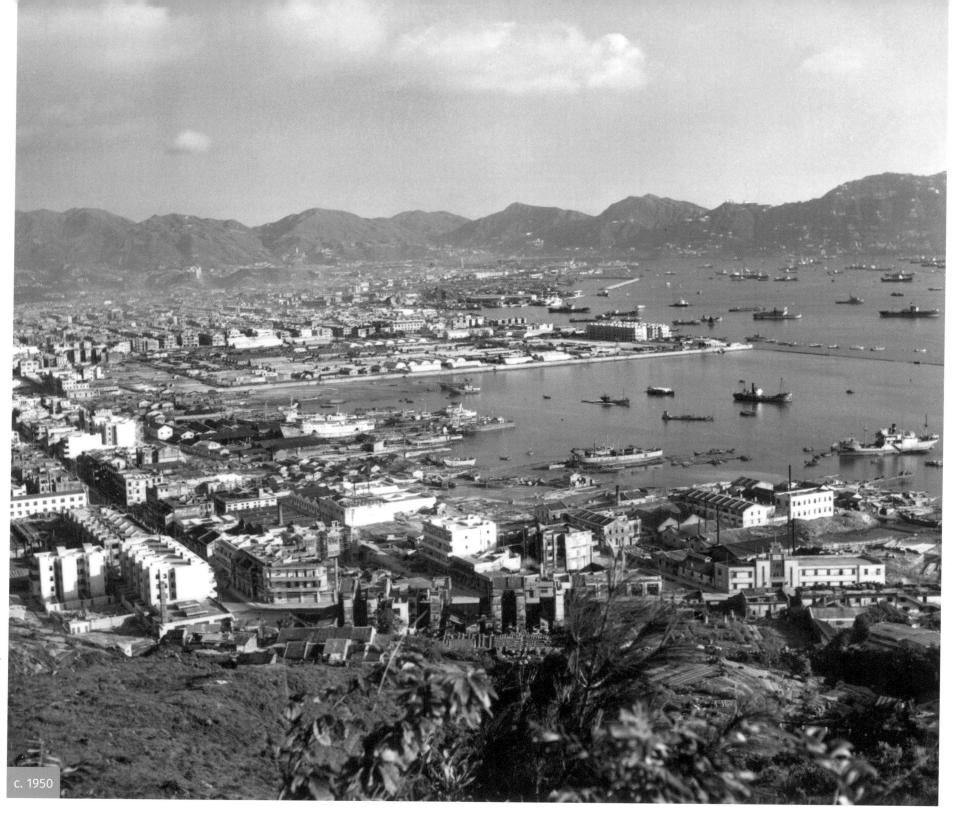

c. 1950

COMMERCIAL PORT
The world's fifth busiest port

LEFT: The success of Hong Kong has always been tied to its ability to export and import goods between the colony and mainland China. Indeed, the British set it up for that sole purpose in 1841. As the Civil War in China developed throughout the late 1940s, it became increasingly clear that the Communists were winning and the Nationalists losing. Shanghai importers and exporters panicked and started to move to Hong Kong in large numbers. In 1949, when the Communists gained control of mainland China, there was uncertainty in Hong Kong as to whether trade with a now Red China would continue, especially in view of Mao Tse-tung's public denunciation of capitalist Hong Kong. Yet the opposite happened. Shanghai was now closed to Western trading interests but Communist China still needed to obtain hard currency from the West. Thus the colony replaced Shanghai as China's main exporting port and it continued to thrive, as can be seen in this photograph taken around 1950.

ABOVE: The commercial port of Hong Kong today consists largely of the Kwai Tsing Container Terminals. They lie between Kwai Chung and Tsing Yi Island, with Stonecutters Island to the south. Kwai Tsing has been extended regularly since the 1970s to keep up with demand. The port's business is dominated by containers of goods manufactured in Hong Kong and mainland China. Up until 2004 Hong Kong had the world's busiest port, but China's main entrepôt with the capitalist world is now facing fierce competition from more modern and larger ports. Since 2015 it has been the world's fifth busiest port after Ningbo-Zhoushan, Shanghai, Singapore and Shenzhen.

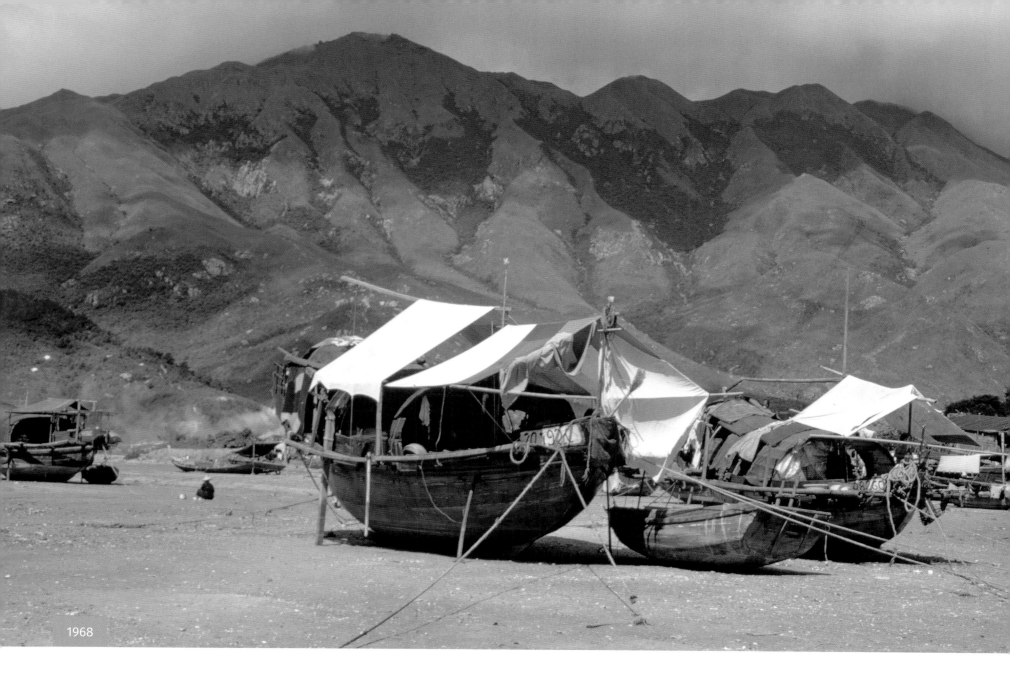

1968

LANTAU ISLAND

Development since the 1990s has transformed the island

ABOVE: Lantau Island, twice the size of Hong Kong Island, is the largest in the Hong Kong archipelago. It lies at the mouth of the Pearl River. This photograph shows what Lantau was known for not so long ago: its empty, mountainous terrain and fishing. Although this photograph was taken in 1968 and the Chinese house boats are therefore not antique, it is one of the more fascinating in this book because it gives a very good idea of what Hong Kong Island itself looked like, and had looked like for centuries, before the British wrested it from China in 1841.

ABOVE: Lantau has been developed in recent years by the construction of the Big Buddha (or Tian Tan Buddha), the world's largest when it was completed in 1993; Hong Kong Disneyland (shown left), which opened in 2005; and Hong Kong International Airport at Chek Lap Kok in 1998 (see following entry). The Big Buddha, near the Po Lin Monastery, is both a focus for Buddhism in Hong Kong and a major tourist attraction. It is free to visit, although there is a fee to go inside the 34-metre (112-feet) tall bronze statue. Hong Kong Disneyland was built in less than three years; the fastest time of any Disney resort. Feng shui was incorporated into the design; thus the walkway near the entrance has a bend in it so that good 'qi' energy cannot be lost into the sea. To be employed as a Disneyland cast member you must be able to speak Cantonese, Mandarin and English. Because of Lantau's size, there are still large untouched areas of this mountainous island that make it popular with hikers.

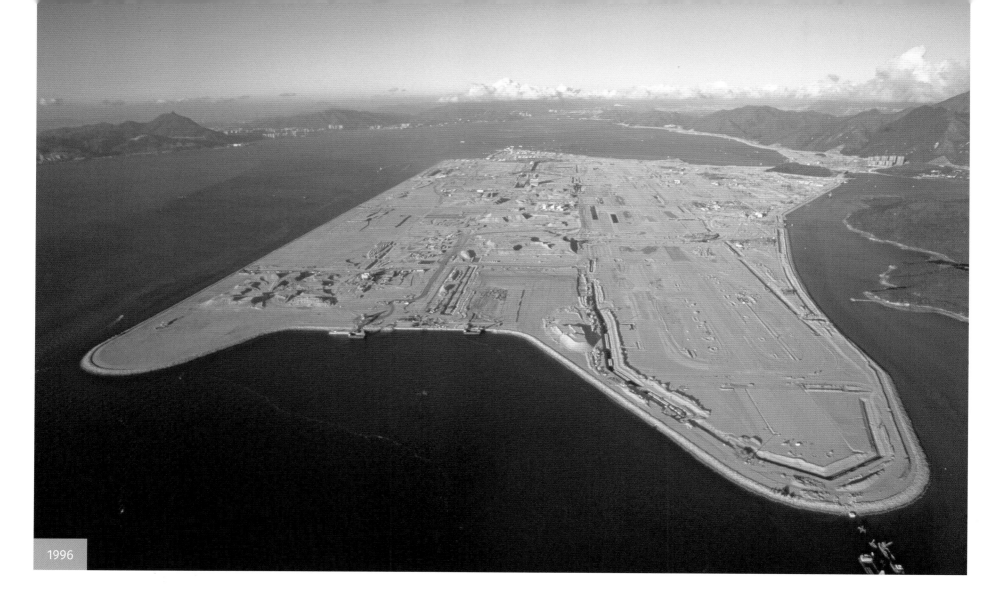

1996

CHEK LAP KOK AIRPORT
The world's most expensive airport development

ABOVE: This photograph shows the construction of a massive airport platform – the largest reclaimed land project in the history of Hong Kong. There are over 12 square kilometres (4.6 square miles) here of which 3 kilometres (1.8 miles) has come from two small hilly islands: Chek Lap Kok and Lam Chau, which were bulldozed flat and joined together. This view is towards the northeast with the north coast of Lantau Island to the right. It was first believed that construction would take 10 to 20 years, but it actually took less than seven (from 1991 to 1998), helped no doubt by a political sense of urgency – the Chinese government first regarded this as an extravagant and cynical project hurriedly dreamed up by the British to spend Hong Kong's reserves on hiring

British companies before the 1997 handover. The design of the platform was by Mott Connell, the Hong Kong branch of Mott MacDonald, a British international engineering company whose history of consultancy included the London Underground system and Egypt's Aswan Dam. The specification for airport-related aspects was the British Airports Authority while the airport buildings were designed by London-based Foster & Partners, with Ove Arup as structural engineers. A linking railway, roads, tunnels and even a new town at Tung Chung were spin-offs from what became the world's most expensive airport development. The final cost reached HK $155 billion (US $20 billion). The photo on the right shows Chek Lap Kok a year before the airport was completed.

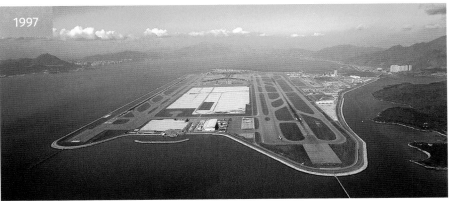

1997

ABOVE: China's early suspicions did not prevent President Jiang Zemin from opening the new Hong Kong International Airport on 2 July 1998 in a grand ceremony. At the moment Chek Lap Kok, as it is commonly known, carries more cargo traffic than any other airport in the world. Seen above is Terminal 1, designed by Foster & Partners. It is the third largest airport terminal in the world after Dubai and Capital Airport, Beijing (also by Foster & Partners.) The windows are designed to break in the event of a serious typhoon; thus relieving pressure and helping to prevent the roof being blown off. The vintage biplane seen above is a replica of one flown at Sha Tin in the New Territories in 1911 by the Belgian Charles Van den Born. The replica's builder, American engineer and pilot Roger Freeman, flew this plane over the newly completed southern runway of Chek Lap Kok on 15 November 1997.

c. 1955

HARBOUR WALL, MACAU
The Outer Harbour provides ferry, hydrofoil and helicopter services to Hong Kong

LEFT: Sixty kilometres (37 miles) from Hong Kong across the Pearl River is the former Portuguese colony of Macau; the first and the last European settlement in East Asia. The ferry from Hong Kong arrives in this harbour, called the Porto Exterior (Outer Harbour). To the left is a tree-lined promenade. The ferry terminal is just off-camera to the right. This photograph of boys fishing off the stone harbour wall was taken sometime in the 1950s.

ABOVE: The old promenade and trees have disappeared and the stone harbour wall has been replaced in concrete. Although it follows the same line, it is further out into the sea on reclaimed land that now accommodates the wide Avenida da Amizade. The annual Macau Grand Prix circuit follows the shoreline around the Avenida da Amizade, which lies off camera, behind the construction work on the left. Until 2007 the famous Macau Palace floating casino was moored where the crane now stands. The casino scene in the James Bond movie *The Man with the Golden Gun* was filmed there in 1974. To the right is the Outer Harbour Ferry Terminal and heliport, which provides regular hydrofoil services to Hong Kong.

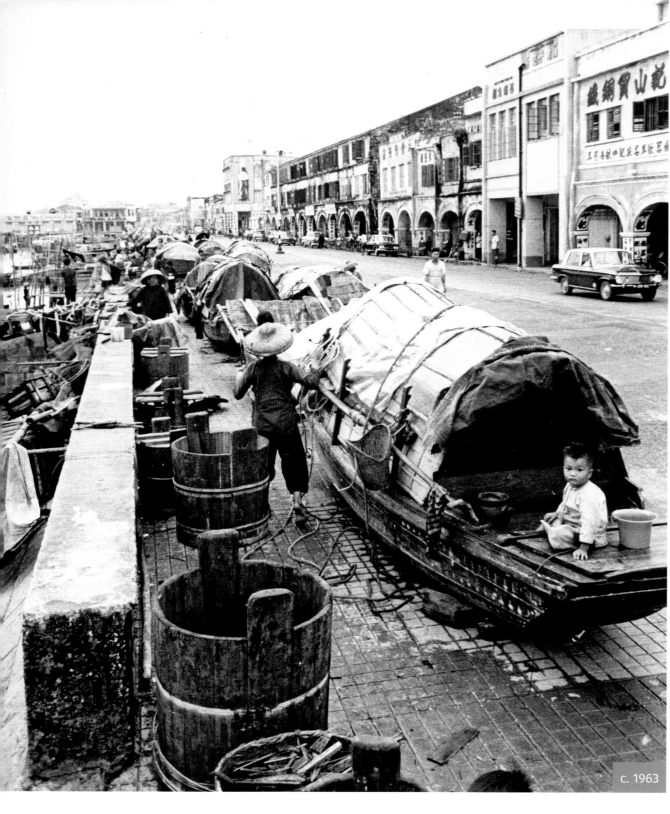

c. 1963

FISHERMAN'S WHARF, MACAU

Macau's working quayside is now a waterfront entertainment complex

LEFT: For centuries, a key activity for the inhabitants of Macau was fishing. The sampan, as seen here, was the boat they used. In Hokkien Chinese the word 'sampan' means three planks: the flat-bottomed hull and the two sides. The sampan is propelled by poles and designed for fishing in shallow waters, such as the Pearl River Delta where Macau is located. Here we see a quay where the catch is brought ashore. To the right is a parade of shops of varying vintage. The cars date this photograph to the early 1960s.

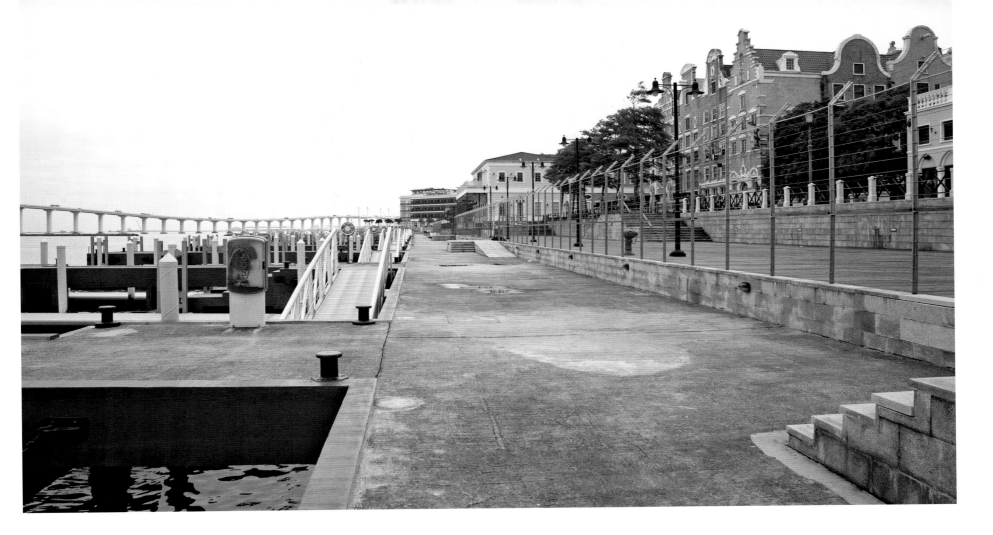

ABOVE: Although the old quay is now called Fisherman's Wharf, there isn't a boat in sight. Each of the extensions leads to a landing stage for private craft. Fisherman's Wharf was officially opened in 2006 and took five years to build. It is a theme park with shops, hotels, restaurants and a casino. The buildings on the right are themed on Amsterdam. Their intricate details are in sharp contrast to the unadorned promenade. The photograph on the left was taken just behind the row of Dutch pastiche buildings. From here the development takes on an antique hue with the Dutch merging into a classical basilica on the left. A 2,000-seat replica of a Roman amphitheatre is included in the design. It is a popular venue for concerts and as a backdrop for wedding photographs. The tessellated pavement ushers visitors to the Sands, which opened in 2004 as Macau's first Las Vegas-style casino resort.

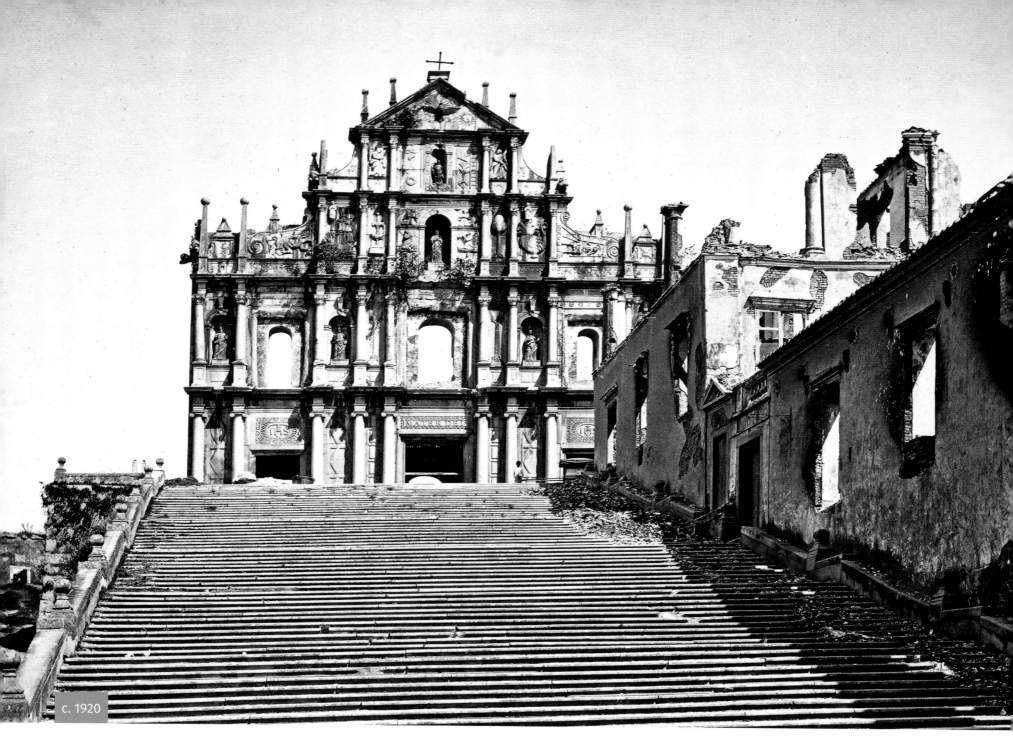

CHURCH OF ST. PAUL, MACAU

The most famous sight in Macau

LEFT: The Jesuit church of St. Paul (or São Paulo) was built in 1602. It was part of the college of Madre de Deus (Mother of God) which was Portuguese; although the architect of the church was Italian, the style Spanish and the builders Japanese. Eclecticism has an honourable history in Macau. The church burnt down in 1835, leaving just the facade intact. Standing high in the centre of Macau, this survivor of conflagration became the colony's enduring and most loved structure. To the right, crumbling remains flank the impressive, if rubbish-strewn, steps. Just one figure inhabits this scene. Mass tourism has yet to arrive.

RIGHT: Of all the sights of Macau, other than the casinos, the ruins of St. Paul's Church are the most popular with tourists. This is the place to be photographed, so that you can show you have been there, exhausted or not. Today many tourists are from the Chinese mainland on day-trips. The buildings on the right have long-disappeared and the steps have been restored, as has St. Paul's facade. At the apex, a dove representing the Holy Spirit is flanked by the sun and the moon, while below Christ is surrounded by the implements used in his crucifixion: crown of thorns, ladder, manacles, flail, spear. Below Christ is the Virgin Mary, flanked by a peony representing China and a chrysanthemum representing Japan. Jesuit saints fill the niches of the tier below. Buried in the crypt behind are skulls and bones, displayed in orange and glass boxes, of 23 Christians crucified in Nagasaki, Japan, in 1597. This may explain the prominence given to the implements of Christ's Crucifixion. Over the central west door is the legend Mater Dei (Mother of God).

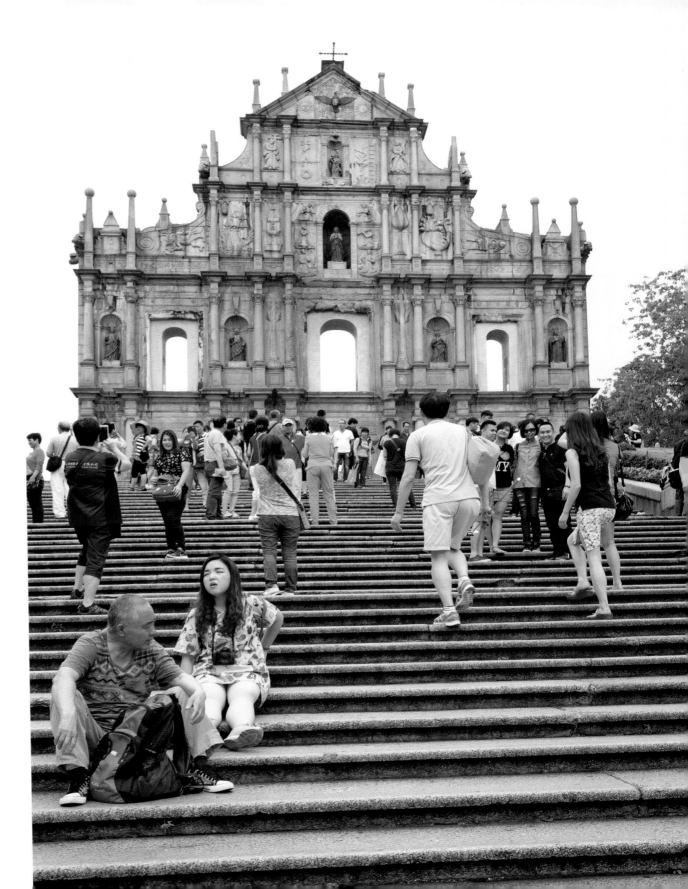

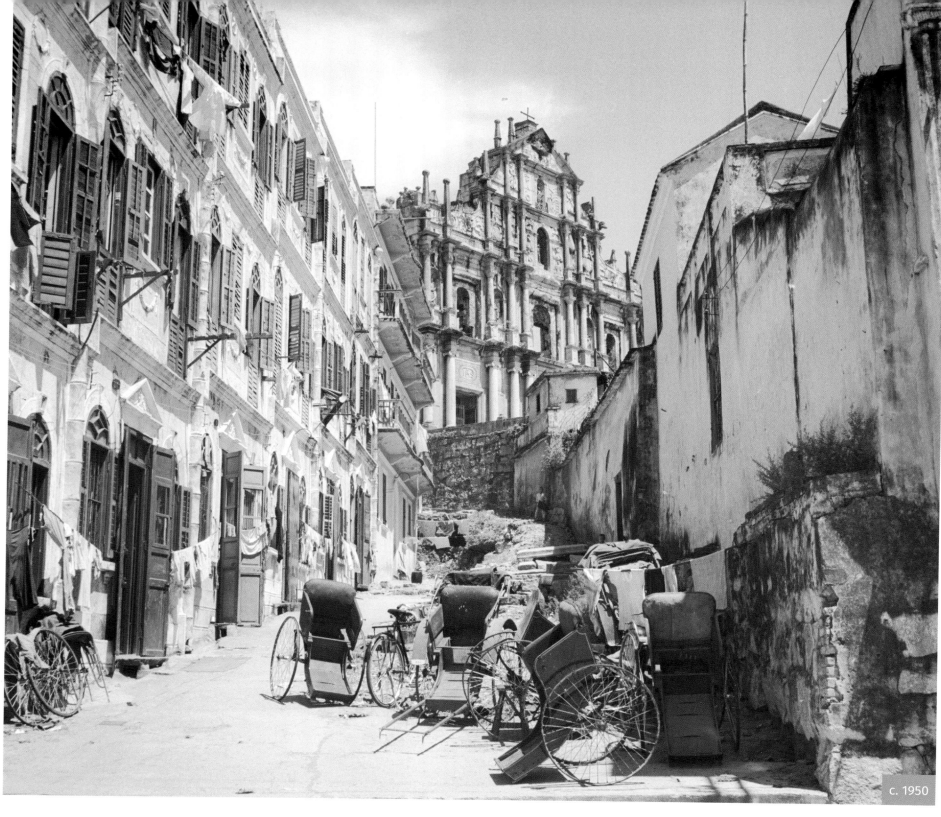

c. 1950

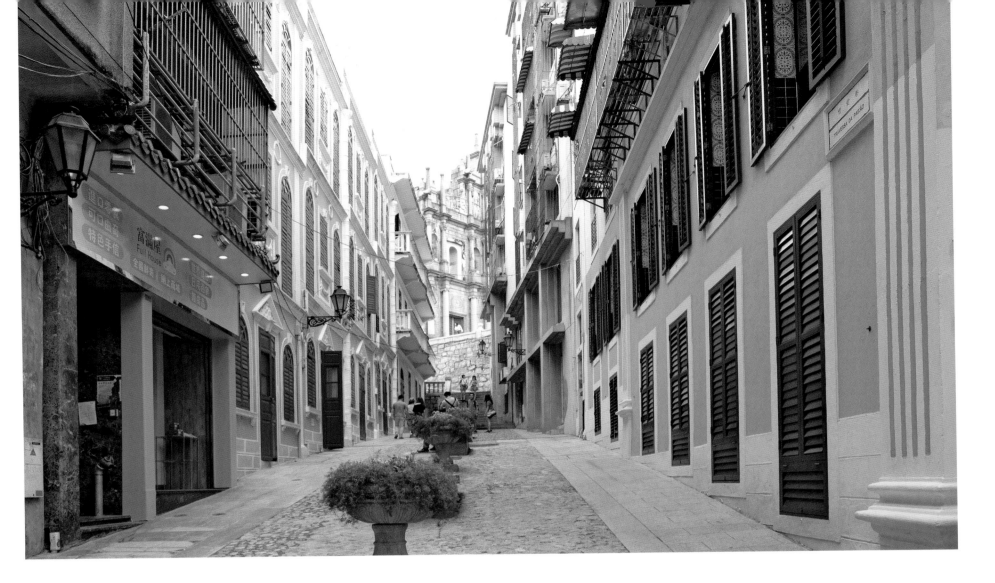

TRAVESSA DA PAIXÃO, MACAU

An alternative view of the ruins of St. Paul's Church

LEFT: Travessa da Paixão is only 50 metres (164 feet) long. The street received its name, which means Love Lane in English, in 1925; although the 'love' most likely refers to the love of Christ, given its position below the ruins of St. Paul's Church which can be seen at the end of the street. Below the church is a remnant of the city wall and what appears to have been steps. The building on the left looks as though it is being used as a rickshaw station, or at least a repair shop, judging from the rickshaw wheels stacked outside. With laundry artfully draped in the sun, this photograph from around 1950 could almost be a staged still from a black and white movie of the period.

ABOVE: Travessa da Paixão has had a major makeover with the first two buildings on the left, and all those on the right, entirely replaced. Two old-looking classical pilasters have appeared on the new building to the right. At the end of the street, the city wall has been cleaned and repointed, while below the wall, new steps replace what was essentially rubble. Down the centre of the street are stone or concrete urns filled with flowers. It would be easy to regard the restoration of this street and the addition of flowering urns as almost too picturesque, yet given its previous condition its transformation has been a success. It's cleaned-up appearance offers the perfect frame for tourists looking for a different view of St. Paul's.

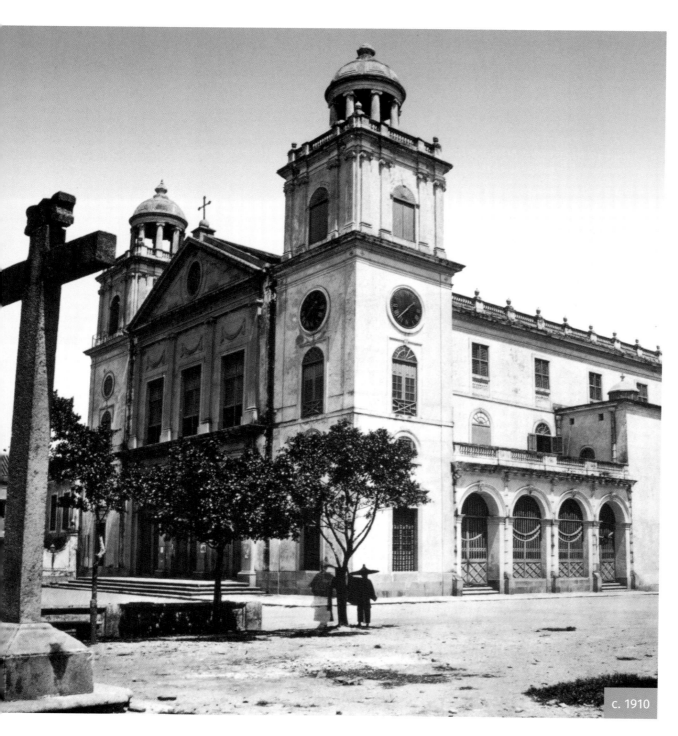

c. 1910

MACAU CATHEDRAL
Completely rebuilt in 1937

LEFT: The first building on this site was a wooden chapel, constructed in 1576 and elevated to cathedral status in 1623. The stone-built Macau Cathedral (Igreja da Sé) seen here was erected in 1850. The cathedral suffered a serious typhoon in 1874, after which it was extensively repaired. The cathedral was completely rebuilt in concrete in 1937. In this photo, two figures stand under a tree wearing traditional Chinese sun-hats. The ghostly appearance of the figure on the left is due to the photographer's long exposure.

RIGHT: When the cathedral was rebuilt in 1937, the cupolas were dispensed with – probably thought too risky to replace in the event of a serious typhoon – and this side of the building was remodelled. Although it is no architectural masterpiece, the cathedral has some fine stained-glass windows. The stone cross and plinth have been replaced on the left and a new fountain has arrived surrounded by Portuguese-style tessellated paving. The yellow building behind is a replacement and is owned by the church. In the background several apartment buildings and a casino hotel (behind the pink structure) have sprung up.

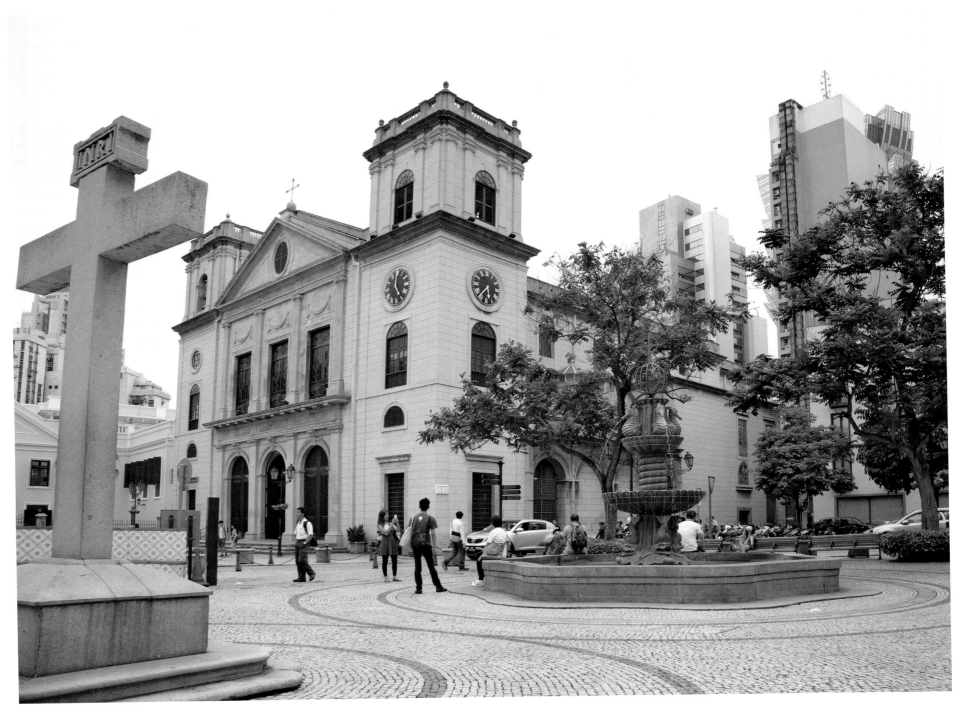

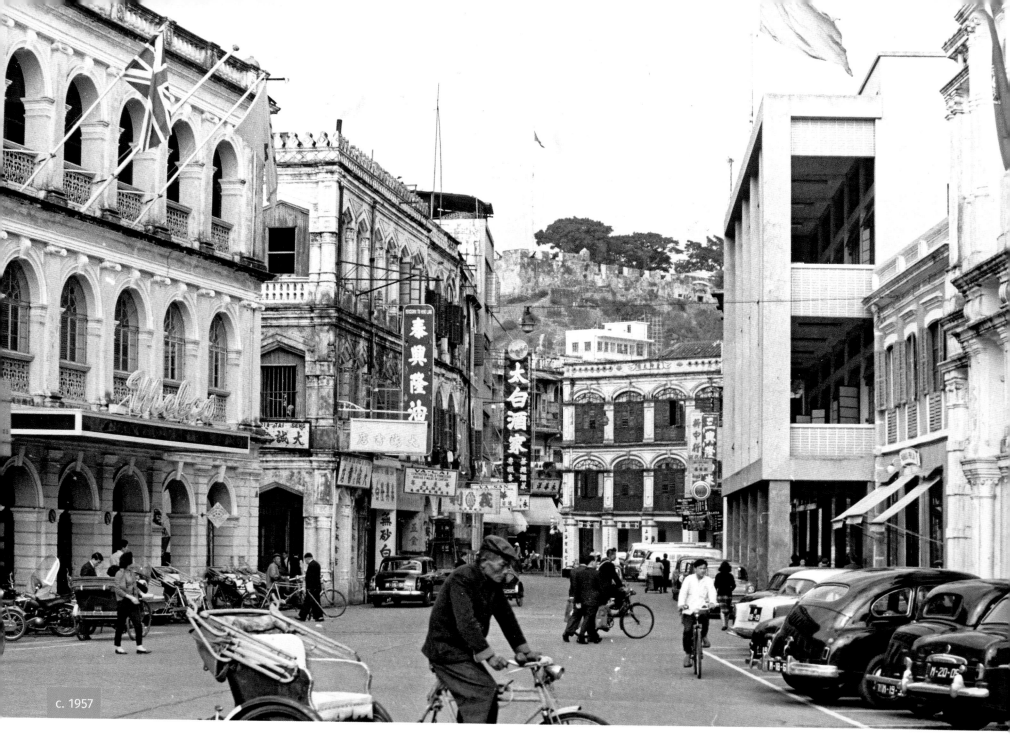

c. 1957

SENATE SQUARE, MACAU

The administrative and historic centre of Macau

136

LEFT: Senate Square (Largo do Senado) is the administrative and historic centre of Macau. It was named after the Senate building, which lies behind the photographer of this late 1950s image. Ahead on the hill are the remains of the Fortaleza do Monte. In 1622 the Dutch tried to capture this Portuguese colony but the fortress's guns drove them back. On the near right is Macau's oldest institution, the Holy House of Mercy (Santa Casa de Misericórdia), which was founded in 1569 by Dom Belchior Carneiro, Macau's first bishop. His skull is displayed inside. On the right, over the Modernist building, flies the flag of Communist China, while the British flag is visible on the colonial building opposite. The flag flying above the fortress is that of Portuguese Macau. This tiny European colony, the oldest in East Asia, has survived by staying friends with everybody.

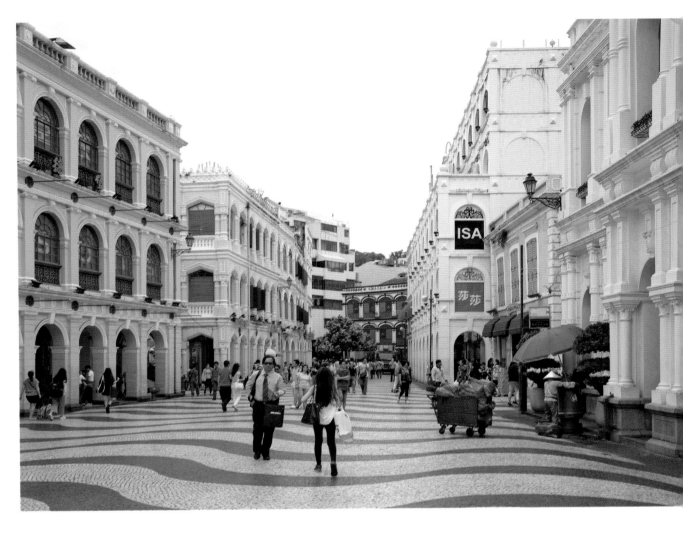

ABOVE: In the early 1990s the square was restored, mainly through the introduction of Portuguese-style tessellated paving, which, although impressive, seems out of scale with the buildings. Santa Casa de Misericórdia is now a medical clinic and the view of the fortress is obscured, but the biggest change is to the building on the right, from which the red flag of China once flew. A new historic building has replaced the old Modernist one. At first glance it seems a complete replacement, but a stroll through its arcade (shown left) indicates that it may just be a makeover. Displaying the flags of interested parties is no longer thought necessary since Portugal transferred Macau back to China at the Millennium.

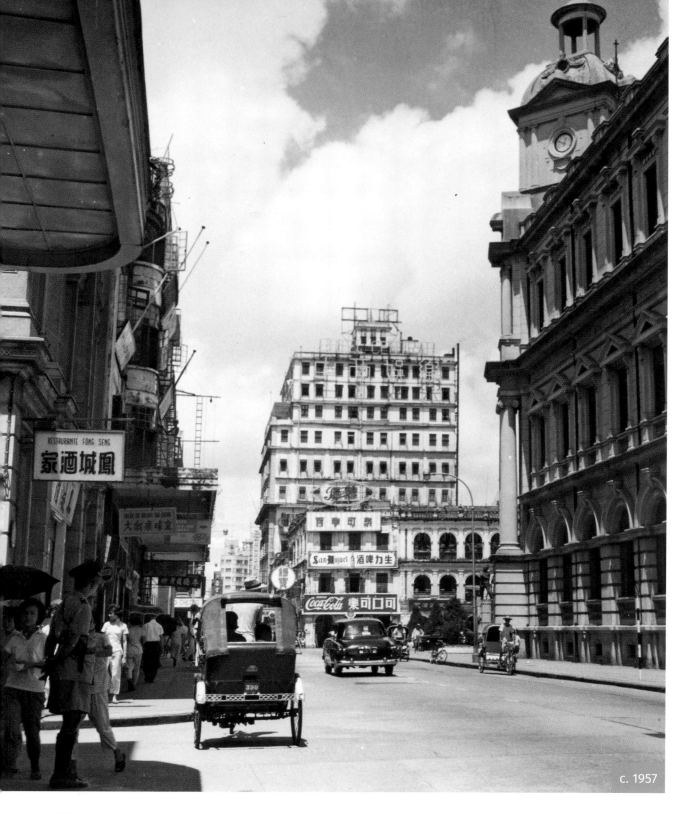

AVENIDA DE ALMEIDA RIBEIRO, MACAU
Macau's main thoroughfare

LEFT: Also known as New Road, or San Ma Lo in Chinese, Avenida de Almeida Ribeiro was completed in 1920 following demolition of a winding lane. The large building with the clock tower on the right is the General Post Office, which was completed in 1929. Further along on the same side is Senate Square and beyond that is Hotel Central. Avenida de Almeida Ribeiro forms the southern boundary of the old city, which lies to the right. When this photograph was taken in the late 1950s gambling was popular in many of the buildings lining Macau's main street, which perhaps explains why a policeman stands watch on the left. In the aerial photo below, Hotel Central is the tall building on the left.

c. 1957

c. 1960

RIGHT: The rickshaws may have gone but everything else looks relatively unchanged. Two Macau landmarks, the General Post Office and the Hotel Central (the prominent green building), continue to provide the services they were built for. Obtrusive signs on old buildings at Senate Square have been removed and their facades restored. The real changes, such as they are, cannot readily be seen. Gambling in small establishments has been discouraged here. It was difficult to police, and with the arrival of big Las Vegas-style hotel casinos, such as the Sofitel Macau at the end of the street, was no longer commercially viable.

c. 1955

PORTAS DO CERCO, MACAU

The Siege Gate marked the border between Portuguese Macau and China

LEFT: The Portas do Cerco, or Siege Gate, marked Portuguese Macau's border with China. It was first built in 1849 after a short battle between the two countries. (The present gate dates to 1870.) The battle was ostensibly about the murder of Macau's Governor at the time, Ferreira do Amaral. Appointed in 1846, he directed several provocative acts against the Chinese. When seven Chinese murdered him, battle commenced in 1849. The underlying reason was that Amaral had seen an opportunity to provoke the militarily weak Chinese – as the British had done successfully a few years before – to gain further concessions and territory, which Portugal eventually did. The Portas do Cerco honours the battle and marks the new border. The inscription at the top of the gate means 'Honour your motherland for your motherland looks over you.'

ABOVE: The restored Siege Gate was moved several metres into Macau to accommodate the Posto Fronteiriço das Portas do Cerco, or Siege Gate Frontier Building. The new development (directly behind the gate) opened in 2004. Since being returned to China at the Millennium as a Special Administrative Region (SAR), the number of tourists from the Chinese mainland has increased and now outnumber those from Hong Kong. Other than the 1849 incident, Macau's policy over the centuries has been to avoid tweaking the Chinese dragon's tail. Yet today the Chinese government is concerned about the rise in serious money laundering in Macau. Most Chinese tourists are here for innocent pursuits: a honeymoon, a tour, a minor flutter. But now there are many professionals operating a simple scam: bring in Chinese currency, exchange for chips to play the tables and collect winnings or losings in other currency.

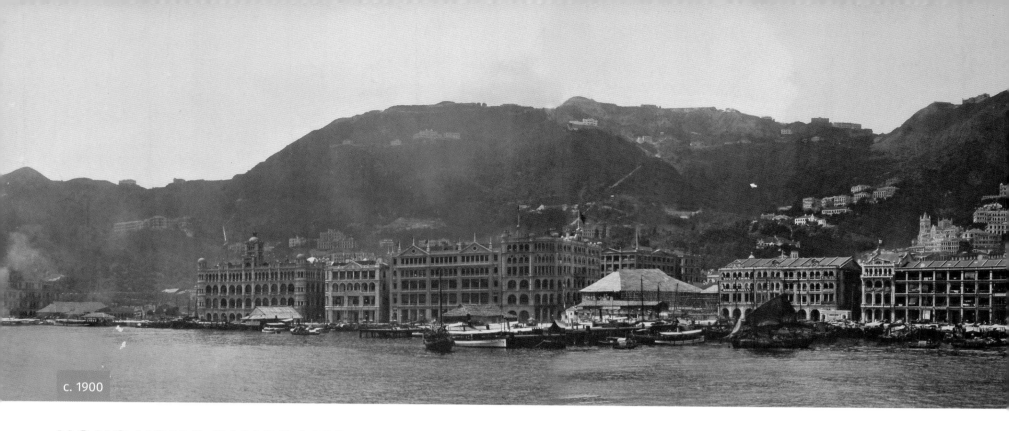

c. 1900

HONG KONG PANORAMA The skyline from Kowloon

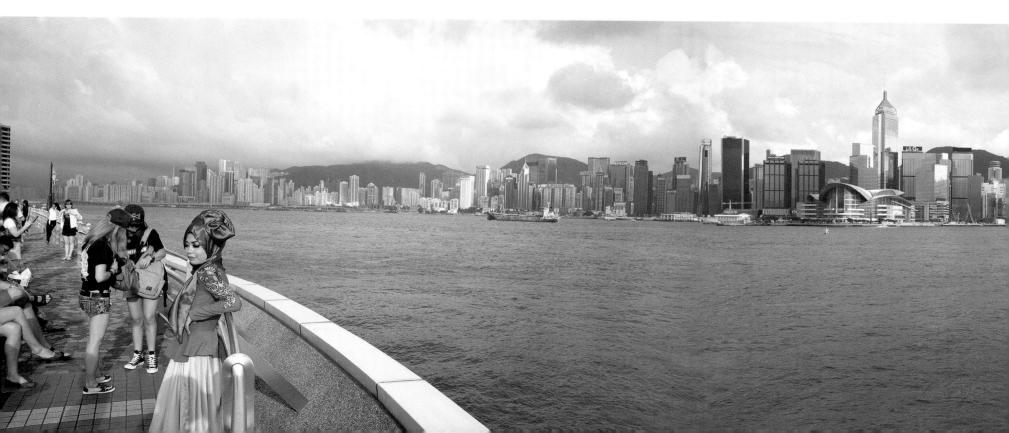

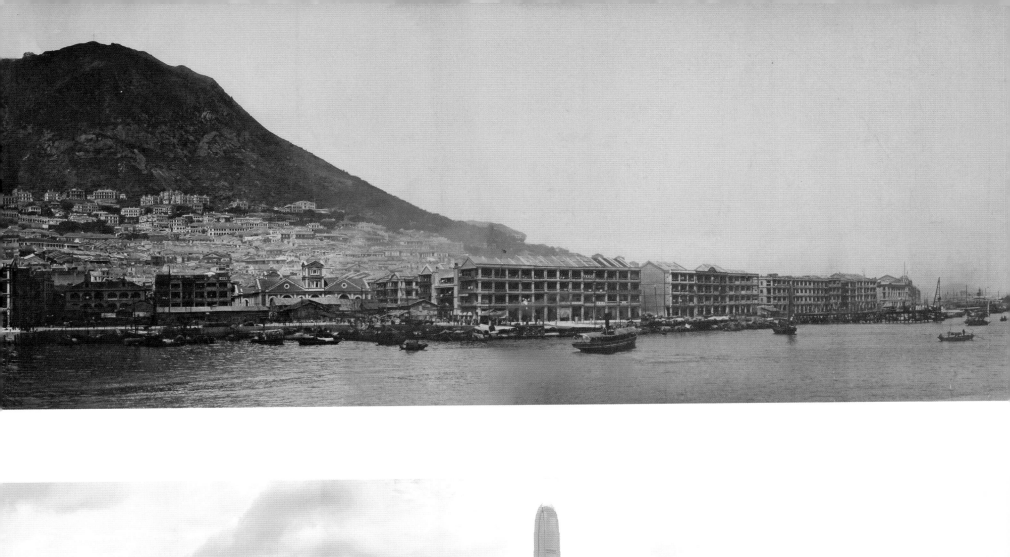
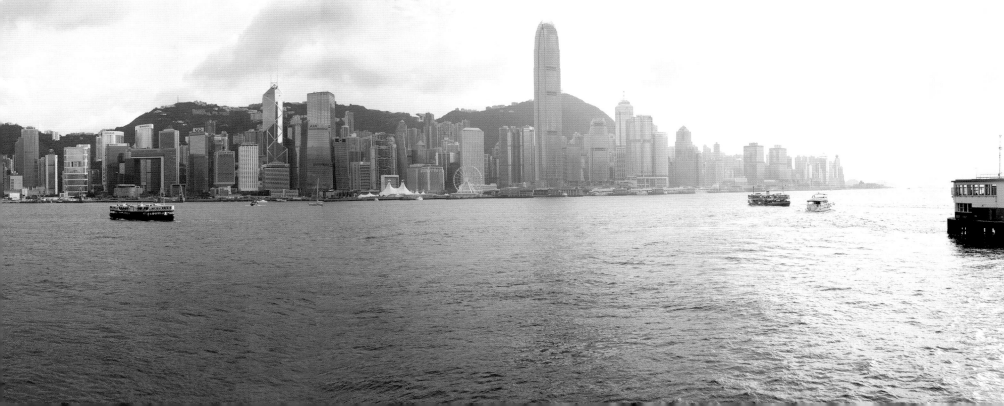

INDEX